TURNER

"TURNER"

The Man and His Art

JACK LINDSAY

Franklin Watts
New York
1985

First published in England in 1985 by Granada Publishing Limited

First published in the United States in 1985 by Franklin Watts, Inc.,
387 Park Avenue South, New York NY 10016

ISBN 0–531–09792–7

Printed in Great Britain

Contents

LIST OF ILLUSTRATIONS

[vii]

1. Early Years

Of the three greatest English landscape artists, two were
country born and bred: Gainsborough and Constable, in the
Stour valley between Essex and Suffolk. The third, Turner, was
born in London in 1775 at 21 Maiden Lane, which runs between
Covent Garden and the Strand. He thus grew up in the most·
rowdy and crowded part of London. Covent Garden was the
first London square as well as the first piece of town-planning in
Britain. Originally the Convent Garden of St Peter's Abbey,
Westminster, it was taken over by the Earl of Bedford, who sold
his surplus fruit and vegetables there; the fourth Earl
commissioned Inigo Jones to develop the area. Jones adapted the
planning system he had seen at the Italian seaport Livorno
(Leghorn): houses rising above arcades that framed an open
piazza, with a church at one end as the focal point. The rebuilding
was completed in the late 1630s. In Turner's day vegetables were
brought in from Chelsea and other outlying areas. Two national
theatres had been built near the Piazza: the Royal Drury Lane and
the Theatre Royal. Musical societies gave concerts, and art
academies used the area, for example St Martin's Lane Academy,
revitalized by Hogarth, and Shipley's Drawing-School. From
the later seventeenth century on, artists lived in the area: Lely,
Hoskins, Cooper, Kneller. Taverns, coffee-houses, whore-
shops multiplied: a situation that inspired Gay's *Beggar's Opera* in
1728 and stirred Fielding to organize the Bow Street Runners,
linked with Bow Street Magistrates Court from 1727 to 1829,
when the Metropolitan Police came in.

The lively nature of the area strongly affected Turner. Ruskin

[1]

noted how he liked litter in his pictures; and the contrast between
the well-organized space of Inigo Jones and the tumultuous life of
the people inside it, ebbing and flowing in changing patterns, left
impressions that carried on in various ways inside his art. Ruskin
remarked that his foregrounds always had 'a succulent cluster or
two of greengrocery at the corners. Enchanted oranges gleam in
Covent Garden of the Hesperides; and great ships go to pieces in
order to scatter chests of them on the waves.' He liked to bring in
oddments, 'smoke, soot, dust, and dusty texture; old sides of
boots, weedy roadside vegetation, dunghills, strawyards, and all
the spillings and strains of common labour'. He liked shingles,
debris, heaps of fallen stones. 'The last words he ever spoke to me
about a picture were in gentle exultation about his St Gothard:
"That litter of stones which I endeavoured to represent."'

Turner thus knew the urban scene of his age in all its contrasts
of fine show and dire poverty, of display and broken oddments.
He was familiar with the world of commerce, warehouses and
manufactures. One of his father's best friends (later visited in
Bristol) was a fishmonger and glue-boiler. Turner must have
been early affected by the Garden's mixture of market-business,
loose living, and art, music, drama. The house where he was
born had a Cider Cellar, a basement reached by a ladder, where
from 1730 to 1858 gatherings of artists, writers and musicians
went on, and midnight concerts were held. In the house were
auction-rooms taken over by the Free Society of Artists in
1775–6; the Incorporated Society of Artists used it as a school
and show-place for three years. Turner's parents lived there
from 1773 to 1776, then moved elsewhere in the area. In 1790
they were back in the Lane, at No. 26. Turner's room, used
as a studio, was on the second floor, at the rear, and faced a
narrow passage, Hand Court, so that the light could not have
been good.

For contrast with the busy scene of the Garden he had the
Thames and its shipping a few minutes' walk away. The nearest
point for him to reach was the banks and the steps by the Savoy,
along the Strand. There the river sweeps to the left and he could
see over the housetops the dome of St Paul's, which had been the
key-point ever since Canaletto, the Venetian *vedutista* (painter of
views), depicted it during the period which he spent mainly in

England (1746–56), with Samuel Scott following in his steps. The view upstream led to the Houses of Parliament. The eager boy must have soon come to know the sailors and the ships, the serried mass of masts, the sails of yellow and madder, the green and vermilion dragonfly-boats, the racing of the tides through the piers of the heavy bridges, the rickety sheds and the smoke from Thrale's Brewery on the other side. He listened to the tales of sailors and noted the swirl and flow of water, the varying effects of light and colour through mist and fog, especially at dawn and sunset. He thus had a very different sort of scene to set against Covent Garden with its planned architectural forms and confused movement of vehicles and people, its untidy heaps of fruit and flower.

No doubt he made his own small boats and launched them on the waters. Later he compared his pictures to ships. The Academy was closing 'and the Spanish Fleet (*alias* pictures) will be removed from their present moorings to be scattered' to all points of the compass, 'like the Armada'. He fears that he himself 'may be driven by the wind with his passport' to Switzerland. And he writes of his *Fishing Boats with Hucksters bargaining for Fish* that Lord Gower in buying it 'launched my Boat at once with the van de Velde' which he, the Lord, owned. In a poem on fishing at Purley near Pangbourne (1809) he wrote of 'the daring boy' who in the rain

> Launches his paper boat across the road
> Where the deep gulleys which his fathers cart
> Made in their progress to the mart
> Full to the brim deluged by the rain
> They prove to him a channel to the main
> Guiding his vessel down the stream
> The pangs of hunger vanish like a dream

He seems to have been born on 23 April, St George's Day, also Shakespeare's birthday. He was christened on 14 May 1775. It is possible that with his liking for mystification and symbolism he picked on St George's day later as a suitable date. Charles Turner, the engraver, says, 'He either never knew, or would never tell, his birthday.' His old housekeeper, Hannah Danby, said that,

'when asked, Turner would answer that he had been born in the same year as the Duke of Wellington and Napoleon Bonaparte – 1769'. But in his will of 1832 he left £50 for a dinner to all members of the Royal Academy on his birthday, 23 April; and on a watercolour exhibited in 1796 the pavement stone in a chapel of Westminster Abbey is inscribed, 'William Turner natus 1775', so that he awards himself a burial in the Abbey.

His father William was a barber, as was the father of Cotman, the watercolourist born in Norwich in 1782 who worked with Turner under Dr Monro, as we shall later see. Covent Garden, as a fashionable quarter, had many perruquiers and hairdressers as well as dealers in old clothes and articles of personal adornment. The hairdressers were plentiful in Henrietta Street, Tavistock Street and Maiden Lane, where Voltaire once lodged at the sign of the White Perruque. William Turner seems to have had a good hand at shaving faces and dressing wigs; he would have waited on the neighbouring gentry in their own houses. Barbers' shops still had a tradition of prints on the wall and newspapers for clients to read.

William had come from South Molton, Devon. At the age of twenty-eight he married Mary Marshall, some six years his senior. Her father was a salesman of Islington, her grandfather a well-off butcher at Brentford. She came from a level of tradesmen superior to William, and her family pride was shown in calling her son Joseph Mallord William, the first two names being those of her family. The boy was known as William, though in later life he generally used the initials, J. M. W. Turner. The marriage of his parents took place in the Covent Garden church; and when we consider that his mother was thirty-four at the time, we may surmise that she married William as her last chance. She was an unhappy woman, who became subject to fits of manic rage. In 1778 she gave birth to a girl, Mary Ann, who was christened on 6 September in the same church as the boy and who died in her eighth year, when her brother was almost eleven. She was buried in the churchyard on 20 March 1786; the register described her as 'from St Martin in the Fields'. Her death must have increased the tension in the family.

Thornbury, Turner's first biographer, tells of an early unfinished work, a portrait of his mother:

[4]

There is a strong likeness to Turner about the nose and eyes. Her eyes are blue, lighter than his, her nose aquiline, and she has a slight fall in the nether lip. Her hair is well frizzed – for which she might well have been indebted to her husband's professional skill – and she is surmounted by a cap with large flappers. She stands erect and looks masculine, not to say fierce; report proclaims her to have been a person of ungovernable temper, and to have led her husband a sad life.

In stature, like her son, she was below the average height. The Rev. H. S. Trimmer, an amateur painter who became friendly with Turner about 1806, remarks that he never saw her, never heard Turner mention her, and never heard of anyone who had seen her. Thornbury adds that Turner 'fiercely resented any allusion to his mother's family in after life'. Her outbursts grew worse, until in 1800 she was put in Bethlehem Hospital for the Insane. It was apparently there that she died, still mad, in 1804.

The experience of living for his first twenty-five years with a fierce mother torn by tempests of fury and ending insane could not but have deeply affected her son. It certainly underlaid his inability to enter into a settled relationship with a woman, despite his strong sensuality. And we are probably correct in linking it with his interest as an artist in convulsions and violent moods of nature, on the sea and among the mountains, together with the need to express the forces bringing about a radiant transformation of the dangerous universe.

His relations with his father were very different. The elder William was through his long life deeply loved by his son, who must have sympathized with him in his marital troubles over the years. He encouraged young William to work at his art and exhibited drawings of his for sale in the shopwindow, selling them at prices from three shillings. We hear of the lad colouring engravings, working for instance on seventy prints in Boswell's *Antiquities of England and Wales* for a distillery foreman at tuppence each. Old William lived until 1829 when he died at the age of eighty-five, a tough and lively fellow. Trimmer remarked on his low stature, small blue eyes, parrot nose, jutting chin and fresh complexion. He was a chatty old man who talked fast, but

from speaking through his nose his words had 'a peculiar transatlantic twang'. He always had a smile on his face. Thornbury says he used to claim he had given his son 'a good eddycation', and Alaric Watts, poet, who wrote an early biographical sketch of Turner in 1853, says that old William taught his son to read – the latter was otherwise 'entirely self-educated'. Later, when Turner had a house at Twickenham, his father worked daily in the garden, except on Tuesdays when he trudged to Brentford market and brought back a week's provisions in a blue handkerchief. There, adds Trimmer, 'I have often met him, and asking him after Turner, had answer, "Painting a picture of the battle of Trafalgar."' Thornbury says he had a habit of nervously jumping up on his toes every two or three minutes. Turner commented, 'Dad never praised me for anything but saving a halfpenny.' When he died, Turner never appeared the same, Thornbury tells us, 'his family was broken up'. At Twickenham, besides being gardener, he had been studio assistant, housekeeper, secretary and general factotum. It was a way of life that suited Turner better than having a woman to look after him.

The young Turner did not know only London. He seems to have been sent in the early 1780s to stay with some relations of his mother at Margate in Kent. He certainly remained much attracted to that town all his life; he made some of his earliest and his latest drawings there. The sight of the open sea would have fascinated him, giving a sudden new dimension to the movements, gleams and light-effects that he had known on the Thames. Then in 1786, the year that his young sister died, he was sent to his uncle, a Brentford butcher, 'in consequence of a fit of illness', says the engraver E. Bell. The phrase is not clear; but the death of Mary Ann may well have upset the boy badly and brought about some sort of breakdown.

Brentford was a lively market-town some ten miles from London. The uncle's shop was on the north side of the market-place, next to an old inn, the White Horse. Turner attended the Free School as a day-boarder, so that he was not wholly dependent on his father for his 'eddycation'. The school in the High Street, under John White, had fifty boys and ten girls. Later Turner used to visit Trimmer at Heston, 'not merely for the

fishing and fresh air, but because Mr Trimmer was an old friend and lover of art, and because he was close to his old school at Brentford Butts, now a public-house exactly opposite the Three Pigeons'. He told Trimmer, says the latter's son, that on his way to and from the school he used to amuse himself 'by drawing with a piece of chalk on the walls the figures of cocks and hens'. He seems to have stayed for a year at the school, and no doubt, with his eager curiosity and his need to master whatever problems came up, he worked hard and increased his capacity to read, laying the basis of the deep interest in poetry which possessed him all his life.

At Brentford he again had a view of the Thames, but a very different one from that which he had learned to know so well from the Savoy. Here the river wound through a landscape that could be interpreted in terms of the recently evolved aesthetic of the Picturesque. 'Picturesque' was a term first applied to a view that suggested a work by a painter such as Claude, then to one that was worthy of being transferred straight on to canvas; but, partly through arguments connected with landscape gardening, it came to mean the particular aspects of a view, its irregularities and roughnesses, its individual character. As the poet Shenstone insisted, 'Ground should first be considered with an eye to its peculiar character: whether it be the grand, the savage, the sprightly, the melancholy, the horrid or the beautiful ... We form our notions from what we have seen; and though, could we comprehend the universe, we might perhaps find it uniformly regular; yet the portions that we see of it, habituate our fancy to the contrary.' Gilpin, exponent of the Picturesque, remarks that the Thames in the Brentford area formed a noble bay, 'and when we draw near the righthand shore, and can get such a foreground as we had at Thistleworth, we may have a good view. Such a one we had towards Brentford, when we attained a foreground from some of the lofty trees of Richmond Garden.' Turner gained a lasting love of the westerly reaches of the Thames. Later he was to trudge over the area of Putney and Twickenham, Bushey Park and Hampton Court, noting the entrances of stately mansions and the reflections of cattle in the river.

We see that by the age of twelve Turner had absorbed impressions of nature that were to be of fundamental importance for his

[7]

development as an artist. He knew the Thames in London, with its shipping and sailors, and had seen the endless moods of the river, of water flowing gently or tossed into furious shapes, with all the varieties of light-effects. Margate gave him the vision of waters extending far out and developing much larger forms of agitation and swirling surge. Brentford gave him a chance to appreciate the gentler expanses of green landscape and the rich meanderings of the river. What was yet lacking was the experience of mountainous country. Covent Garden must not be omitted from the factors coming together to form his characteristic responses. What we may call the organized space of Inigo Jones did much to build his sense of structural systems in the world he looked at, and the hurrying crowds of intent people gave him the awareness of humanity as an essential element in any vision of nature. People, in small or large groups, appear in most of his landscapes and, even when the human element is not immediately evident, Turner was always aware of an inseparable active relation of humanity and nature, both reacting on one another in endless ways.

We may further look at children in his drawings or paintings to get the full sense of his own childhood. We find in his art no rosy-cheeked cherubs. Instead we see youngsters with sharp faces, shrewdly aware of the hard world surrounding them, in which they must find their places. Some lines of his verse describe a village-school, 'to urchins dreadful'. A boy sits on the dunce's stool

> In doleful guise twisting his yellow hair
> While the grey matron tells him not to look
> At passers by thro' doorway, but his book.

Children are shown busy at all sorts of labour. They harvest, glean, pull a plough, drive cattle, look after sheep, feed hens, gather sticks or straw, lead carts, mind babies, attend to fires, draw water, fill a kettle, water horses at ponds, open tollgates, accompany drivers so as to learn how to hold reins or flick whips. Both in England and on the Continent they are yoked to twigcarts. A sketchbook of 1807–9 records: 'Children picking up Horse Dung, gathering Weeds, Driving asses with coals.

[8]

Milk carriers to Manchester. Yorkshire with Barrels, Pigs, Geese, Asses Browsing upon Thistles. Asses going to Coal Pits.' Ships have boy-drummers and other youngsters in the crew. The children are among the farmers and their wives round the agents at the harvest-home table. In a cottage room (drawn in Turner's teens) we see three children before a fire, girls playing with a cat, a kneeling boy who breaks twigs. Boys build defences on a tombstone and hurl books at one another. Hoops and kites are used at games. A girl puts a bonnet on a dog. In *Kilgarren Castle*, watercolour for *England and Wales*, a woman and child with hoop stabilize the curves of banks and boats below; the hoop represents accord. In the four watercolours of Richmond a girl with a playful dog in the foreground gives the key-balance. There is a special interest in games involving wind and water. 'Children fishing with clothes tucked up. Love instead of fishing – blue apron. Water cart', 1823–4. The last sketchbook shows children on the seashore; they have lost their little boat. In 1840 Turner sent to the RA a painting of children and dogs on a beach: *The new moon; or 'I've lost my boat, you shan't have your hoop'*. An 1834 sketchbook has 'Boys with a dish floating for a Boat'.

As a grown man, with a strong veil of withdrawal and aloofness over his naturally warm-hearted nature, it was with children that he could most unbend and let himself go. He scribbled at the side of a sketch of a little girl running, 'My dear'. Clara, daughter of his watercolourist friend W. F. Wells, wrote of him, probably in his early twenties:

> Of all the light-hearted, merry creatures I ever knew, Turner was the most so; and the laughter and fun that abounded when he was an inmate in our cottage [in Kent] was inconceivable, particularly with the juvenile members of the family. I remember one day coming in after a walk, and when the servant opened the door the uproar was so great that I asked the servant what was the matter. 'Oh, it's only the young ladies (my sisters) playing with the young gentleman (Turner), Ma'am.' When I went into the sitting-room, he was seated on the ground, and the children were winding his ridiculous long cravat round his neck; he said, 'See here, Clara, what these children are about.'

She adds, 'He was a firm, affectionate friend to the end of his life; his feelings were deep and enduring. No one could have imagined, under that rather rough and cold exterior, how very strong were the affections which lay hidden beneath.'

Robert, son of the artist C. R. Leslie, describes meeting Turner at Petworth in 1834. Robert was eight years old. One September evening he and his father saw a solitary man pacing to and fro, watching five or six lines that floated outside the water-lilies near the bank of the lake. As they neared they found it was Turner, who grew excited and fussy, trying to clear a line that had got fouled of a stump or root. The Leslies tried to help, to no avail. Turner said that he didn't care so much about losing the fish as the expensive tackle, which had cost half a crown. Leslie went to get a boat. The boy recalled, 'Turner became quite chatty, rigging me up a little ship, cut out of a chip, sticking masts into it, and making her sails from a leaf or two torn from a small sketchbook.' Later, as they walked to the house, he noted that the fish, which Turner carried with a finger through the gill, trailed its tail on the ground, and that Turner's coat-tails trailed almost as low. No other description brings out so well Turner's small and stumpy stature.

He loved fishing. It was an occupation he could carry out on his own, in a world of bushes and trees, watching the changing movements of the water, the varying light-effects. The Petworth anecdote shows him as the maker of the toy-boat, though he does it for a small boy. A poem of his describes the poor cottage-boy who, defying the rain and launching his paper-boat, 'acts like Britain['s] early race'; that is, he represents the hardy seamen who have won Britain her great name on the sea. In a poem drafted in 1809–11, Turner develops this idea in a complicated way. He takes Jason as the first shipbuilder and his Argo as the archetypal ship; he then identifies Jason with the worker building British ships, who eats 'his hard earn'd bread with heated face', his great work ignored while others gain all the honours. Why should not the British workman, he asks, go on to create new kinds of ships? He deals at some length with timber and the work applied to it, referring to Noah to bring out again the idea of reviving and extending the archetypal idea (Argo or Ark). He then describes the building of the new Argo and comes to her

launching day. Suddenly something goes wrong and Argo would have been wrecked unless the shipbuilder became once more the creative inventor, Jason, who is also the small boy launching his home-made boat in the Thames. About 1811 Turner wrote another poem on a toy-boat made by 'the little native wading in the stream'. Thus small beginnings give birth, he says, 'to the great Demagogues that tyrannize on earth'. What should be used for constructive purposes falls into the hands of war-mongers, men with a lust for power, who 'wield an iron sceptre uncontrould'. In 1811, at Bridport in his West Country tour, he closely watched the rope-twisting; his interest in hemp was connected with his concern for Britain's naval supplies.

The way in which he thus developed fancies round the boat of childhood brings out the way in which his mind worked. There was a continual imaginative play of thought and image round objects that interested him, and round the various facets of his own experience. Early experiences kept reasserting themselves at new levels, taking on new meanings in a wider sphere of references.

But now we must turn back to what was happening to him in his early teens. We are told that his father used to boast, 'My son, Sir, is going to be a painter.' If his words are correctly reported, Turner had already decided to work in oils, since watercolours were still looked on as mere tinted drawings. As far as we know, however, his first oil came in 1795. No doubt he began drawing very early; we have noted that some sketches seem to survive from his first visit to Margate. We know little of his teachers, though names suggested include Thomas Hardwick, architect of Brentford; Palice, flowerpainter; John Raphael Smith. He certainly worked under Thomas Malton, an architectural topographer, who had developed a clear, lively style, dealing with street-scenes and recent buildings. One thing we can be sure of: he was working very hard. In December 1789, at the age of fourteen, he submitted a study of a cast to the Royal Academy, and was accepted as a student. This year he also seems to have made his first journey, of the kind that he carried on strenuously for the rest of his life. He went with a sketchbook to visit his uncle who had moved from Brentford to Sunningwell, near Oxford. His drawings were mostly of buildings in the area, but

[11]

he made one sketch of Oxford seen in the distance along the Abingdon Road, and then did a watercolour of the view.

There was a strong architectural bias in his early training. We noted how the planned enclosed space of Covent Garden affected him very powerfully and pervasively; and though his development led him into very different areas, there was a part of him that was drawn to clear architectural forms, especially of a directly classical kind. Clara Wells tells us, 'I have often heard Turner say that, if he could begin life again, he would rather be an architect than a painter.' It seems that he designed the gate-houses for his friend Fawkes at Farnley in Yorkshire. Effie, wife of the painter Millais, remarked in 1851 that he 'had a fancy for architecture but the lodges which he planned at Farnley are a sort of heavy Greek design, and not quite a success'. We cannot, however, imagine his dynamic vision ever being content with architecture alone. What he did was to use his architectural sense to help him in developing complex but precise structures of form, light, colour in his work as it grew ever richer in its vision of reality.

2. First Steps

Turner went on working in the offices of various architects, but he concentrated on the Royal Academy. From 1789 he attended schools there, and showed at the spring exhibitions, his first watercolour being in 1790. Now, as always, he was a hard worker. He told an enquirer that his working day began 'when you were still in bed'. He went on travelling energetically in England, by foot, by coach, or on horseback, then on the Continent, in tour after industrious tour, of which we have his sketchbooks as the rich and varied record. He was elected to Associateship in 1799 and became a full Royal Academician in 1802, at the age of twenty-six. Though he kept studiously to himself, he carried out painstakingly all duties that came his way. He was elected to the Council in 1803; and in 1807 he became Professor of Perspective. He took the RA shows very seriously and sent in works almost every year, right up to the end of his life. Mostly he sent new works, but at times he showed works that he had finished long before or had reworked. In 1850, the year before his death, he contributed four quite novel and powerful works. By then he was the oldest surviving Academician. But despite his high prestige and the fact that he had been contributing works for some sixty years (chequered, it is true, by many attacks and controversies as well as praises), he was never made President, though he was Acting President in 1845 when Sir Martin Shee was ill. His unconventional and at times uncouth manners, his cockney accent and odd way of speechifying, the unpredictable element in his character and his actions, made the Academicians afraid of putting him in charge.

[13]

Mixed with his reticence and aloofness was a keen ambition, and he may well have both wanted the presidency and been afraid of it. His general attitude to the RA was determined by the strong views he held that originality should proceed out of as thorough a mastery of all aspects of art as was possible and not be prematurely developed out of partial skills. Hence the need he felt to get all that was possible out of the RA, while seeking his own way forward and being ready in the last resort to stand by positions that were criticized or ridiculed. His attitude was clearly and emphatically stated when in 1846 the history-painter Haydon, who had attacked the RA for corruption, committed suicide. The artist Maclise called on Turner to tell him the news. To his surprise Turner scarcely paused in his painting, growling between his teeth, 'He stabbed his mother, he stabbed his mother.' Maclise at first thought Turner was accusing Haydon of killing his actual mother; but Turner refused to explain, slowly chanting in a deep voice, 'He stabbed his mother.'

Haydon had not been an Academician, and Turner considered that he should have recognized the key importance of the RA. His comment brings out how the practice of art, connected for him unbreakably with the Academy, turned that body into something intensely personal as well as importantly public, a body with which he could, indeed must, identify himself emotionally, even if at the same time he needed to fight in it for his own individual outlook and expression. Together with his art and his father (while he was alive), it constituted his family. We see how deeply and permanently he had been affected by the tragedy of his mother, which wrecked his home-life while making him feel all the more urgently the need of an organized group with which he could identify himself. We noted how hard he took the loss of his father; he said that he felt as if he had lost an only child. He was alone as never before, needing his surrogate mother, the RA, with increased urgency.

His early training had made him an expert topographical draughtsman. His drawing in the RA of 1790 was of the Archbishop's Palace at Lambeth, a subject he had drawn the year before for Hardwick (who had already commissioned a drawing based on the Oxford sketchbook as well as another design). In 1791 he toured the West Country, visiting John Narraway, his

[14]

father's old friend, at Bristol. Now, aged sixteen, he grew interested in wild scenes such as the Avon Gorge or a ruined chapel on an island in the Severn. He added a romantic and picturesque element to his designs for buildings such as Malmesbury Abbey with its ruinous Gothic. In 1791 he showed in the RA two works which brought out the contrasted elements in his outlook: *Malmesbury Abbey*, worked up out of his sketches and developing the Gothic theme, and *The Pantheon, the morning after the fire*, a London building drawn in Malton's style. The latter showed not the hurly-burly of the conflagration, but the damaged building in the mild morning glow, the glitter of the ice that had followed the fire, the sightseers in the foreground.

In 1792 he again visited South Wales, drawn to the falls and gorges of the Upper Wye Valley and making his first study of Tintern Abbey, which Gilpin had stressed in his picturesque *Wye Tour* of 1783. There was increased precision in his drawing, and he drew Tintern from a low viewpoint that gave the effect of a soaring structure. An itinerary in his sketchbook said, 'To St David's and back, 36 miles.' He added, 'No inn.'

He had established the general lines on which he was to work through the 1790s. He produced watercolours based on his increasing store of sketches, which he showed at the RA. There were ten in 1796. He went on fusing topographic and picturesque in a style increasingly his own, though linked with the trend of advanced artists like Edward Dayes and J. G. Cozens (who went mad in 1794). His colours were mostly low-toned blues, grey-greens, blue-greys. His widening interests appear already in a 1791 sketchbook, where, as well as designs of buildings and trees, we see copies from Ruysdael and Gainsborough, studies of a flayed figure, a cherub's head, and a composition on the death of Ophelia. He was soon seeking to bring together several ideas or motifs in a scene, whereas the usual topographic method was to concentrate on one important feature. Soon he shows a feeling for movement: in trees, clouds, and such outlines as those of cliffs. All the while his sense of design was growing stronger.

He moved restlessly about through the 1790s. He was at Oxford and in Kent in 1793; in the Peak District and the Midlands in 1794; in the Isle of Wight and South Wales in 1795; in the Lake District and other areas of northern England in 1797; in

North Wales in 1798 and 1799; in Kent, April 1798. The one quiet year was 1796, when he seems to have done little drawing and to have stayed in Brighton, perhaps watching the sea. From 1794 he was commissioned to do drawings for engravings: a line of work that was to be of great importance in his later career. Already prints were bringing him into the ken of an enlarged public. He began with town-views (Rochester, Chester, Ely, and so on) for *The Copper-Plate Magazine* and *The Pocket Magazine*. In 1795 he was asked for ten views of the Isle of Wight by the engraver John Landseer, with whom he was associated for several years. Landseer, like many engravers, was not afraid of the advanced trends in art. Turner had not yet evolved what we may call the short-hand system of his later sketches in which he set down in very abbreviated ways the elements of a landscape that he wanted to recall, elements that he had noted as the most characteristic or attractive of the scene; but his methods grew steadily simplified. He had begun to gather a number of patrons: Hardwick, Lord Maldon, Sir Richard Colt Hoare, Edward Lascelles, Bishop of Ely. In 1798 he told the artist Farington that he had 'more commissions than he could execute'; in 1799 he had 'sixty drawings now bespoke by different persons'.

He was keen to lose no chance of grasping any of the main trends of the time and learning how to adapt them to his own needs. He had mastered the topographical and picturesque angles of approach, was absorbing romantic trends while strengthening his realistic vision, was extending his watercolour techniques, and at the same time was studying the Dutch masters of sea-scapes. In 1795 he was one of a group of young artists including Girtin, known as the Monro Academy, where he worked for three years. Dr Monro had a house in the Adelphi Terrace, close to Turner's home, overlooking the Thames. Each artist worked for three or four hours, being paid 2s 6d or 3s 6d a day, plus supper. The task was to copy outline drawings and develop them into finished artworks. The originals included works by Dayes, Hearne, Cozens, also some by Canaletto (lent by J. Henderson). Turner and Girtin were both affected by Canaletto's firm rhythmic outline. (Farington had been influenced by Canaletto, but in a staid sort of way.) Girtin, son of a Southwark brushmaker, was talented and young like Turner. The pair of them dealt with

works by Cozens with his airy feeling, grey-greens and browns, and melancholic mood. They both learned to unify a scene, realized in various aspects, with the lights. Farington says that Girtin made the outlines; Turner washed them in. The themes included romantic scenes of Switzerland and Italy. The two young artists learned to turn out copies bolder and livelier than the originals, and the collaboration must have excited Turner. Girtin's watercolours were in some respects ahead of Turner's: in the selection of an effective angle that stressed romantic feeling, breadth of treatment, warm harmonies. But Turner was making his art subtler all the while. In 1794, when not yet nineteen, he showed full mastery of the picturesque style in *Tintern Abbey*; in 1795 his drawing of the Bishop's Palace, St David's, in Wales, based on a slight pencil sketch, showed him entering vitally into the principles of architectural construction, not merely recording and manipulating what he saw.

In 1796 he at last broke into the world of oils with *Fishermen at Sea*. The engraver Bell, who went round with him on some of his tours at this time, saw in the work 'a view of flustered and scurrying fishing-boats in a gale of wind off the Needles'. There is a dark green tonality, and the moon amid the clouds with the heaving sea makes up a vortex. Turner was drawing together a number of influences, and was making a break from his water-colours, even the most advanced ones, in the nuances of tone, the subtle and complex range of light and shade, with the moonlight coming down through a cloud on to the heaving mass of water: all the elements held together in the tension of the vortex. The light of a lamp reflected in the sea is distinguished from the moonlight; the two sources of light are contrasted, warm and cold. Turner may have had Rembrandt in mind, but the direct link is with painters of night-scenes like Wright of Derby or the French artist C. J. Vernet who liked to depict shipwrecks. (Wright did not cloud his moon as Turner did, though both painters achieved a smooth leathery finish. Wright's *Moonlight with a Lighthouse* had been shown in 1789, the year Turner went to the RA as a student.) He is also no doubt thinking of de Loutherbourg, whose exaggerated *Shanklin Cove* was shown in 1794, and whose drawing of boats by the Needles weakly antici-pated Turner. (We are told that Turner, taking up a print of a

[17]

sea-piece by van de Velde of a ship tossed by wind and wave, remarked, 'This made me a painter.')

The same year, 1796, brought to a head his studies of medieval ruins in three works depicting interiors in a fine interrelation of light and shade, with the diagonals of light opposed to those of perspective. The watercolour of Llandaff Cathedral shows a subtle play of light and shade over masonry in a chiaroscuro bringing out the mass and structure of the building. A very different work is *Internal of a Cottage*, which is Dutch in its humble intimate detail and light-concentration. In 1797 he did another painting of *Moonlight, a study at Millbank*, affected again by Wright and Vernet. After that he turned to a more varied and expressive use of paint which involved rich impasto and an attempt to link what was expressed by the way it was expressed. His movement into oil-painting showed a new sense of mastery. Oils were considered far superior to watercolours, and he would need to master them to become an Associate and full member.

He did not do much work in the summer of 1796; he may not have been well and, as we saw, may have gone to Brighton. There is a suggestion of a love-affair, though no definite evidence. Thinking of oils, he was using body-colour on tinted paper. In 1797 he went over several areas of northern England. He had no commissioned drawings to do there, and wandered from Derbyshire through Sheffield, Doncaster, Wakefield, Leeds (Kirkstall Abbey), Durham, on to Tynemouth, Norham, Melrose, dealing mostly with abbeys and castles. He then moved to the Lake District in quest of the picturesque. He made a use of pale luminous washes that was linked with a sense of poetic subtlety which he underlined with quotations from Thomson's *Seasons*, for instance in his pictures of Norham and Dunstanborough Castles (shown in 1798). His new assurance appears in the way, at Berwick-on-Tweed, he depicts a small boat somewhat off the central axis as it goes into the sunrise. He still did some topographical drawings, though looking for a striking angle of view, one that was more capable of defining mass. Gothic structures still intrigued him, as in some interiors of York Minster. In *Buttermere Lake* (shown 1798) he tried to go further in mastery of oils. He was trying to set himself up against Richard Wilson who had died in 1782 and who had struggled to bring the grand

manner into English Landscape. We see his awareness of Wilson in the handling of the paint and the little bright flecks, blue, red, yellow, though the banks of shadow look rather to Cozens's breadth of tone. He was so keen to express the retreating landmasses that the work looked heavy to Hoppner, a modish portrait-painter, when he saw it in Turner's studio. Turner was 'a timid man afraid to venture'.

The way in which, in the midst of immensity, Turner liked to stress the human presence, is shown in *Buttermere* by the small rowing boat in the centre of the foreground water, caught in the final glimmering curve of the rainbow.

In 1798, as well as *Buttermere*, he exhibited the two paintings of the isolated castle mentioned above. After the show he went off to North Wales, wanting to get a good look at Wilson country, and to study more castles, Harlech, Caernarvon, Doldabern. The studies related to Wilson were, however, few; he concentrated on colour analyses, at times concerned with detail, at times seeking a new economy in the handling of paint. The sketchbook with work around this period shows much interest in boats on calm or rough water (perhaps at Brighton) and a variety of themes: interiors, sunsets, snowscapes, animals. We find him reversing his watercolour methods as the result of working in oils; he works from a dark ground to highlights instead of seeking to intensify the density of transparent colours on white paper, and thus achieves a stronger range of tones. His paint, 1798–9, was growing freer, rougher in texture, to give a direct sense of the objects depicted or of the flicker of light, of variations in the movement of differing levels of space, sea and sky, of time itself at work in the elements and totality of a scene. In watercolours he was experimenting with the use of blue paper washed with red-brown tone; he was trying out chalks, body-colour, pen-and-ink, often in original combinations. A few years later, 1804, Farington described his watercolours:

The lights are made out by drawing a pencil [brush] with water in it over the parts intended to be light (a general cloud of dark colour having been laid where required) and raising the colour so damped by the pencil by means of *blotting paper*; after which with crumbs of bread the parts are

[19]

cleared ... A rich draggy appearance may be obtained by passing camel Hair pencil *nearly dry* over them, which only *flirts* the damp on the part so touched and by blotting paper the lights are shown partially.

He was ready now to use any unconventional methods to get effects he wanted. Farington also tells us, 'Turner has no settled process but drives the colours about till he has expressed the idea in his mind.' A series of studies of Caernarvon Castle begin with a blue wash and the use of white, and build up to rich colours on a red-brown basis, yellow and gold brown. Here the watercolours seem to be using methods devised for oils, but keep their own character. In 1799 his watercolour of the Castle showed darkish shapes asserting themselves, moving, in an ambience of half-reflected light, with an orange sunset burning over all.

A 1798 sketchbook shows how much he was thinking of songs and poems. As well as a herbal remedy for cuts given by Miss Narraway, it includes a song, 'Tell me Babbling Echo why', two nautical ditties about Jack and his Nancy, and a poem about his fatiguing travels in the hills. 'Cottages appearing as he's nigh to drop./O how briskly then the way worn traveller/Threads the mazes towards the Mountains top ...' The sketchbook deals with the docks at Bristol, distant mountains, ruined castles and abbeys, town with distant mountains, a blasted tree, rocks, clouds round the sun, tree-trunks, a range of mountain tops, a waterfall, clouds, cliffs, castle in mid-distance with distant mountains. He was trying to learn French, as another 1798 sketchbook shows: 'Learn. Substantives No Comparison but by Adjectives, as, good bonne and Beau, fine Positive Plus Beau finer Comparative le Plus Beau Superlative of Finer...' The same book includes drawings of Pembroke, Powis and Caernarvon Castles; fishing-boats with distant castle on rock; Stourhead, Wilts; interior of St Paul's with figures; interior of Covent Garden Theatre, from the gallery, with figures; ruined castle with cattle and trees; tracery of windows; Gothic arch; river with distant mountains, and so on. His interest in views and objects was omnivorous. On 26 September Farington recorded, 'William Turner called on me. He has been to South and North Wales this summer – alone and on horseback – out 7 weeks. Much rain

but better effects on clear day and Snowdon appears green and unpicturesque to the top.' That Turner had been much in the rain is evidenced by an unfinished watercolour of Cader Idris which shows where the raindrops fell.

In 1799 he again tried to impress viewers at the RA show, putting in four oils and seven watercolours. He had applied to become an Associate after his return from Wales in 1798, but was beaten. In any event he was still under the minimum age. This year (1799) saw the foundation of a Sketching Society, with Girtin as a leading member, 'for the purpose of establishing a school of Historic Landscape, the subjects being designs from poetic passages'. (The main categories of painting were consi-dered to be History and Portraits, with Landscape as a minor third. The most important themes of History were mythological and ancient–heroic, though modern historical events such as battles were also depicted.) We shall see how Turner's attempts to develop Landscape and gain it a high place were closely connected with his struggle to master History. The aims of the Sketching Society may well have quickened his sense of what was at stake if he were fully to elevate Landscape. But though he must have been strongly sympathetic he did not join Girtin. No doubt he felt that he must concentrate his efforts inside the RA.

Among the 1799 exhibits was a (lost) watercolour illustrating Langhorne's poem, *Visions of Fancy*. Probably there he showed for the first time a work with all topographical basis omitted and with landscape built up out of his own ideas. Probably about the same time he produced his *Aeneas and the Sibyl, Lake Avernus*. Here he turned at last to Historic Landscape, drawing on Virgil, and attempted to take over the schemes and methods of the classicist Claude. Also, using the works of artists like Claude, he tried to express the light and colour of Italian landscape, basing his picture on a sketch made by his patron Colt Hoare on the spot. His success was slight, but he had embarked on a course that was to beget many of his greatest works. He was in fact looking at Wilson rather than Claude, but he had realized how necessary it was for him to be able to incorporate the tradition that Claude embodied. William Beckford was a patron of his, for whom he did five drawings of his mansion, Fonthill (shown in

[21]

the RA of 1800). In the early spring of 1799 Beckford bought the two Claudes brought from the Altieri Palace in Rome, and allowed artists and connoisseurs to see them at his house in Grosvenor Square. On 8 May Farington met Turner there. Deeply stirred, Turner told him of *The Sacrifice to Apollo* that 'he was both pleased and unhappy when he viewed it, it seemed to be beyond the power of imitation'. Turner was there again the next day. His picture of Aeneas shows that he already knew Virgil's epic, no doubt through Dryden's translation. The idea of Carthage, its queen Dido, its hero Hannibal, was to recur at important moments in his development, in 1812, 1823, 1834, and 1850, in his final subjects. In *Aeneas* he brought together many elements: Wilson, whose *Destruction of Niobe's Children* was the outstanding example of History Landscape in English art; Claude; the studies of castle-ruins; long vistas over water. The construction as yet was rather tamely symmetrical. But the synthesis he was attempting was seen by discerning critics. *The True Briton* wrote of his *Harlech Castle* that it 'combines the style of Claude and of our own excellent Wilson, yet wears an aspect of originality that shows the painter looks at Nature with his own eyes'. Thomas Greene of Ipswich, a man of literary interests, had noted in his diary in 1797 a sea-view by Turner: 'fishing vessels coming in, with a heavy swell, in apprehension of tempest gathering in the distance, and casting, as it advances, a night of shade; while a parting glow is spread with fine effect upon the shore . . . I am entirely unacquainted with the artist; but if he proceeds as he has begun, he cannot fail to become the first in his department.' Now in 1799 he wrote:

again struck and delighted with Turner's Landscapes: particularly with fishermen in an evening – a calm before a storm, which all nature attests is preparing, and seems in death-like stillness to await: and Caernarvon Castle, the sun setting in gorgeous splendour behind its shadowy towers: the latter in water colours; to which he has given a depth and force of tone, which I had never before conceived attainable with such untoward implements. Turner's views are not mere ordinary transcripts of nature: he always throws some peculiar and striking *character* into the scene he represents.

[22]

We see that Turner at this phase is appreciated by the most perceptive sections of the public. He was, as we noted, studying Wilson's works and seeking to match himself against them, but at the same time he was diverging from Wilson. It is of interest to compare his *Kilgarran Castle* with a painting by Wilson of the same subject (certainly unknown to him). Wilson's work is cold in tone, and there is a single strong movement into the distance along the converging banks of the river, which do not meet. In Turner's work the banks come together (as they do in a pencil-sketch and three watercolours), producing variously angled Vs. His painting showed 'hazy sunrise, previous to a sultry day', and the light is drawn down into the big cleft with its V-shape reflected upside-down in the water. The effect is given of a rhythmic movement of planes into the luminous cleft, which balances the clear sky on the left and the misted ruins on the right. There is an impression of a swinging-round of vanes, which gives a dynamic touch quite lacking in Wilson. This sort of effect, though lacking the force it gains in Turner's later work, already distinguishes his vision. He already has a liking for a correspondence of forms, especially of earth and sky in water. To take a late instance, in *Campo Santo, Venice* (1842) the white butterfly-winged sails of the boat, projecting into the sky, are reflected in the water, where the drawn-out image is the main of several verticals that draw our eyes up into the light.

At the RA in 1799 he showed a *Battle of the Nile* (now lost). This work, his first venture into direct history (and recent history at that: the battle was fought in August 1798), may have led him into taking over the job of designing the paintings for a panoramic view of the same event which was staged at the Naumachia (Seabattle), Silver Street, Fleet Street. The notice stated: 'The whole designed and executed by, and under the direction of Mr Turner.' We have no proof that the artist was our Turner, but it seems very likely that it was he. (Girtin painted pantomime scenes at Covent Garden, a dropscene, and a huge panorama of London exhibited in 1802.) Such views had been popular for some time, using themes such as London, the Review of the Grand Fleet at Spithead, the Battle of Seringapatam. On 13 June 1799 *The True Briton* had an advertisement for *The Blowing up of*

[23]

L'Orient, 'with the Representation of the whole of the battle of the nile, aided by the united powers of Mechanics, Painting and Optics, from its commencement on the Evening of Attack, until the glorious termination on the ensuing morning'. Events were shown in elaborate detail.

Behind the panorama lay the stage-experiments of de Loutherbourg with his mechanism of 1781, the Eidiphusikon, which produced imitations of various light-effects, atmospheric effects of different times of day: dawn seen from Greenwich Park, storm over London, sunset in an Italian port, a Mediterranean moon-scene, shipwreck, Niagara Falls, as well as a grand Miltonic display of Satan marshalling his troops and the building of Pandemonium. Turner could not but be greatly interested in such spectacles with their light-imitations and depictions of nature in violent moods. In December at the Naumachia there was 'a truly grand and awful Representation of a Storm at Sea, accompanied with Thunder, Lightning, Rain, &c.' and in February came 'Eruption of Mount Vesuvius Vomiting forth Torrents of Fire, environed with spiral streams of Burning Lava, and in her utmost state of Convulsion, as well from across the Bay of Naples'. Whether he had a hand or not in the Storm or the Eruption we do not know, but he would certainly have been much stimulated. In 1800 he showed at the RA his violent *Seventh Plague of Egypt*.

The memories of the Bristol Narraways give us a picture of Turner as he was in these years. One of them wrote that he was difficult to understand and disinclined to talk, yet people could not help liking him. He had 'no faculty for friendship, and though so often entertained by my uncle he would never write him a letter, at which my uncle was often vexed'. He was 'exclusively devoted to drawing . . . and had for music no talent'. He took no notice of anything in the house, went out sketching before breakfast, and at times before and after dinner. He wasn't particular about turning up for meals, was careless and slovenly in dress, and stayed at home in the evening, 'apparently thinking'. He wasn't polite at table, but was generous in giving sketches away. He borrowed a pony to ride into North Wales, with saddle, bridle and cloak, but never brought it back. So he was called an ungrateful little scrub. (Turner was scrupulous

[24]

about loans and such things; there must be some story about the pony of which we know nothing.)

A clergyman named Robert Nixon had some years back noticed Turner's drawings in the barber's shop. Impressed, he had taken the lad to the artist J. F. Rigaud who encouraged him and introduced him to the Royal Academy as a student. Turner later gave Nixon some lessons in landscape painting, and in April 1798 he visited him at Foots Cray, Kent. Rigaud's son, Stephen, was already there, and the trio went on a sketching trip for three days. Stephen stresses that Turner was quite uninterested in religion. He and Nixon, returning from church, were grieved and hurt to find him 'shut in the little study, absorbed in his favourite pursuit, diligently painting in water-colours'. On their trip they breakfasted at an inn, but Turner objected to wine being asked for: 'No, I can't stand that.' Stephen insists that Turner was too mean to pay for it. 'I mention this anecdote to show how early and to what an extent the love of money as a ruling passion already displayed itself in him, and tarnished the character of his incipient genius; for I have no hesitation in saying that at that time he was the richest man of the three.' This year, 1798, saw a financial crisis and was a very difficult one for artists; anyway Turner may merely have wanted to keep a clear mind. But the view of him as mean and dominated by a need to hoard his cash, though common enough throughout his life, had no real basis. He could be very generous, though it is true that a thrifty concern to guard against the least effort to cheat him of what he felt to be his just deserts made him at times suspicious and grudging; he inherited to the full a petit-bourgeois need to indulge in no unnecessary spending and so hoard what he could. (We may add that he does not seem to have cared much for wine. His tastes in drinking are those stated in 1834 in a sketchbook of the Rhine tour: 'Bread and cheese. Bottle of ale. Dinner, 2 Small Bottles of Stout. Glass of Gin and Water.')

Soon after his visit to Kent there occurred an event of great importance in his life. He had come to know John Danby, a leading glee-composer, who lived in Covent Garden, at 26 Henrietta Street. Danby's songs were in a lush pastoral style. A Catholic, he was also organist at the Chapel of the Spanish Embassy. His wife, Sarah, seems to have been an actress or

singer; she bore him four children. For some time he had been suffering badly from arthritis, and on 16 May 1798, at the age of forty-one, he died on the way home from a concert given for his benefit. Sarah published a posthumous collection of his glees. Turner gave her all the help he could in her difficult circumstances and they became lovers. With his intense secretiveness, he managed to keep their relationship hidden, but she seems to have remained his mistress till some time in the 1820s. She bore him two girls, Evelina and Georgianna. The wife of Danby would presumably have been well-bred, educated. One of her girls by Danby married H. G. Nixon, organist of St George's Cathedral, London, so she seems to have kept up her place in the musical world. Turner's daughter Evelina married Joseph Dupuis, who had a good post in the consular service. Dupuis wrote in 1853 that she and her sister had been well schooled and brought up 'in the expectation of always enjoying a respectable position in society'. As Evelina was married in 1817 she must have been born soon after Turner and Sarah came together, perhaps in 1799. Despite the many scribbles in his sketchbooks, the only reference to her he ever seems to have jotted down was: 'Mrs D. 4–4', that is four guineas to Mrs Danby. We may assume that the relationship stimulated his interest in music. (Two Danbys occur in the list of subscribers to the posthumous glees, but that is all we know of them.) Otherwise we have no clue as to what Sarah meant to him. His intense and well-organized secrecy, his inability to marry the mother of his daughters, his overwhelming fear of any open connection with women, must go back to the intense strains of his early family life. His mother with her violent outbreaks made it impossible for him to enter into any normal relations with women. He seems even to have taken little interest in his daughters after they had grown up, or to have been afraid of any close links with them. About the time that Sarah became his mistress, things must have been very difficult at home, with his mother's outbursts worsening. For it was in 1800 that it was found necessary to put her in a lunatic asylum.

It was not a withdrawal from sex that made him fear any open union with a woman. His sensuality was clearly very strong. Among the love-poems he composed and scribbled in his sketchbooks is the following:

Be still my dear Molly dear Molly be still
No more urge that soft sigh to a will
Which is anxious each wish to fulfill
But I prithee dear Molly – be still.

By thy lips quivering motion I ween
To the centre where love lies between
A passport to bliss is thy will
Yet I prithee dear Molly be still

By thy Eyes when half closed in delight
That so languishingly turn from the light
With kisses I'll hide them I will
So I prithee dear Molly be still

By thy bosom so throbbing with truth
Its short heavings to me speak reproof
By the half blushing mark on each hill
O Molly dear Molly be still

For Love between them takes his rest
I am jealous of his downy nest
My rival in his lair I'll kill
So I prithee dear Molly lye still

By the touch of thy lip and the rove of my hand
By the critical moment no maid can withstand
Then a bird in the bush is worth two in the hand
O Molly dear Molly I will

And there is a variant stanza:

By those Hairs which hid from my sight
Those sweet eyes when half closed with delight
Then with kisses thy lips I will pill
Yet I prithee dear Molly be still

Thornbury tells that Turner was given to visiting brothels in the
London Docks, and that he made furtive trips to Wapping where
among other things he drew whores. (He certainly went to
Wapping to get in rents from property that he inherited from his

mother's family; but it is possible that he used the visits to let himself go in low company as a relief from the respectability of his normal way of life.) The drawings are gone, but they may have been in the books with 'grossly obscene drawings' which were burnt, as Ruskin tells us, in the latter's presence at the request of the National Gallery trustees, in December 1858. Ruskin was horrified at works that seemed to him to represent total moral dereliction. He inscribed one sketchbook: 'They are kept as evidence of the failure of mind only.' We have three small sketchbooks with metal clasps. One holds drawings of people fishing at a weir. Then we meet pages on which red and grey washes have been dashed, swelling into floods of dark hue. We make out embraces going on in curtained beds in a diversity of postures and entanglements. We may surmise that the dark-toned bursts in Turner's later work held for him an emotional suggestion of such obscurely hidden embraces and tumbling encounters, desperate, fading away into a lost isolation of brooding satisfactions and frustrations.

In late 1798, after having begun his liaison with Sarah, he clearly felt that he must consolidate and in some ways change his position in the art world, his way of living. He wanted to make sure of becoming an Associate of the RA and, despite his usual reticence, he called on Farington to discuss the matter. Farington told him that he was sure to be elected. Turner then described his present situation, or as much of it as he thought suitable to discuss with Farington. 'He said that by continuing to reside at his Father's he benefited him and his Mother; but he thought he might derive more advantages from placing himself in a more respectable situation.' He had more commissions than he could execute and earned more than he spent. Farington advised him to carry on as things were till he had laid aside a few hundred pounds; then he could confidently 'place himself in a situation more suitable to the rank he bears in the Art'. Turner no doubt, with his frugal, even ascetic habits, had several hundred pounds in hand, but he was not likely to tell Farington that.

Later that day Farington called at the barber's shop in Maiden Lane, and found Turner's apartments 'small and ill-calculated for a painter'. Turner showed him two books of sketches from nature, 'several of them tinted on the spot, which he found, he

said, were much the most valuable to him'. He urged Farington to choose a sketch and offered to make a drawing or picture from it for him. Farington demurred, then said he would choose a sketch at some later time. Hoppner, Turner said, had chosen a Durham subject and told him that his pictures tended to be too brown. So, 'he had been attending to nature in order to be able to correct' that defect.

He had been seeing much of his fellow artists, perhaps to muster support for the election. He called on Farington again a few days later. There were twenty-four candidates for the two Associate vacancies; in the final ballot for the second vacancy Turner was elected by sixteen votes to twelve. He called at once on Farington to thank him for support; and when next Sunday the latter went to dine at Hoppner's he found Turner and Girtin there. By the end of the year Turner had already followed Farington's advice and taken lodgings in Harley Street. A mediocre sea-painter, Seeres, lived in the same house, with a flighty and extravagant wife whose presence seems to have worried Turner. Sarah Danby was a subtenant at 46 Upper John Street, not far away.

3. SWITZERLAND AND THE THAMES

In 1800 Turner exhibited *The Fifth Plague of Egypt* – properly the Seventh, as shown by his quotation: 'The Lord sent thunder and hail and the fire ran along the ground.' He had done the work a couple of years earlier. (The only part of the Bible that seems to have interested him personally was the Apocalypse, though in 1833–6 he made twenty-six designs, based on the drawings of others, to be engraved for Finden's *Landscape Illustrations of the Bible*.) The scene of *The Fifth Plague* is said to be based on a storm he saw in the Snowdon area. His model is Poussin, but he breaks the classical structures with his effect of a huge cavernous cataclysm, a fiery swirling sky with its hot lights swung down into the foreground tree. The vigorous handling of watercolours like *Kilgarran Castle* here bursts into a new dimension of violent rhythms, in which nature as a hostile force is powerfully realized. He prepared himself, the sketchbooks show, with drawings of Egyptian gods, Osiris and Apis, and of various archaeological oddments. His painting started off what later became the Apocalyptic school of John Martin and Danby, which in its turn reacted back on him.

In the same show he had paintings of Dolbadern Castle (his diploma piece) and of Caernarvon Castle. In the shows of 1798 and 1799 he had attached pieces of poetry to his pictures, using quotations from Thomson (four) and from Milton and Mallet. But now he used his own verses. Dolbadern Castle, with its ruined tower through which gleams an eye of light (suggesting the towers of Wilson), has five lines:

[31]

How awful is the silence of the waste,
Where nature lifts her mountains to the sky.
Majestic solitude, behold the tower
Where hopeless OWEN, long imprison'd, pin'd,
And wrung his hands for liberty, in vain.

The medieval tower in ruins thus stands for the defeat of feudal tyranny; it is a monument to the men who fought that tyranny. The lines for Caernarvon Castle, imitating Gray, make the same point.

And now on Arvon's haughty tow'rs
The Bard the song of pity pours,
For oft on Mona's distant hills he sighs,
Where jealous of the minstrel band,
The tyrant drench'd with blood the land,
And charm'd with horror, triumph'd in their cries,
The swains of Arvon round him throng,
And join the sorrows of his song.

At Dolbadern the human actors are not shown; the forces of resistance are symbolized in the rugged mountains and menacing tower, with the burst of light through the masonry representing the ultimate victory of freedom. At Caernarvon an old harper plays to the 'swains' whom he inspires; but again the main stress is on the mingled conflict and harmony of the natural scene and human structures. Turner had been deeply influenced by the ideas of a work like Thomson's *Liberty*; and though he was never political in the sense of belonging to a party, the concepts of freedom, independence, resistance to corruption had already entered into the heart of his world-view and continued to play a key part throughout the rest of his life. Disaster and convulsion were seen as deeply linked with the forces in society making for corruption and tyranny.

The Fifth Plague was bought by Beckford, and Turner could pride himself on already having a work hung near the Altieri Claudes. The Duke of Bridgewater commissioned a sea-piece to go as a companion piece to a work he had of van de Velde (5 by 7 feet). Turner produced *Dutch boats in a gale: fishermen endeavouring*

to put their fish on board. Black clouds on the left and a powerful wind bear down on the boat that heels over in the furious sea. Here he was drawing on Rembrandt for his effects, as was recognized by West, the RA President, who saw in the work 'what Rembrandt thought of but could not do'. The painting was shown in 1801, and with it was a watercolour of Pembroke Castle with a thunderstorm approaching, in which we see a topographical subject transformed in the direction of works like the Bridgewater sea-piece. In the same show he had three more watercolours and *The Army of the Medes* (lost) in which a whirlwind destroys the host in the desert. (Turner described the event 'as foretold by Jeremiah', 25: 32–33. But it is unlikely he ever read Jeremiah; he learned of the passage and its theme from a note to Thomson's *Ode on Aeolian Harp*, a poem that much attracted him.) The design seems to survive in a sketch that depicts a violent upspouting blast. The critic of *The Star* wrote that 'to save trouble the painter seems to have buried his whole army in the sand of the desert with a single flourish of the brush'; that of *The Porcupine* described the work as 'all flags and smoke'. Now Turner was outdistancing the taste of most of his contemporaries, and the abuse began, particularly voiced by the wealthy amateur, Sir George Beaumont, who made Constable his protégé. Still, when in 1802 there were three vacancies in the Academy, Turner won the first. He was aged twenty-six.

Before that, in 1801, he made his first tour of Scotland. He had taken rooms in Norton Street, Portland Road (while keeping on his place in Harley Street), in order to be near Sarah who was staying round the corner. His co-tenant was Jaubert, who had published Danby's posthumous glees. (It seems likely that he kept on the Norton Street rooms till 1809, and used them for his association with Sarah.) In June 1801, as he was preparing for Scotland, his relations with Sarah seem to have become rather difficult. Perhaps it was about this time that his second daughter was born. He complained to Farington of 'being weak and languid', then a few days later 'of imbecility – of feeling lost and worn out'. At last, however, he got away, travelling via York, Scarborough, Durham. He had meant to stay away three months, but was back in three weeks. He had made some sixty

[33]

drawings in pencil, chalk, white body-colour, studying hillsides and moors, rocks, woodland, clouds, in a style concerned to define the tonal relationships of each section in terms of a coherent whole rather than to stress the outlines of individual objects. Back in London he made a series of finished drawings which, Farington says, were 'much approved'. He told Farington that Scotland was a more picturesque country to study in than Wales; he considered the lines of the mountains were 'finer, and the rocks of larger masses'.

Now a full Academician, he wanted an impressive contribution to the 1802 show. He sent in two sea-pieces that carried on the theme of swirling billows and furious skies, with men in boats meeting the challenge of the elements. (One of these was bought by Lord Egremont of Petworth.) He also sent in another apocalyptic History Landscape, *The Tenth Plague of Egypt*, treating the deaths of the firstborn. Here, in the dark tumult of clouds, we are closer up against buildings than in *The Fifth Plague*, closer to the stricken human beings. In doing paintings such as these Turner was not indulging in mere sensationalism. He wanted to show humanity and nature in all their relations. In the sea-scene he had found the most satisfactory setting in which to define directly the struggle of men and nature. He was not uninterested in the industrial scene; in Wales, for instance, he had drawn the Iron Works at Cyfarthfa, and he was to tackle many such scenes. But it was in the ship that he saw most strongly defined human skill and constructive capacity in a ceaseless conflict with the elements. The pictures of disaster represented the moment when nature proved too much for human powers. Disaster or cataclysm was also coming to symbolize for him the moment when the creative and positive side of human endeavour was outweighed by the destructive and negative. We shall see how he tried to work out this problem in the snatches of his verse that he attached to his pictures, in the RA catalogues, under the heading *The Fallacies of Hope*.

There was also in such works as the *Plagues* the aim of gaining more respect for landscape painting by drawing it into the sphere of History, in which the main themes were mythological or ancient–heroic. We must not, however, see Turner as actuated merely by the wish to raise the status of Landscape; he saw the

material of History as vitally a part of the whole nexus of poetry, symbolism, depth and variety of meaning, which he felt to be essential for a fully developed art. Claude and Poussin were the two great artists of the past who had effectively produced Historic Landscapes, and they were therefore the subjects of close study on his part. He felt the need to understand what they had achieved, and to draw their vital elements into his own new synthesis. Landscape painting still had a relatively low status. Reynolds, after stating that history-painting dealt with man in general, portrait-painting with a particular man, went on to ask 'whether landscape-painting has a right to aspire so far as to reject what the painters call Accidents of Nature', that is, the particularities of a scene. The landscape-painter, he thinks, should be tied down to what we now call naturalism, a direct reflection of fact.

Shortly before the summer show of 1802 the Treaty of Amiens was signed, and for a while the war between England and France was halted. Now was a chance for artists to cross the Channel and see the magnificent collection of artworks, looted by Napoleon in his wars, in the Louvre. Turner, we saw, had been struggling to learn French; he was among the first to go, leaving on 15 July. He had two aims: to see the Louvre and to visit Switzerland, which he had studied in the Cozens drawings and which he knew by repute to be the land of mountainous sublimity and grandeur. We must recall that there was still no National Gallery in England; artists depended on chances of seeing the collections in rich houses and often knew famous works of the past only through engravings. War had cut off for many years the chance of seeing the artworks on the Continent.

Turner must have been excited too at the chance of sailing at last on the deep sea, even if only on such a short passage as that from Dover to Calais. The weather was rough and he had a difficult landing in France, as we know from his sketches and his painting, *Calais Pier, with French poissards preparing for sea: an English packet arriving*. One sketch has the comment: 'Our landing at Calais. Nearly swampt.' The confusion of the scene, actually experienced, is very different from the dignity of the ships bearing up for anchorage in the Bridgewater sea-piece. (Turner may have been thinking of Fuseli's picture, *William Tell*

leaping from a boat, engraved 1780; in his jottings we read: 'Willm Tell escaping from the Boat'.)

He travelled from Paris in a party who bought a cabriole for thirty-two guineas and later brought it back to Paris 'to dispose of'. They were 'well accommodated in it', taking with them a Swiss servant paid five livres a day. Their own expenses for 'living might be averaged while on their tour at 7 shillings a day – *all* their expenses *except travelling* at half a guinea a day', says Turner, but it 'is necessary to make bargains for everything, everywhere, or imposition will be the consequences'. It took four days to get to Lyons, through Auxerre, Châlon-sur-Saône, Mâcon, along bad roads. They stayed three days at Lyons, where Turner found 'very fine matter', the buildings 'better than Edinburgh, but there is nothing as good as Edinburgh Castle'. But he 'did little there', as the place was 'not settled enough', and it was dear, eight livres a bed. Two days' journey took him to Grenoble where charges were more 'reasonable'. The Defile of the Grand Chartreuse, some nine miles long, Turner found 'abounding with romantic matter'. They went on to Geneva and Chamonix, where he climbed the Montanvert and made sketches of the Mer de Glace. Then came the tour of Mont Blanc, going over to the head of the Val d'Aosta. Descending the valley, he went through the road cut out of Fort Roc and down to Aosta. There he 'was within a day's journey of Turin – Repents not having gone'. 'Road and accommodation over St Bernard very bad. Afterwards very well.' After roaming a while, he went down the Rhône valley to the Castle of Chillon and to Vevey, then on through the Simmenthal to Thun, Interlaken, Grindewald, over the Great Scheidegg to the Reichenbach Falls and Meiringen. From there he seems to have visited Lucerne, then Altdorf, and gone along the St Gothard Pass as far as the Devil's Bridge. After that he retraced his steps, went to Zürich and on to Schaffhausen, where the great waterfall, he told Farington, 'is 80 feet – the width of the fall about four times and a half greater than its depth. The rocks above the fall are inferior to those above the fall of the Clyde, but the fall itself is much finer.' Then, via Basle, Strasburg, Nancy, he returned to Paris, a couple of days before 30 September, when he met Farington in the Louvre.

[36]

He said that he found Switzerland 'in a very troubled state, but the people were well inclined to the English'. He kept comparing the scenes with those of Scotland and Wales. 'The lines of the landscape features' he considered 'rather broken, but there are very fine parts'. He found 'fragments and precipices very romantic and strikingly grand'. But the trees in general 'are bad for a painter', except the walnuts, which he thought Poussin must have studied. The houses were 'bad forms, – tiles abominable red colour'. Still, 'the country on the whole surpasses Wales, and Scotland too'. The wines in both France and Switzerland were 'too acid for his constitution being bilious', but there were no other drinks available. He underwent much fatigue from walking, and often experienced bad conditions and lodgings. The weather was excellent. He saw 'very fine Thunderstorms among the Mountains'. He made over 400 drawings in six sketchbooks; and for the rest of his life Swiss scenes kept appearing in his work, though it was seventeen years before he went back to the Alps.

On analysis the sketchbooks reveal new procedures in many ways. Two of them show notes of subjects jotted down, and many of the subjects are French, not Swiss. A third book holds a few records of costumes that caught his eye. A fourth, concerned with Lake Thun, has only his usual pencil notes. A fifth, dealing with Grenoble, suggests the pencil sketches made in Scotland; the drawings are done in pencil, with black and white chalks, on grey sheets, each separated out. They are often worked up, out of hasty pencil-sketches in outline. The Grenoble book is not a collection of rough material for later use, but a working-out of ideas to the point where they can be directly carried out as finished works, as can be seen clearly in some later watercolours. The book of St Gothard and Mont Blanc shows this process even more thoroughly. The drawings are often already coloured so as to define the spacious atmospheric effects of the mountains, and so well worked out that they need little reconstruction when made the basis for larger systems in watercolour or oil. The ground of grey washes in all the pages of this sketchbook shows that Turner wanted to carry on yet more fully the immediate control of tone begun on the Scottish tour. This method, setting down from the outset all the main elements required for finished

paintings, was to be carried on further when he made his visit to Italy.

He thus had ready the basic systems that he used in the large number of Swiss views produced in the following years. Now that he had seen Switzerland he could let himself go in mountain views that embodied all the aspects considered necessary for the making of the Sublime. The cult of the Sublime was part of the new romantic sensibility, of which the Picturesque was another aspect. An aesthetic appreciation was developed of things previously considered terrifying. Edmund Burke codified the new system in *A Philosophical Enquiry into the Origin of our Ideas of the Sublime and Beautiful*, 1753 (with the fifth edition in 1767); his work was meant to be a guide to reading the 'characters of nature'. Horror became a tamed and pleasing sensation. The poet Gray, after visiting Scotland in 1765, wrote, 'The mountains are ecstatic, and ought to be visited in pilgrimage once a year. None but those monstrous creatures of God know how to join so much beauty with so much horror.'

In Paris Turner met the engraver Raimbach and told him that he found the place irksome, 'partly from his want of acquaintance with the language and partly from the paucity of material offered to his peculiar studies'. But he was finding more than enough to interest him in the Louvre. He sketched there and made notes on over thirty paintings. He carefully studied works by Titian, fascinated by the colour of the *Entombment*. He sketched or wrote on Guercino, Correggio, Raphael, Domenichino. He was critical of Rubens and Rembrandt, but admired Ruysdael, though doubtful of his strong 'usurping' skies. He made a sketch of a painting by the latter of a ship in a storm near dykes, omitting the house on the right which he said spoiled the work's dignity.

He had a low opinion of contemporary French art, though finding Mme Gérard's little pictures 'very ingenious' and sketching *The Return of Marcus Sextus* by Guérin. His main interest was in Poussin and Titian. In Poussin's *The Israelites gather Manna* he saw 'the grandest system of light and shadow in the collection', and found there a subtle link of colour and theme or emotion. He had already seen several Poussins in the collections of Lord Ashburnham and the Duke of Bridgewater,

works that he thought superior to many in the Louvre. He continued to think hard about Poussin and discussed him in his later Lectures. Thus of *The Israelites* he declared:

> Two figures of equal power occupy the sides and are color'd alike. They carry severally their satellites of color into the very centre of the picture, where Moses unites them by being in Blue and Red. This strikes me to be the Soul of the subject, as it creates a harmonious confusion – a confusion of arts so arranged as to fall into the sides and by strong colour meeting in a background to the side figures which are in Blue and Yellow, so artfully arranged that the art of causing this confusion without distraction is completely hid. The centre has been touch'd, particularly Moses, and I think all the Red draperies in the shadows.

He was already working out the system which he called Historic or Poetic Colours. Colour, he realizes, has a function that goes far beyond any naturalistic basis. It produces a dynamic unification, which is at once aesthetic and emotional, and provides 'appropriate tones to particular Subjects'. In Poussin's *Deluge*, 'The colour of this picture impresses the subject more than the incidents.' In his Louvre notes he says that in Guercino's *Resurrection of Lazarus*, 'the sombre tint which reigns thro[ugh]out acts forcibly and impresses the value of this mode of treatment, that may surely be deemed Historical colouring'. His growing concentration on colour both as a unifying force and as a structural system appears in two schemes that he set down, using initial letters to stand for colours. He sets the latter in their spatial relations, but seems unconcerned with the forms involved. Colour is being seen as a supreme system that swallows up all other elements. On the other hand, in Titian's *St Peter Martyr*, 'The characters are finely contrasted, the composition is beyond all system, the landscape tho' natural is heroic, the figures wonderfully expressive of surprise and its concomitant fear . . . Surely the sublimity of the whole lies in the simplicity of the parts and not in the historical color.' A note shows that he meant to base the composition of his *Holy Family*

on Titian's work, but he changed his mind before he exhibited the picture in 1803. However, he used the discarded system in his *Venus and Adonis*.

While in Paris he visited David's studio and saw his large painting of Napoleon on horseback. He also no doubt looked at works by Boucher and Fragonard, and learned something from their decorative effects. Then, with the strong impact of Swiss scenery on the one hand and the profound stimulus of the Louvre paintings on the other, he returned to England more effectively equipped for carrying on his work and for realizing his complex aims.

On 9 November Girtin died, and two days later Turner was one of the artists at his funeral in Covent Garden church. 'We were friends to the last,' he later told Trimmer, 'although *they* tried to separate us.' *They* were the hangers-on of Girtin and know-alls of the art world who had tried to treat them as competing tradesmen. As late as 1840 Turner wrote beside the sketch of a tower on a rock, 'Tom Girtin'.

In 1803 he showed at the RA five oils, including *Calais Pier*. His skill in conveying the movement, the foam-patterns, of the waves aroused attacks from those who wanted only conventional handling of paint. A critic complained, 'The sea looks like soap and chalk . . . The sky is a heap of marble mountains.' Next year the painter Opie said of his *Boats carrying out Anchors* that it 'looked like a turnpike road across the sea', and the year after West thought his sea was like stone.

In other works he made clear his resolve to develop his art in new directions. *The Holy Family* was mainly a figure-piece, with the landscape of slight importance except in so far as it concentrates the interest on Joseph, Mary and the baby. (How often in recent years must Turner and Sarah have bent over a baby like the pair here.) He had meant to base the composition on Titian's *St Peter Martyr*, but instead cut it down to keep attention on the family group. He then went on to use the vertical tall system for his *Venus and Adonis*, with the *amorini* fluttering over the lovers in the trees, painting his lively Titian pastiche in a clear, dry way. In the 1803 RA show he included *The festival upon the opening of the vintage at Mâcon*, a Claudean composition – his first large ambitious one. (He started it with 'size colour on an unprimed can-

vas', and it is now mainly a work of greens and blues, but in 1803 it showed vivid greens and yellows.)

Another 1803 work was the watercolour, *St Huges denouncing vengeance on the shepherd of Cormayer, in the valley of d'Aoust*. Here he attempted to fuse History and a Swiss landscape, which reveals a deep central V, a light-vortex, between dark mountain-masses, with the saint standing, back turned, under the V, appealing to the forces of heaven.

In a discussion on 2 May 1803 between Farington, Opie, Fuseli and Northcote, the latter said that Turner's works 'had produced more effect from their novelty than they were entitled to: that they were too much compounded of art and had too little of nature: that they consisted of parts gathered together from various works by eminent Masters'. Opie admired *Mâcon* and thought it perhaps the finest work in the show: 'that is in which the Artist had obtained most of what he aimed at'. Fuseli praised *Calais* and *Mâcon*. 'They shewed great power of mind, but perhaps the foregrounds too little attended to – too undefined.' *The Holy Family* he thought 'appeared like the embrio, or blot of a great master of colouring'. Farington added: 'Garvey said to me today that this praise of such crudeness was extravagant and a Humbug.' Constable considered that Turner grew more and more extravagant and less attentive to nature. His Swiss views had fine subjects, but were 'treated in such a way that the objects appear as if made of some brittle material'.

Turner had now marked out the elements of art tradition which he wanted to take up and develop. There were the sea-pieces linked with the great Dutch tradition; the Historical Landscapes which looked back to Poussin and Claude; the union of landscape and human figures, whether the latter were dominant as in *The Holy Family* or submerged in the world of nature like the dancers at Mâcon. He must have felt that his pictures at the 1803 show had demonstrated his resolve to widen his range. In 1804 he sent along a small work in the Poussin tradition, *Narcissus and Echo*, a large watercolour of Edinburgh from Caulton-hill, and another oil painting of a turbulent sea-scene, *Boats carrying out anchors and cables to Dutch men of war in 1665*. The sea-piece was again attacked. *The Sun* said that it 'seems to have been painted

[41]

with a birch broom and whitening', while the *St James's Chronicle* objected that the sailors were 'all bald or like Chinese'.

Meanwhile his hopes of building up a strong position in the Academy were dashed for a while by his involvement in its internal dissensions. Since 1799 a sharp struggle had been going on between two groups that we may call the Court Party and the Democrats. Trouble had begun through a new member, an Irishman, Tresham, who wanted to be elected quickly on to the Council. He appealed to the King, George III, to annul the elections held by the General Assembly. Beechey, high in favour with the King, supported him, and the King quashed the elections and ordered that future Councils be appointed by a system of rotation. Then the President, West, annoyed the King by praising Napoleon on his visit to Paris in 1802, so his pension and his work of decorating Windsor Castle were stopped. The King saw him and his supporters as villainously 'democratical'. The Court Party was led by men who like Beechey or Wyatt were profiting from work done for the royal family. Turner, entering the Council, found it torn between the court-adherents (Wyatt, Copley, Bourgeois, Yenn) and three democrats (Ozias Humphrey, Soane, Rossi). He joined the latter group. A clash soon came over a move to increase the salary of the Treasurer and some other officials. Turner seconded a proposal by the architect, Sir John Soane, that a court of inquiry be called in. The Court Party walked out. Condemned by a General Assembly, they wrote a threatening letter to West. The conflicts intensified, coming to a head when West was found to be sending in a picture already exhibited, though the rules forbade such re-exhibition. The matter was leaked to the press and West was attacked in the *Morning Post*. An attempt was made to find out who was responsible for the leak, and after many bitter moves Turner and the sculptor Rossi led the fight for the rights of the Academy. Five of the Court Party were suspended from the Council and the King intervened to have the resolutions against them expunged from the Minutes, then he intervened again to ensure that a Declaration by Copley was not removed. At the Annual General Meeting his letter was twice read out, but received in silence. It was feared that he would refuse to accept the new Council, but he or his advisers shrank from further interference.

Turner seems to have been much worked up by his role as a leader of the democrats. On 24 December, in an argument about awards, he clashed with Bourgeois, who called him a Little Reptile. In reply Turner called Bourgeois 'a great Reptile – with ill manners'. (Bourgeois was trying to hurt Turner by jeering at his short stature.) Troubles began afresh in 1804 over the election of a new Keeper. But a fit of madness prevented the King from intervening. Turner supported Smirke, who was considered a dangerous democrat, remarking after Marie Antoinette's execution, 'The guillotine might be well employed upon some more crowned heads.' On 11 May, at a Council meeting, Bourgeois took Farington aside to discuss the scandal of some verses against the collector Hope circulated at the Academy dinner. 'On our return to the Council,' writes Farington, 'we found Turner who was not there when we retired. He had taken my Chair and began instantly with a very angry countenance to call us to account for having left the Council, on which moved by his presumption I replied to him sharply and told him of the impropriety of his addressing us in such a manner, to which he answered in such a way, that I added his conduct as to behaviour had been a cause of complaint to the whole Academy.'

Farington's parting-shot suggests that Turner had been throwing his weight about. We have seen how for several years he had been talking of his movements and aims to Farington, clearly wanting to gain his support. Now, in calling him to order for conduct that he regarded as faction-making, we see how far he had gone in feeling himself independent and able to hold his own in the Academy.

It was no doubt as the result of these clashes in the Academy that he decided to assert himself by extending his house in Harley Street so as to take in a large exhibition gallery, 70 by 30 feet. Here in 1804 he held a one-man show. Such a project was new in England, but perhaps in Paris he had heard similar methods discussed. (He had bought the lease of a property at the back of his house, facing out on Queen Anne Street, and there built the gallery. At first the entry was via Harley Street, then from 1812 via Queen Anne Street. The last show was held in the gallery in 1816.) In 1805 he sent no works to the RA. He was continuing with his paintings of cataclysm, producing about 1805 *The des-*

[43]

truction of Sodom. In 1806, at the British Institution, recently organized in London by some connoisseurs, he showed *The Goddess of Discord choosing the apple of contention in the garden of the Hesperides.* Here he combined a lyrical foreground with a menacing rocky background, which, as Ruskin noted, is based on a careful observation of geological formations. A notebook shows him struggling to write an *Ode to Discord.*

We must recall that his mother, still mad, died in 1804. The death must have agitated both him and his father. In 1805 he showed at his own gallery *The Shipwreck*, which has a powerful effect of moving space and wild water. A strong diagonal, given a series of inner tensions by the lines of masts, stays, spars and waves, leads down into a central vortex, a kind of exploding lozenge full of local whirls and surges. The desperate efforts of the human figures to master the situation provide a counter-force, which we feel may well triumph. The tragic moment is given its full depth of emotion by its reflection in a woman's madonna-face.

The reaction of leading artists to the gallery and its pictures was hostile. Hoppner said the place was 'like a *Green Stall,* so rank, so crude, and disordered were its pictures'. West saw the works in general as 'tending to imbecility'. The young Wilkie, who had just entered the RA schools, wrote, 'I do not understand his method of painting at all, his designs are grand the effect and colouring natural but his workmanship is the most abominable I ever saw and some pieces of the picture you cannot make out at all and although his pictures are not large yet you must be at the other end of the room before they can satisfy the eye.' However, he had admirers among the young. In 1803 Constable was surprised in talking with a group of young artists that they looked on Turner's work as being 'of a very superior order', and refused to agree that they were 'in any extreme'. And some rich collectors bought his work. Sir John Leicester bought *The Shipwreck* for 300 guineas, and Charles Turner (no relation) engraved it. The print appeared in January 1807, was very popular, and marked the start of many large engravings after Turner that did so much to spread his name among a new public.

In 1806 Turner again exhibited at the RA. He must have felt that his revolt had gone far enough. One of his pictures was a

[44]

large oil, *The Fall of the Rhine at Schaffhausen*. Here the overawing scenery is linked with a humble piece of human drama. People try to control the situation as two cart-horses start fighting and a woman dashes to save her child. There was also *The Battle of Trafalgar*, shown unfinished this year in his own gallery, more finished at the British Institution in 1808. He had in 1805 sketched the *Victory*, still carrying Nelson's body, as it entered the Medway. In *The Battle* the view was from the 'mizen starboard shrouds on the *Victory*'. But the picture did not gain much applause. Farington thought it a 'very crude, unfinished performance, the figures miserably bad'. In 1807 Turner went to Portsmouth to see the Danish ships captured at Copenhagen; but when he recorded the event in Spithead, he made no attempt to gain attention by some patriotic title. He simply depicted the scene as one of British ships in a British harbour, with subtitle, 'boat's crew recovering an anchor'.

A patron who much admired the Swiss watercolours was Walter Fawkes of Farnley near Leeds. He had been in Switzerland in 1802 and may even have met Turner there. He bought a large watercolour at the RA in 1803, *Glacier and source of the Arveron, going up to the Mer de Glace*. Next year he bought two more, *St Gothard* and *The great fall of the Reichenbach*, from Turner's own gallery. He then went on and bought almost all the rest of the Swiss series that Turner put on sale, steadily till about 1810, then more irregularly until 1820. These works had mainly as their themes the aspects of Swiss scenery that had attracted tourists and artists for some half a century, but they added to the usual picturesque elements a grandeur and a massiveness that was all Turner's own. To get his effects he employed all the varied and original methods he had now worked out for watercolours: broad washes blotted or wiped off to bring out underlayers of colour or the white of the paper itself. Details were given in clear definition, in which he often used knife or fingernail. Rocks or woodland, or distance itself, were given texture or tonal clarification by hatching with a dry brush or even with the brush's wooden end used for scraping.

In 1806 Wilkie had much success with his *Village Politicians*. Turner was keen to master any method or genre that he could use for the strengthening or extension of his aims; in 1807 one of

[45]

his two pictures was *A country blacksmith disputing upon the price of iron, and the price charged to the butcher for shoeing his pony*. There is a tale that he drove up the tone of his picture on Varnishing Day so as to dominate Wilkie's *The Blind Fiddler*. If the tale is true, this was the first occasion when he made a display of his virtuosity with paint on a Varnishing Day. Normally he did not like to work while being overlooked, but he overcame this feeling so as to surprise his fellow artists and to make sure that his pictures stood out with their strength of colour and tone, their triumphant key and obvious mastery of light.

In 1808 he made another display of the wide range of his powers. He was commissioned by the connoisseur Payne Knight to do a companion work to his *Candle Piece* by Rembrandt. Turner, we noted, did not think much of the Rembrandts in the Louvre; he now produced a mocking pastiche (in which he was recalling also Wilkie and Hogarth) entitled *The unpaid bill, or the Dentist reproving his son's prodigality*. In 1807 he had drawn together various influences in a more ambitious work, *The Sun Rising through Vapour*. Here the sun is about to emerge to light up a Dutch fishing port (built up out of the art of Cuyp, Ruysdael, Willem van de Velde). Critics noted that the work had drawn on Claude for its quality of penetrating calm light.

In 1808 Turner was invited by Sir John Leicester to paint two views of his Tabley House, Cheshire. Sir John had been one of the patrons who set the fashion for making collections of pictures by living British artists. In 1803 he had admired *Mâcon*; Turner said his price was 300 guineas, a high price at the time, and refused Sir John's offer of 200. In 1804 Sir John offered to buy at 300, but Turner now wanted 400. (Later *Mâcon* was bought by Lord Yarborough.) Sir John in 1805 bought *The Shipwreck*, as we saw. In July 1808 Turner was at Tabley House, and another artist who was there said he spent more time fishing than painting. He may have been mistaken; for Turner, a very early riser, often did a great deal of work while his host and the others were still abed. Sir John went on buying pictures and in 1819 opened his gallery to the public. He had eight works by Turner, more than by any other living artist. In 1809 Turner was commissioned by Lord Lonsdale to paint two views of Lowther Castle, Westmorland. And Lord Egremont invited him to paint Petworth in Sussex.

[46]

Turner thoroughly enjoyed Petworth and got on well with Egremont; he was to have a long connection with him and his house. In 1810 he called on Fawkes at Farnley Hall and again found himself enjoyable at home. He became a close friend of Fawkes and the rest of the family.

He himself had bought a house on Hammersmith Mall in 1807, where he installed his father, living less at Harley Street though he kept the gallery there. In his Hammersmith garden he had a summerhouse from which he could watch the Thames and draw or paint. In 1811 he moved upstream to Sion Ferry House, near Sion House, Isleworth. He bought some land nearby and built a house there, first called Solus Lodge (apparently to stress the way he lived alone), then Sandycombe Lodge. His father, passionately concerned to defend and further his son's interest, was put in charge of the Lodge and everything connected with it.

Round this time, certainly connected in large part with his nearness to the Thames, he began to paint *plein-air* oils. Normally, in the open he made sketches or watercolours; it was unusual for him to paint in oil in the face of the object or scene depicted. He bought a boat, it appears, so that he could move about on the water, paint or fish. About 1806 he seems to have begun the practice. In that year Sir John Leicester bought the painting of Walton Bridge. Then from 1807 the Thames-subjects increase. Egremont bought *Thames near Windsor* (1807), *Eton College from the River* (1808), *Near the Thames' Lock, Windsor* (1809). By May 1807 there were enough of such subjects in his gallery for West to tell Farington that he was 'disgusted with what he found there, views on the Thames, crude blotches, nothing could be more vicious'.

He was painting watercolours as well as oils on or along the Thames. His studies show trees and plants by the river as well as more elaborate scenes in which trees and boats play their part in the fresh lively compositions. The sketches give an immediate effect of the scene, with clouds in the blue sky as they were at the moment of vision. In the pictures exhibited there is usually something of a golden transformation of the scene. For instance there is a warm golden haze filling the distance in *Ploughing up Turnips, near Slough* (1809). We are reminded of masters like Cuyp. Other works move towards Claudean constructions, for

[47]

example *View of Richmond Hill and Bridge* (1808). The experience of direct painting on the Thames seems to have led to a series of works on the Thames estuary, perhaps painted on the spot. In the sketches of the upper Thames, Turner painted on thin mahogany panels as a unifying basis for the tones of sky, water, vegetation.

Now, with his Swiss oils and watercolours, his many-sided attempts to use and develop Historic Landscape, his mastery of the direct and spontaneous vision of nature in the Thames pictures, he had made great advances in the last decade and had raised the whole concept and practice of landscape-painting to a new level.

4. LANDSCAPE AND POETRY

Landscape was a comparatively recent arrival among the art genres. It had been introduced by Dutch artists such as Ruysdael, who died in 1670 and at first was not much considered even in Holland. Apart from the work of topographical artists such as Hollar (1607–77), it appeared in England in the later seventeenth century and was closely connected with the rise of the new gentry, who lived most of the time in the country and were proud of their mansions and grounds. They were ready to pay for Prospects, in which their house was usually at the centre, with the grounds and surrounding scenery incorporated in varying degrees. The main idea can be called Georgic after Virgil's poem. The gentry saw themselves as fostering local agriculture directly or indirectly, and as carrying on a tradition of benevolence and hospitality. The ideal was stated in a couplet of Pope's in 1713:

> Rich industry sits smiling on the plains,
> And peace and plenty tell, a Stuart reigns.

While Thomson soon after wrote of 'the blended voice/Of happy labour, love, and social glee', waking the breeze.

However, it was long before Landscape could detach itself as a genre in its own right. Gainsborough, to his indignation, had to live by Face-Painting and sold very few landscapes. The poets did much to build a new aesthetic with their accounts of country life, landscape, seasonal changes, and so on. The Prospect appeared in poetry with John Dyer's *Grongar Hall* (1726), and

[49]

was treated lavishly in Thomson's *Seasons*. Thomson added the new sense of colour and light that was emerging out of Newton's work on optics and the spectrum. That was why Turner looked back to the poets of the eighteenth century, and above all to Thomson, for inspiration and guidance, for assurance that he was on the right track. By 1740 artists like George Lambert and John Wootton were trying to introduce classical landscapes with a Claudean basis, but gained little patronage. About the same time, however, paintings of a mansion's gardens, such as *The Gardens at Hartwell House, Buckinghamshire, with two Bastions and Men Scything*, by Balthasar Nebot, were commissioned. Indeed the development of interest in elaborate gardens, at first formal, then more and more linked with the local scenery, played a key part in stimulating a sense of landscape. The growth of interest in antiquities and medieval remains also helped. As examples we may take Paul Sandby's *Roslin Castle, Midlothian*, about 1770, or Michael Angelo Rooker's *Interior of Ruins, Buildwas Abbey, Shropshire*, about 1785. Topographical publications increased, needing engravings of buildings and scenes.

But the concept of a prosperous countryside, centred on the mansion with its gardens, was receiving many shocks. Industrialism was developing, with its mills and factories, and the situation depicted in Goldsmith's *Deserted Village* was growing more common. Urban populations who felt themselves divorced from the land were increasing, and we find the first waves of a romantic feeling about a Lost Earth emerging. From the 1750s there appear writers describing regions like the Lake District or the Welsh Mountains, which had previously been considered too wild and forbidding to have any aesthetic virtues. Tourists visit these areas. There are two resulting cults: that of the Sublime, the terrible and grand in nature, and that of the Picturesque. Tour books multiply. Thomas Pennant published a *Tour in Scotland*, 1771, and a *Tour in Wales*, 1778. Joseph Craddock issued *Letters from Snowdon*, 1770, and *An Account of the Most Romantic Parts of North Wales*, 1777. De Loutherbourg and Cozens painted the Peak District, and Dayes wrote an *Excursion through Derbyshire and Yorkshire* (published after his death). Wright painted his native Derby. Gilpin, making notes on his tours, published the first part of his *Observations on*

the River Wye, 1770. He developed the picturesque aesthetic, which Price defined as being concerned with two qualities: roughness and sudden variation.

But despite these developments landscape painting had still not established itself. Richard Wilson, converted to landscape in Italy in the 1750s, brought back to England what he had learned there, especially from Claude; but though he ended as Librarian of the RA, his work had little impact and did not sell. Joseph Wright, though he painted the Peak District, had his impact rather through a concern for light-effects (for example, from opposing sources) and scenes of scientific experiment. But the way was now clear for the artist concentrating on landscape and bringing together the various aspects or approaches that had been opened up. The first important creative advances were made by the more adventurous watercolourists such as Sandby and Cozens, Girtin and Cotman. The young Turner was among this group. So we see that he began his work just at the time when landscape was a genre being taken seriously and revealing outstanding new possibilities.

He was influenced not only by the tradition sketched above, but also by the expressions in poetry that were linked with it. As well as Thomson he drew inspiration from Milton, Mallet, Shenstone, Akenside, and from later poets such as Campbell, Rogers, Byron. We saw that from 1798 he attached verse-passages to the titles of his works in the RA catalogues, and his sketchbooks show that he kept on trying to write poems himself through much of his life. Thornbury cites a friend as saying, 'Turner's manners were very odd, but not bad. He was fond of talking about poetry.' The engraver Lupton remarked, 'Turner among his social friends was always entertaining, quick in reply, and very animated and witty in conversation. He was well read in the poets.' Trimmer in his account of Turner's house states, 'I next inspected his travelling-box. Had I been asked to guess his travelling library, I should have said Young's *Night Thoughts*, and Isaak Walton; and there they were, together with some inferior translations of Horace. His library was select, but it showed the man.' He knew Homer and Virgil well from translations. That he knew much verse by heart is shown by the way in which, citing a passage, he often inserts variants of his

own. Thus, in some annotations, he cites Mason's *Du Fresnoy*, compressing five lines into two and changing the phrases.

Thomson himself had responded strongly to art; he carried into poetry elements of sensibility developed by artists like the Venetians, Claude, Poussin, Salvator Rosa, then gave those elements a new dynamic intensity, which is what stirred Turner and helped him to the new synthesis he desired. In 1798 Turner attached lines from Thomson to *Dunstanborough Castle*, which depicted 'Sun-rise after a squally night'.

> The precipice abrupt,
> Breaking horror on the blacken'd flood
> Softens at thy return. – The desert joys,
> Wildly thro' all his melancholy bounds,
> Rude ruins glitter; and the briny deep,
> Seen from some pointed promontory's top,
> Far from the blue horizon's utmost verge,
> Restless reflects a floating gleam.

He is concerned with the way that the poet expresses the transformative power of light, the effects it creates as it sweeps darkness away and expands the scene. Nature ceases to be a static system, of which the parts are separately delineated, and is realized as something in unceasing movement and change, with sharp clashes and dominating harmonies. This inherent instability, with its unceasing reassertion of stability and controlling interrelationships, involves a continual outburst of contrasts and of colliding opposites. Here we meet the hard-edged cliff and the softening light, desert and fertility, horror and joy, nearness and distance. Light becomes the active principle connecting the parts, not a medium spread passively over the scene. The recession of planes and colours into the far distance is centred on a point of light, which is both the stabilizing keystone and the core of a disturbing force. Everything flows into it as well as bursts out from it. The balance of inward- and outward-going forces is caught on a sudden flash of comprehensive vision, so that all the elements of the scene come richly together in a secure pattern, yet the whole thing is transient in essence, about to make way for a new conflict of symmetry and asymmetry.

[52]

We have seen that Turner misquotes. He jots the words down from memory, or, even if he has the book open before him, his hasty mind, taking the verses excitedly into itself, starts reading what it wants to see. In Thomson the second line opens with the word 'projecting'; Turner uses the more active word 'breaking', which gives an alliterative impact to the line. He changes the stop after 'bounds' to a comma, so that the lines run together more fluidly and ambiguously, with the desert and the ruins brought more strongly together. These changes are slight, but they bring out the way in which Turner feels the verses to be a part of himself, of his definition.

Consider also how the next year he played about with the passage attached to *Warkworth Castle*, 'thunderstorm approaching at sunset'.

> Behold slow settling o'er the lurid grove
> Unusual darkness broods; and growing, gains
> The full possession of the sky; and on yon baleful cloud
> A redd'ning gloom, a magazine of fire,
> Ferment.

The verses bring out the fusion of heavy, lurid darkness and the reddening gloom which is about to 'ferment' into violent thunder. But he has cut out after 'the sky' several lines that extend the metaphor of artillery and chemical explosion. The grammar is confused, so that gloom and fire do the fermenting instead of the combining chemicals. The concision indeed gives an even more dynamic effect than the full text. But perhaps he wanted to keep the worked-out idea of thunderstorm and artillery warfare for *The Battle of the Nile*, in the same exhibition. To that work he attached lines from the sixth book of *Paradise Lost*, which describes the invention in Hell of artillery and blast-missiles, 'chained thunderbolts and hail of iron globes'. It is clear that the two paintings were linked in his mind with a symbolic fusion of storm, war, gunpowder, explosion, hell.

This sort of symbolic thinking must be stressed, for it was an essential element in his work and the process by which he built up his imagery and themes. Indeed it reveals the deepest levels in his whole creative approach. And it is clear that he needed poetry in

[53]

order to clarify his thinking, to develop it in ways in which he felt that he came close to the living processes of nature, with all their harmonies and contradictions, and worked out a parallel definition in his art. We can even see that he had been reinforced in the symbolism of storm and battle by his reading of Mallet. For another picture shown in 1799, *Caernarvon Castle*, he cites Mallet's *Amyntor and Theodora* in a description of evening calm. But a few lines later in the poem we meet a long account of sea-storm and shipwreck. Turner would have known Mallet's *The Excursion*, which tells of an earthquake preceded by a 'sullen calm', and uses the Miltonic images of chemical combustion, sulphur, nitre, an 'enkindled mass, mine fir'd by mine in train' that 'disploded bursts its central prison', releasing thunder and lightning, and begetting the cataclysm. Turner knew these poems thoroughly, and indeed without them we would find it hard to explain how he built up and extended his ideas. The idea of a vital union of poetry and art was in the air. Hurdis, Professor of Poetry at Oxford, opened his lectures in 1797 with the statement that the poet 'is strictly a Painter with colours and canvass before him, and the whole Creation is his subject – things animate and inanimate, intellectual and corporeal. The first and most obvious features which he copies from *inanimate* nature, are the *changes* of the *day*, and of the *year*. Nothing therefore is more common with every Poet, than descriptions of the *morning*, the *noon*, the *evening*, the *night*, and the several *seasons* . . .' (In 1800 Turner was commissioned to paint views of Fonthill, William Beckford's Gothic Folly rising above the hills of its large park. He did five pictures: Fonthill at morning, noon, afternoon, sunset, evening. He produced a grand but natural effect of the open country, a Claudean spaciousness without classicism.)

In a letter of 1811 dealing with the engraving of his *Pope's Villa*, he objects to the phrase 'mellifluous lyre', in connection with Pope in his Grotto. The phrase 'seems to deny energy of thought – and let me ask one question, Why say the Poet and Prophet are not often united? – for if they are not they ought to be'. Since he believed in the unity of Poetry and Art, he held that Artist and Prophet should be united if art was to be developed in its full potentialities.

His use of poetry, his close and indeed indissoluble connection

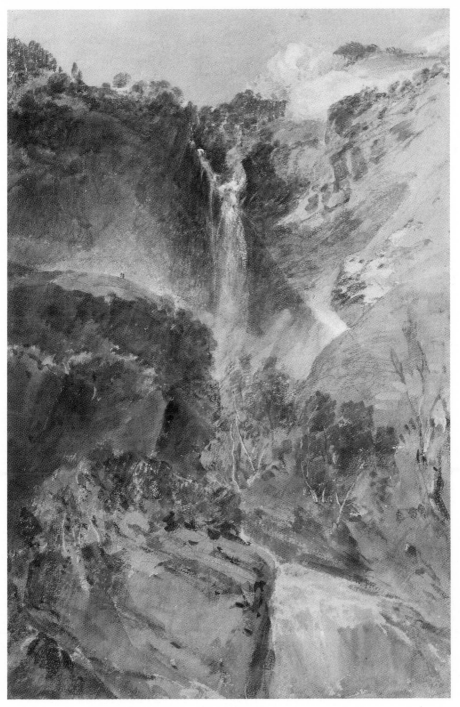

*The great fall of the Reichenbach, in the valley of Hasle,
Switzerland*, 1804. Watercolour. The precipitous fall down the
narrow ravine powerfully presented. Pencil, watercolour,
body-colour on white paper with grey wash.

Portrait of the artist aged about twenty-three, 1798
Oil. Here we have a vivid impression of Turn[er in]
his youth, strongly confronting the world,
somewhat coarse, sensuous, determined.

Snowstorm: Hannibal and his army crossing the A[lps],
1812. Oil. Based on a storm on the Yorkshire
moors, with the moral that after carrying out
heroic deeds in hardship men go down into
worsened corruption. (The moral is set out in
accompanying verses.) Perhaps the first of his
works to use black as an expressive element in [a]
colour system, helping to produce chiaroscur[o]

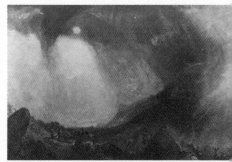

Field of Waterloo, 1818. Oil. Turner omits all aspects of
grandeur and national pride, and stresses only the suffering in
the after-night.

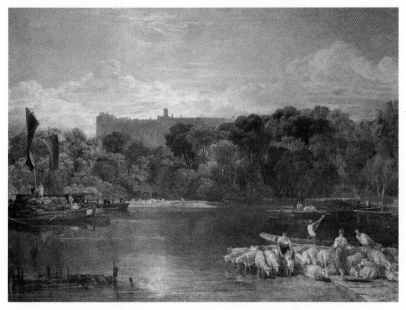

Windsor Castle from the Thames, about 1804–6. Oil. Turner had
bought a house at Isleworth, Richmond, and painted many
open-air studies along the river.

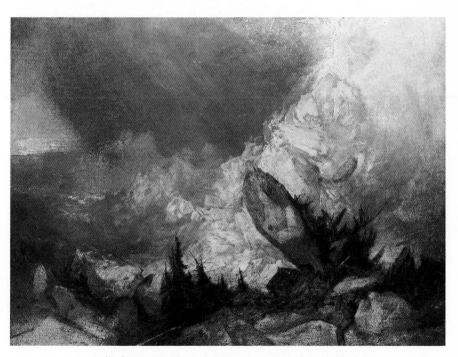

*Fall of an Avalanche in the Grisons (Cottage destroyed by an
Avalanche)*, 1810. Oil. The small house of domestic life is
crushed by forces outside its control. Turner goes far beyond
earlier pictures of disaster such as those by Loutherbourg,
using diagonals but in terms of violent thrust and resistance.
Much of the picture-space is filled with a patch of nebulous
grey worked on with palette-knife.

*Dido building Carthage; or the rise of the Carthaginian Empire – 1st
book of Virgil's Aeneid*, 1815. Oil. Once again Turner
transforms a Claudean system with his suffused golden light.
Carthage, a doomed commercial empire, keeps recurring as a
symbol of his England. Each figure in this picture carries out a
task that plays its part in the total meaning.

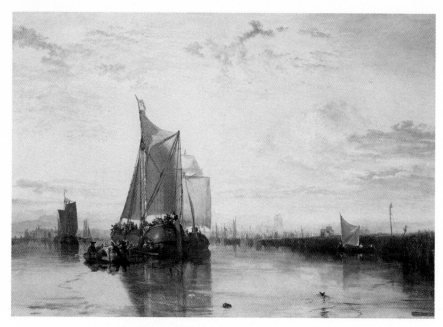

Dort or Dordrecht; The Dort packet-boat from Rotterdam becalmed,
1818. Turner brings out his link with Dutch artists like Cuyp,
showing his love of diffused sunlight and a
unified colour-scheme.

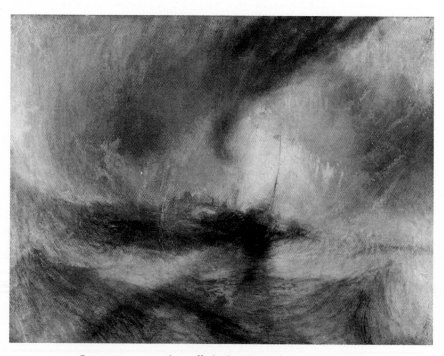

*Snowstorm – steam-boat off a harbour's mouth making signals in
shallow water, and going by the lead. The author was in this storm
on the night the Ariel left Harwich,* 1842. Oil. He was not,
however, in that boat, but in one going down the south coast
from London. He is said to have had himself tied to the mast
so that he could observe the storm.

England: Richmond Hill, on the Prince Regent's Birthday, 1819.
Oil. The biggest painting Turner ever made. The classical
overtones from Claude are given a sunny informality, an
elegant homeliness.

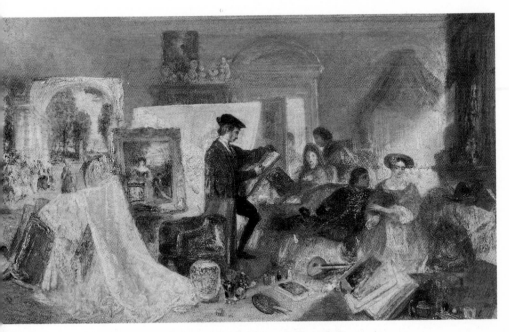

Watteau study by Fresnoy's rules, 1831. Oil panel. Turner is
commenting on an artist he admires, both as practitioner and
man, in terms of the theory connected with his art.

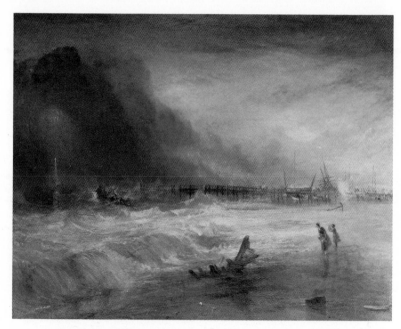

Life Boat and Manby apparatus going off to a stranded vessel making signal (blue lights) of distress, 1831. Oil. Turner all his life kept up an interest in matters connected with ships and the sea. C. Manby's apparatus fired a rope out to a ship, using a mortar. It was first used in 1808.

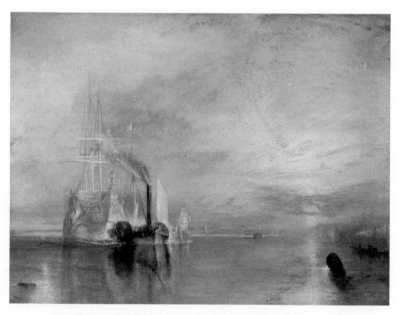

The Fighting 'Temeraire' tugged to her last berth to be broken up, 1838. Oil. Exhibited 1839. His most elaborate piece of sunset symbolism: the fine old ship of the days of sail being taken to her doom by the squat steam-tug.

with it, help us to understand in many ways how he developed his aesthetic, his sense of nature as a ceaseless process out of which endless patterns emerge, harmonious and violent, stable and unstable. But the verses he himself wrote often do much more than that. They give precious glimpses into his total philosophy, the way in which his symbolism of nature was related to his concept of humanity and its history, the pattern of its development. *Hope* was the key-word here. In 1798 he attached to *Morning amongst the Coniston Fells* some lines from Langthorne's *Visions of Fancy*. The lines link morning, 'radiant colours', youth, joy, hope, fancy, and against them set decay, dark clouds gathering, the betrayal of hope. Here we meet in simple moralizing form a question that was to nag at Turner for the rest of his life. Hope is the forward impulse in which is formulated the goal of both individual and society; its frustration implies the defeat of the deepest emotions and ideals that hold men together and drive them on. We shall see some of the many ways in which Turner applies his concept of Hope.

Two poems provided Turner with this concept. There was Cowper's *Hope* of 1781. This poem declares that those who accept existing society at its own values cannot rebut the statement that life is 'a vain pursuit of fugitive false good'. Men go round in vicious circles, 'the rich grow poor, the poor become purse-proud', until the 'prospect shows thee a disheartn'ing waste'. Yet earth is lovely with flowers and light, and all things cry 'Rejoice'. Neither despair nor joy is true; they are 'imputed tints'. Hope is both illusion and reality. Against the greeds and corruptions is set the love of life where 'a brother's interest' lies at the heart's core and man is ready if need be to forsake country, kindred, friends, ease, to cross tempestuous seas with a good heart. A sea-image is used to express the human condition. Under the smiling surface of the deep the passions lurk ready to break in wild wintry storm. Cowper ends with Hope seen in religious terms, but in working out his symbolism he has much to say of the corrupting forces in society and the man 'whom hope has with a touch made whole'.

More important was Campbell's *Pleasures of Hope*, published in 1798 when, as we saw, Turner was making an important break-through in his art and linking it with Thomson's poems. The French Revolution seemed to have foundered, losing its drive to

brotherhood, and Campbell set out to claim that Hope can yet be vindicated. It is identified with all creative and exploratory activity in art and science, and is linked with the imagery of sea, sea-travel, trade-expansion. This leads to imagery of sea-storm and wreck, but Campbell refuses to accept the negative aspects as dominant.

> Poor child of danger, nursling of the storm,
> Sad are the woes that wreck thy manly form!
> Rocks, waves and winds, the shatter'd bark delay;
> Thy hope is sad, thy home is far away
> For Hope can here her midnight vigils keep,
> And sing to charm the spirits of the deep . . .

He goes on to elaborate the link of Hope with the imaginative energy that grasps life in its wholeness, as opposed to the mechanist rationality which refuses to admit the possibility of forms or developments outside its own closed circle: 'the shadowy forms of uncreated joy'. He uses the symbol of the deranged lovelorn maid, but, while exploiting the image-complex of wreck and sail-on-the-horizon, he stresses not the betrayal of hope, but the tenacity which accepts madness rather than surrender to despair. Further, the integrative and exploratory work of Hope is identified with the productive advances being made, which are seen as the pledge of a universal movement to peace and plenty. While he mourns the wrongs of fate and the woes of human kind:

> Thy blissful omens bid my spirit see
> The boundless fields of rapture yet to be;
> I watch the wheels of Nature's mazy plan,
> And learn the future by the past of man.

He then sets out the main objectives of freedom implied by Hope: the national liberations in Europe, with the ending of feudal reaction; the abolition of the slave-trade and the handing-over of Africa to the Africans; the ending of all colonial oppression and the rescue of India from imperial controls. He

prophesies the end of all tyrannical authority. 'The patriot's virtue and the poet's song' will unite to bring about the harmonious control of nature without the existing 'wrongs of fate'. They will light up 'with intellectual day,/The mazy wheels of Nature as they play'. The result will be an art, 'warm with Fancy's energy', rivalling Shakespeare in its universality.

We need to know this poem if we are to understand Turner's attitudes to society and history as they developed. The attacks on Tyranny explain why he added to his two castle-pictures of 1798 the verses acclaiming the men who fought it in medieval days. Campbell brought up to date the positions set out in Thomson's *Liberty* and drove Turner to face the contradictions of his world. Would Hope be vindicated or would the corruptive forces win after all? That was the question he kept on asking himself. *Liberty* had raised the typical question of the eighteenth century: why did the great Graeco-Roman civilization break down? Was Britain as an imperial and expanding power to go the same way? Now those questions took on a new urgency. He set out his fears in a poem attached to *London*, shown at his gallery in 1809 and bought by Fawkes.

> Where burthen'd Thames reflects the crowded sail,
> Commercial care and busy toils prevail,
> Whose murky veil, aspiring to the skies,
> Obscures thy beauty, and thy form denies,
> Save where thy spires pierce the doubtful air,
> As gleams of hope amidst a world of care.

These lines are of interest also in showing that forms that rise up and aspire to heaven, like the spires, have a strong emotional meaning for him, linking earth and the realms of light. The smoke and mist are equated with the confusing and destructive side of human activities; the spires represent the element that seeks to break through into a true harmony of sky and earth.

This year Turner embarked on a new venture, seeking to take advantage of the growing market for prints. He was encouraged by his friend W. F. Wells, a minor watercolourist with a keen mind and a capacity for organization. Wells had founded the Water-Colour Society and seems to have suggested to Turner the

opening of his own gallery. In October 1806, at Knockholt, his home in Kent, he had told Turner, 'For your own credit's sake you ought to give a work to the public which will do you justice – if after your death any work injurious to your fame should be executed, it could then be compared with the one you yourself gave to the public.' Turner hesitated, then replied (as Wells's daughter recalled forty-six years later), 'Zounds, Gaffer, there will be no peace with you till I begin . . . Well, give me a sheet of paper there, rule the size for me, tell me what subject I shall take.' Thus was born his *Liber Studiorum*, modelled on Claude's *Liber Veritatis*, a book of drawings in which he recorded the composition of each of his paintings. The engravings of Claude's drawings, long afterwards, by John Earlom, made them rather monotonous; but Turner was attracted by the idea of a large-scale record of the kind of work he was attempting. (We perhaps can read some fears or doubts about the project in verses he wrote at Knockholt on a line of poplars outgrowing themselves. 'How near is pride to earth allied.')

In his *Liber* he did not attempt a catalogue of even his main works; he did include some compositions already done, but he soon decided that he would use the series to show the wide range of his works and, in so doing, carry on his campaign for the acceptance of Landscape as an art-genre as important as any other. He divided the prints into several categories: History, Mountains, Pastoral, Marine, Architecture, and EP (Epic Pastoral, Elegant Pastoral, or Elevated Pastoral – we are not sure what meaning he intended, but the group certainly represented Pastoral at some higher sort of level). He used his *Fifth Plague* to provide the design for one plate of History; some of his Swiss scenes for Mountains – for instance *The Little Devils' Bridge*; *Lake of Thun, Lucerne, Schaffhausen*; various farmyard scenes for Pastoral; his first sea-painting of 1796, with a storm-piece, *Coast of Yorkshire near Whitby*, for Marine; some townscapes and topographical drawings of buildings for Architecture; a variety of works for EP – *Solitude, The Junction of Severn and Wye, A View of Isleworth. The bridge in middle-distance*, also called *The Sun between Trees*, was Claudean in style. For the Pastoral themes he made many drawings of agricultural scenes and of people at work: *Bridge and Cows; Sheepwashing at Eton; Blacksmith's shop*

[58]

The straw yard, farmyard with the cock; Juvenile Tricks; Watermill, woman at a tank; The Bridge and goats; Peat Bog; Hedging and ditching; Ploughing, Eton; Woman and Tambourine; A silent pool; Young Anglers.

In deciding how to engrave the drawings he kept Earlom in mind, but worked out a system that gave him a maximum of control over the engravers. He himself made wash drawings in bistre or drawings in pen and sepia, and himself etched the outlines. Then he brought in established engravers to deal with tonal aspects, in aquatint or mezzotint. He followed Earlom in using a warm brown ink in the printing, so as to give something of the same colour as the drawings. The aim was to print a series of a hundred works but, though the project went on from 1809 to 1819, he issued only seventy-one. Lack of sales stopped the venture. While there is ample variety in the designs, the total effect was rather monotonous, mainly because the method of etching and engraving the plates omitted the subtle and rich effects of light and atmosphere which were one of Turner's great strengths and without which his work loses in character and depth of definition.

Turner had first visited Farnley Hall, the home of Fawkes, in 1808. He went again in 1810 when on 17 August Farington reported that 'Turner had been in the country, and proposed going to Yorkshire'. He had been in Sussex to make drawings for John Fuller of Rosehill, who had bought *Hastings: Fishmarket on the Sands* from his gallery. (Fawkes bought a watercolour version of the same scene, also dated 1810.) At Farnley Turner soon felt thoroughly at home. Thornbury tells us that, as he became familiar with Fawkes, 'he shot and fished and was as playful as a child', and indeed he himself entertained the children with drawings of birds and men-of-war. On return from one of the shooting-parties on the moors, 'nothing would satisfy Turner but driving tandem home over a rough way, partly through fields. I need hardly say that the vehicle was soon capsized amid shouts of good-humoured laughter; and thenceforward Turner was known at his host's by the nickname of Over-Turner.' (The critics had not missed the chance of thus mocking his name. *The True Briton* in May 1803 declared that he had so debauched the taste of young artists 'by the empirical novelty of his style of

painting that a humorous critic gave him the title of *over-Turner'*.)

In 1813 at Farnley he did two paintings of grouse- and woodcock-shooting, and shortly before his death, in January 1851, he wrote, 'A Cuckoo was my first achievement in killing on Farnley Moor in earnest request of Major Fawkes to be painted for the Book' of Ornithology. Luckily, however, we have in his sketchbooks the poems he wrote at Farnley, which reveal what he really felt: extreme revulsion from blood-sports.

> Oh, why unfortunate victim to my zeal . . .
> Not the coarse ling or splashy spring
> Prevent. No, tis alike to him
> Wades falls or swims alike pursues
> And wet with blood his hand embrue[s]
> Again the thundrous gun then plies
> Again another helpless lies.

He may have been upset by the death in August 1816 of Fawkes's brother in a shooting accident on the moors while he, Turner, was at Farnley.

We have seen how many of the Swiss drawings Fawkes bought. His patronage continued to be lavish. In the years 1808–18 he bought nearly 200 watercolours and six oils from Turner, spending £3,500 or more on his work. After being generally interested in Swiss and Yorkshire subjects, he preferred local scenes that he knew intimately: Caley Park and Otley Chevin, the house and grounds at Farnley. About 1815 Turner did a detailed watercolour of a shooting party on the moors, with tents and elaborate paraphernalia. About 1818 he made a drawing in body-colour on buff paper of Caley Hall (which Fawkes owned), depicting the return from a hunt, with dogs excitedly running about and bearers carrying a dead stag. The drawing is a close but warmly felt transcript of the scene, with watering-can and roller, basket, beehives by the lawn, the central tree depicted with expressive realism.

In February 1810 he was in Oxford, commissioned to make a view of the High Street by James Wyatt, a carver and gilder, who wanted to make a large engraving of the subject. We have several

of his letters to Wyatt, which are worth citing to show how careful he was when dealing with a view that was to be precisely recorded.

> The figures introduced are as follows . . . two Clericals, one in black with a master of arts gown, the other with lawn sleeves for the Bishop (being in want of a little white and purple scarf) preceded by and follow'd by a Beadle. Hence arise some questions – first, is it right or wrong to introduce the Bishop crossing the street in conversation with his robes, whether he should wear a cap? what kind of staff the Beadles use, and if they wear caps – in short, these are the principal figures, and if you will favour me with answers to the foregoing questions and likewise describe to me the particularities of each dress, I should be much obliged to you, for I could wish to be *right*.

Wyatt decided against the bishop, and a pretty girl was put in instead. Turner wrote:

> As to the figures introduced, I have made use of those you sent, and therefore hope you will find them right. Yet I took the hint, for the sake of color, to introduce some Ladies. The figures taking down the old Houses are not only admissable but I think explains their loss and the removal of the gateway.

Later his topographical conscience was touched.

> I feel some concern about the Spire of St Mary. Many who look at that spire at the side opposite to it in the street think that it should look equal high at the angle, but which wholly changes its character. It becomes more dignified than piercingly lofty. However, if you can get me the height and base from the springing or setting off of the spire, or from the clock, it shall be altered to measure.

He was paid £105 for the picture.

Among the works in his own gallery this year was *Cottage*

[61]

Destroyed by an Avalanche (later called *Fall of an Avalanche in the Grisons*). We are back at the theme of disaster. He is thinking of a painting by de Loutherbourg, 1804, which had much theatrical energy, but his dramatic realism of catastrophe leaves that painter and Wilson far behind. The shattering effect of great crashing stone is something no one else had achieved. To show human beings falling out of the cottage would have been to trivialize the scene, but he gave the cottage its domestic note by adding a grey cat clinging desperately to the roof. He still uses diagonals, but in a situation of extreme agitation and tension, driving rain under a leaden sky. There is complete unity of theme and the handling of the paint with its rough force and low tones, the way in which he uses white to define the force of the falling snow. He was giving in concentrated form the account in Thomson's *Winter*:

> In peaceful vales, the happy Grisons dwell.
> Oft, rushing sudden from the loaded cliffs,
> Mountains of snow their gathering terrors roll.
> From steep to steep, loud thundering, down they come,
> A wintry waste in dire commotion all,
> And herds, and flocks, and travellers, and swains,
> And sometimes whole brigades of marching troops,
> Or hamlets sleeping in the dead of night,
> Are deep beneath the smothering ruins whelmed.

The line about the armies links *Avalanche* with *Hannibal* which was to come in 1812. No doubt Turner recalled how in 1798, shortly before the Battle of the Nile, the country of the Grisons, as the *Annual Register* said, 'fortified by nature, and inhabited by a brave and hardy people, equally fond of their liberty and able to defend it, was threatened, likely to be overwhelmed between the French and Austrian armies'. His own verses to the *Fall* told how 'The downward sun a parting sadness gleams,/Portentous lurid thro' the gathering storm.' The glacier falls, 'extinction follows,/And the toil, the hope of man – o'erwhelms'. Note how the concept of Hope already intrudes.

In November 1807 Turner had been elected Professor of Perspective at the RA. Previously there had only been a Teacher,

[62]

but now it was decided to create a Professorship held by an Academician. Turner was the only candidate and he was elected. But he must have felt diffident, for it was not until 7 January 1811 that he gave his first lecture, reading too fast and not very comprehensible in his plebeian accent. Of the second lecture Rossi said that he got through it 'with much hesitation and difficulty'. Farington, who chaired the fourth, said it lasted thirty-five minutes. W. P. Frith, who became an RA Associate in 1845, gives a transcription of a later speech of Turner's which vividly brings out the way he spoke: 'the stammering, the long pauses, the bewildering mystery of it'. Turner was appealing to the artists to stand together harmoniously for the good of the Arts and the Royal Academy.

> Gentlemen, I see some (pause and another look round) new faces at this – table – Well, do you – do any of you – I mean – Roman History (a pause). There is no doubt, at least I hope not, that you are acquainted – no, unacquainted – that is to say – of course, why not? – you must know something of the old – ancient – Romans. (Loud applause). Well, sirs, those old people – the Romans I allude to – were a warlike set of people – yes, *they were* – because they came over here, you know, and had to do a great deal of fighting before they arrived, and after too. Ah! that they did; and they always fought in a phalanx – know what that is? (Hear, hear, said some one.) Do YOU know sir? Well, if you don't, I will tell you. They stood shoulder to shoulder, and won everything. (Great cheering). Now, then, I have done with the Romans, and I come to the old man and the bundle of sticks – Aesop, ain't he? – fables, you know – all right – yes, to be sure.

And he went on to tell the fable. When he was using a written text, he would not have been so incoherent, but his method of speaking would still have had this slapdash uncertain note. (The speech, incidentally, brings out his deep feeling for the Academy as a sort of family, which we noted in his comment on Haydon.) Leslie tells us, 'His voice was deep and musical, but he was the most confused and tedious speaker I ever heard.'

[63]

Things were different when he was talking casually. 'In careless conversation he often expressed himself happily; and he was very playful; at dinner talk nobody more joyous.' Roberts says that when he took part in RA debates, nobody knew when he sat down which side he had taken.

In 1811 he showed at the RA *Chryses*. The priest of Apollo sits on the edge of a rough sea, praying to his god (whom Turner saw as god of the sun) for vengeance on the Greeks who had taken his daughter, Chryses. The theme is an odd one, and perhaps the cry 'Give me back my daughter' is addressed by Turner, priest of the Sun in art, to Apollo. If so, there must have been some disagreements and quarrels with Sarah about his girls. The quotation from Homer describes, 'The anguish of a father, disconsolate, not daring to complain'. A poem in a sketchbook with his Harley Street address suggests that he had many difficulties with Sarah:

> Love is like the raging Ocean
> Wind[s] that sway its troubled motion
> Women's temper will supply
>
> Man the easy bark which sailing
> On the unblest treachrous sea
> Where Cares like waves in fell succession
> Frown destruction oer his days
> Oerwhelming crews in traitrous way
>
> Thus thro life we circling tread
> Recr[e]ant poor or vainly wise
> Unheed[ing] grasp the bubble Pleasure
> Which bursts his grasp or flies.

He would have been a difficult man for any woman to live with in a settled relationship. Much of his time was spent in tours or other movements round the countryside (and later on the Continent); his obsession with work would have left him little spare time for companionship. After his mother's death he must have spent much time at a house outside London, with his father now his close companion. The year 1809 provides us with the only comment by an outsider on his connection with Sarah. Callcott, a devoted disciple, told Farington on 11 February, 'A

[64]

Mrs Danby, widow of a Musician, now lives with him. She has some children.' Even the gossip Farington seems to have known nothing of the relationship. Sarah, it appears, was now living at Harley Street, and that was why her link with Turner was observed. The system based on Norton Street and Upper John Street seems to have broken down. (Callcott, we may note, was brother to a glee-writer who ranked with Danby as one of the most popular composers; and it may have been his connections with the musical world that brought Sarah to his notice. Turner was always on the most friendly terms with him and praised his work, which in various ways tried to follow up lines that he, Turner, had opened up.) Probably about this time Sarah's niece, Hannah Danby, was taken into the household as a kind of manageress. She was given an annuity in Turner's first (1829) will, and must have been in his service then for a good many years. In 1809 she was probably aged about twenty-two; in later years she became a repulsive hag.

Turner's two daughters seem to have been in Harley Street at this time, according to Trimmer's reminiscences. We may note that in the poem cited above, all the blame for discord is put on the woman. The man is identified with the ship (emblem of constructive labour, of human struggle with the elements) and the woman with the treacherous winds that try to sink it.

In 1812 he made an important advance in what he thought of as Historic Landscape. At the RA he showed *Snowstorm: Hannibal and his army crossing the Alps*. At first he considered that the picture was badly hung and thought of withdrawing it, but at last he was satisfied. The diarist Crabb Robinson said that it was the most marvellous landscape he had ever seen; the sculptor Flaxman admired it. After the argument about its hanging Callcott dined with Farington and three other artists; he declared that Novelty was the essence of art. There was a long discussion, and the others held that while his view might have a good interpretation it was very dangerous to state it to students.

Turner had been deeply impressed by the *Aeneid* with its story of the founding of Rome after Aeneas visited Dido, Queen of Carthage. In fact Carthage and Rome became rival imperial powers and Carthage was destroyed. Thomson in *Liberty* took Carthage as the type of state that is broken by inner corruptions,

[65]

and in one passage linked corruption, 'the syren plains', with the fall of Hannibal and the ultimate breakdown of Rome herself. Turner himself composed verses to go with his picture:

> Craft, treachery, and fraud – Salassian force,
> Hung on the fainting rear! then Plunder seiz'd
> The victor and the captive, Saguntum's spoil,
> Alike became their prey; still the chief advanc'd,
> Look'd on the sun with hope; – low, broad, and wan;
> While the fierce archer of the downward year
> Stains Italy's blanch'd barrier with storms.
> In vain each pass, ensanguin'd deep with dead,
> Or rocky fragments, wide destruction roll'd.
> Still on Campagnia's fertile plains – he thought,
> But the loud breeze sob'd, 'Capua's joys beware!'

And he now invented a title, *The Fallacies of Hope*, to give the effect that he had written a long poem on that theme, of which the cited lines were a fragment. The main idea is that after all the suffering and heroic resistance the Carthaginians will pass the terrible mountains and come down to the rich cities of the plain and be corrupted.

Turner had long nursed the image of Hannibal in the Alps. In 1776 Cozens exhibited *A landscape, with Hannibal on his March over the Alps, showing to his army the fertile plains of Italy*. Leslie tells us, 'This, I have heard, was an oil picture, and so fine that Turner spoke of it as a work from which he learned more than from anything he had then seen.' Clearly the picture was not at all like Turner's *Snowstorm*; it belonged to a series depicting the lonely hero on a height. In poetry Gray's ode, *The Bard*, which stirred Turner in his 1798 Castles, was an example. In a 1798 sketchbook, where one sketch seems linked with *The Fifth Plague*, he drew an army on mountains gazing at a distant land as well as Roman soldiers climbing. (Cozens sent his painting in to support his claim to RA membership, but so low was the estimation of Landscape that he failed to get a single vote.) We saw how *Avalanche in the Grisons* no doubt raised in Turner's mind the image of alpine warfare. In 1802 he had seen in David's studio the painting of Napoleon on horseback about to ascend the St

Bernard Pass; he later used the motive in book-illustration. (Ironically, soon after Turner's *Hannibal* was exhibited, Napoleon's retreat from Moscow took place in terrible winter conditions.) Turner would further have been much affected by the delegation of Tyrolese who in late 1809 came to London to petition for aid against Napoleon's invasion of their Alps; they aroused strong popular support.

The Hannibal image had certainly been long in his mind. Gray had set out a list of themes suitable for a Salvator Rosa, which was printed in the 1775 edition of his poems and letters edited by W. Mason. The list included: 'Hannibal passing the Alps; the mountaineers rolling rocks upon his army; elephants tumbling down the precipices'. (Turner no doubt also derived from Gray's list the idea of Aeneas and the Sibyl.) Emily in Mrs Radcliffe's novel, *The Mysteries of Udolpho* travels the Alps and imagines Hannibal attacked by mountaineers. Further, Turner certainly knew the passage on Hannibal in T. Gisborne's *Walks in a Forest*, the fourth edition of which (1799) was illustrated by his friend Sawtrey Gilpin. The poem uses the concept of Hope in connection with the Alps-crossing. As late as 1841 Turner cited Gisborne for his *Dawn of Christianity*.

We see then that the image was long prepared in his mind and had rich correlations in the culture of his period. But what gave a powerful immediacy to his definition was the fact that the storm on the Alps was also a Yorkshire storm. Hawkesworth Fawkes, the eldest son of Turner's friend, remembered how Turner once called him out to see a thunderstorm passing darkly over the Chevin and the Wharfe valley. Turner, as he talked, kept on making notes of the storm, its colours and cloud-shapes, on the back of a letter. 'I proposed some better drawing-block, but he said it did very well. He was absorbed – he was entranced. There was the storm rolling and sweeping and shafting out its lightning over the Yorkshire hills. Presently the storm passed, and he finished. "There," he said, "Hawkey; in two years you will see this again, and call it Hannibal crossing the Alps."' Turner was at Farnley in August 1810 and November 1811. The phrase 'in two years' suggests that the storm was in 1810, when we hear of violent storms in London in July and August, rather than 1811 when there was bad weather in November. But Hawkey was

[67]

recalling the event years later to Thornbury, and may have got such details wrong. The important thing is the connection of a Yorkshire storm with Hannibal. Fawkes was a devoted Whig of the Fox school, and during these years he was expressing sentiments of a strong radical kind. While *Hannibal* was on the walls of Somerset House he was calling (23 May 1812), at the radical meeting-place in London, the Crown and Anchor Tavern, for a restoration of the Constitution, 'which has been so long and loudly extolled in theory, and so strangely perverted in Practice'. He cited the Committee of Association of the County of York, of which he was a member, which declared that 'the representation of the Commons of England, is virtually annihilated; and an institution, which was intended to be the people's defence against Aristocratic domination, and Royal despotism, is now become an engine, in the hands of the Minister to tax, oppress, insult, and enslave the People of England'. He went on to attack the vast waste of national resources on war, the extremely dangerous extent of the Crown's influence, the way in which 'the system of corruption has reached its maturity', and called for 'the amputation of that dangerous tumour'. He declared that 'the crisis of our Country has arrived'. All identity of interest between government and governed had ended through 'this corrupt and inadequate system'. The French Revolution gave 'an awful warning'. He spoke of 'the brink of the frightful precipice' on which his countrymen were trembling, and of 'the necessity of their withdrawing themselves from its hollow and crumbling edge'.

There indeed was the very image of *Hannibal*. Turner could not but have heard Fawkes talking in this vehement vein over the recent years, and such comments from a man he respected and even loved cannot but have deeply affected him. As we have seen, he was not politically minded in the ordinary sense of the term; he belonged to no party and certainly had no scheme of reforms or controls that he wanted to see put into action. What he responded to were the moral and political analyses which dealt with the situation, with history, in their large-scale patterns, causes and consequences. The ideas of Thomson and other such social moralists of the last century had deeply affected him, and he would have interpreted Fawkes's radical sentiments in their

[68]

terms. We must not forget that in 1811–12 the Luddite movement was in full swing; the government sent more troops into Nottinghamshire than Wellington took with him to Spain; and while Turner was at Farnley in November 1811 there were bread-riots and loom-wreckings at Nottingham. Fawkes would have discussed and analysed them as evidence of the crisis he foresaw. Also, Turner could not but have read and pondered on the powerful speech made by Byron in the Lords on 27 February 1812 against the law decreeing death for men who broke up machinery; and a few days later he would have known that the first two cantos of *Childe Harold* were published. He would certainly have read the poem with keen interest and been moved by the account of the fight of the Spaniards for freedom against the fresh legions that 'pour adown the Pyrenees', and the contrast between the present state of the Greeks and their heroic past. Thornbury tells us that he prided himself on being well informed on all the leading issues of his day. For him the problem was to transform his emotions about the world, its events, its history, into art-images, into Historic Landscape.

Hannibal brought to a head Turner's fascination with vortex-systems that had begun with his 1796 sea-piece. The swirl of clouds and the dark wintry earth create a cavern in which a wild tension of forces is at work. He moves beyond all previous systems for holding the elements of a picture together. He has been exploring various ways of getting rid of a static interrelation of forms, using all sorts of contrary and resistant lines and curves together with diagonals, the pull or clash of form against form, the complex entanglement of patterns of light, structure, colour, and so on. Now he achieves full mastery of the circling vortex with its set of inner and outer strains and pressures. Foreground and distance are merged and separated by the turning and spiralling forces at play. The soldiers and the attacking local folk emerge as if momentarily, only to be swallowed again by the fury of mist and broken light, distinct and yet vanishing patterns of the storm. The surface pattern consists of a set of intersecting irregular arcs; one such arc is the main outline of valley and mountain, the other main arc lies in the underside of the clouds and swings down to merge with the first. M. Kitson comments: 'Another parabolic shape, with the sun as its focus, and

[69]

downward-sweeping clouds as its boundaries, overlays the first almost at right angles to it. There are further repeated arcs to the right where the snow falls, and other, smaller arcs which cut into the main ones. And so on.' Turner has created a fully dynamic system, in which the notion of nature as a set of dovetailed structures, neatly assembled, is discarded. Nature is realized as the process where everything is interacting in a pattern that is momentary and yet reveals underlying stabilities at the heart of instability, instabilities emerging from the stabilities.

The *Liber Studiorum* was to fail in the end, but it started Turner off on engraving projects. This year, 1811, W. B. Cooke, engraver and publisher, commissioned forty drawings for a work, *Views of the Southern Coast of England*; and in July Turner went off on the sort of sketching trip he had made in earlier years. For two months he moved about Dorset, Devon, Cornwall and Somerset, taking in all the coast from Margate to Land's End, round to Minehead, and making more than 200 pencil sketches. He called on some of his father's family in Barnstaple and Exeter, and wrote a long poem in couplets on the places visited, people seen, and so on. He interleaved the verse in his guide-book, Coltman's *The British Itinerary*. He invoked Thomson to aid him 'throughout the lingering night's career', so it seems that at night he meditated over the day's events for what incidents would best go into verses written 'by Nature's hands'. He sees 'arts and the love of war at mortal strife', and praises Magna Carta: 'To maintain its freedom all have died.' The conflict of the arts and the war-drive 'deprives the needy labourer of his life'. Ancient barrows and a Roman road attest 'the unconquerable germs that sway[s] the human mind'. He tells of the village school, Bridport twine, Poole Harbour:

> One straggling street here constitutes a town
> Across the gutters here Shipowners frown
> Gingling their money, passengers deride
> The consequences of misconceived pride.

He describes the dangers of Portland and Melcombe Sands, and of Scudland Bay; a girl who tended her father's cattle and who was raped by soldiers on her way back from market, so that she

went mad; and the wife of a fisherman captured by the French as he dropped his wicker-cages for lobsters. One confused passage speaks of foam's 'frail power undulating' and links it with village-spires as emblems of Hope.

He did thirty-nine drawings and used one that had been made for *Liber Studiorum*; other artists contributed to Cooke's publication as well. As usual Turner supervised the work of the engravers. His business links with Cooke continued until he quarrelled with him in 1826.

5. FALLACIES OF HOPE

The connoisseur Sir George Beaumont had for some time been attacking Turner and those affected by him as White Painters, because they stopped using the brown and black tones of earlier landscapists. He was now fulminating louder than ever. In April 1803 Callcott called on Farington and complained of the harm that Beaumont had done to him. 'He said Turner also suffered from the same cause, and has not sold a picture in the Exhibition for some time past. Turner called upon Callcott at Kensington a while since and then said that he did not mean to exhibit from the same cause that prevented Callcott, but has since altered his mind and determined not to give way before Sir George's remarks.' In the RA he showed *The Deluge* and *Frosty Morning*. The first work had been begun soon after his visit to Paris in 1802 under the influence of Poussin. He tried to add the elements that he felt Poussin had failed in: the latter's figures and the composition which did not convey 'the conception of a swamp'd world and the fountains of the deep being broken up'. The second work, *Frosty Morning*, was one of his masterpieces, a direct yet subtle representation of a scene at a given moment of time, of the day and the season. It was based on a sketch made during a Yorkshire trip, while he was being driven along. We see the early moment of a sunny day of winter. Hedgers and ditchers are starting work in the fields, a stage-coach is coming up with its lights still on. Both the horses were drawn from his own favourite nag, and the shivering little girl is his daughter Evelina. He added a line from Thomson, 'The rigid hoar frost melts before his beams', which describes precisely the phase of the day. The frost has begun to

[73]

thaw in a few places, so that the ground is brown; in the shadows the frost is still powdered white. The risen sun has not yet managed to dispel the mist. The leafless trees and the foreground weeds still covered with rime, the long shadows, as well as the heavy semi-silhouette of the forms, complete the definition. For once the critics agreed in praising the work, but no one bought it. Wilkie, with his lowlife genre-pictures, and his follower Bird had been gaining esteem; and the RA of 1813 had works by an old and a new painter who were attempting romantic works of dramatic force. Fuseli showed his Lady Macbeth with the dagger, and John Martin showed Sadak searching for the waters of oblivion. Martin had learned much from Turner and was to become famed for his pictures of catastrophe.

Turner's irritation at the praises of Wilkie and Bird appears in a poem he scribbled in a sketchbook:

> Coarse Flattery like a Gipsey came
> Would she were never heard
> And muddled all the fecund brains
> Of Wilkie and of Bird
> When she call'd Wilkie a Teniers
> Each Tyro stopt contented
> At the alluring half-way house
> Where each a room hath rented
> Renown in vain taps at the door
> And bids them both be jogging
> For while false praise sings to each soul
> They'll call for t'other nogging.

During this year, 1813, Constable first met Turner, sitting next to him at an RA dinner. 'I was a good deal entertained with Turner. I always expected to find him what I did. He is uncouth but has a wonderful range of mind.' In the summer Turner went to Devon. A companion, Cyrus Redding, editor of a newspaper at Truro, has given a detailed account of some of their trips. Once they went in a Dutch boat, 'with the usual outriggers (and undecked)'. There was a heavy swell, but Turner enjoyed the scene, sitting in the stern-sheets. 'When we were on the crest of a wave, he now and then articulated to myself – for we were sitting

[74]

side by side – "That's fine! – fine!" ' On Burr Island, while lobsters were being boiled, he climbed nearly to the highest point, and seemed to be writing rather than drawing. Next morning they set off for home, twenty miles away. 'A vehicle was provided, but we walked much of the way, for Turner was a good pedestrian, capable of roughing it in any mode the occasion might demand.' At Saltram next morning they climbed some high ground and Turner made sketches near the mouth of the Plym. They were staying with Lord Boringdon. Before Stubbs's *Phaeton and the horses of the sun*, he would only say, 'Fine.' On the way to bed he had to pass walls covered with paintings by Angelica Kauffmann of nymphs 'and men like nymphs'. 'I directed his attention to them, and he wished me "Good night in your seraglio." There were very fine pictures in Saltram by the old masters, but they seemed to attract little of his attention, though they might have drawn more than I imagined, for it was not easy to judge from his manner what was passing in his mind.' He liked plain fare, 'bread and cheese, bacon and eggs, and home-brew'. They were going to sleep on the floor of an inn, but it was damp. So Turner leaned his elbow on the table, put his feet on a second chair, and went to sleep. He paid his quota at the inns cheerfully; and he took part in a group of nine, with some ladies included, in a picnic on the top of Mount Edgecumbe. He was 'exceedingly agreeable for one whose language was more epigrammatic and terse than complimentary upon most occasions. He had come two or three miles with the man who bore the store of good things, and had been at work before our arrival . . . The wine circulated freely.'

Turner made a watercolour, *Plymouth Dock from Mt Edgecumbe*, which was engraved in his *Southern Coast*. In place of the picnic party he had enjoyed he put a group of sailors and their women singing and dancing in a wild cavorting way to a wooden-legged sailor with a fiddle. Redding adds that Turner himself 'somewhat resembled the master of a merchantman'.

In 1814 he exhibited two Historic Landscapes. The first, at the British Institution, was *Apullia in Search of Appulus learns from the Swain the Cause of his Metamorphosis*. Turner had misread the phrase Apulian Shepherd as a proper name and invented a wife for him, though he had seen Claude's picture of the Shepherd's

Transformation at Bridgewater House. In Ovid, *Metamorphoses* XIV, the Shepherd appears briefly. He mocks and insults a group of dancing nymphs, and is turned into a wild olive tree, the fruit of which has a harsh taste. Hazlitt, remarking that Turner's pictures were usually 'a waste of morbid strength', which pleased only by 'an excess of power triumphing over the barrenness of the subject', found *Apullia* admirable, since Turner had added only his great powers of eye, hand and memory to a borrowed system of taste and imagination. Well indeed might he make this comment, since *Apullia* is so like Claude's picture of Jacob, Laban and his daughter, which was at Petworth, that it might be called a copy. The composition is almost identical, though Turner adds a more delicately shimmering atmospheric effect. There are six figures instead of four, but this is hardly noticeable, since the figure on the right has the same uplifted arms and billowing veil. There is another odd aspect of the work, the invention of a mythological character and incident. There is no Apullia in Ovid. Why did Turner invent her and her quest? Perhaps Sarah had been chasing after him for some misdemeanours and asking questions: Where had he disappeared to? Turner may well have thought the harsh wild olive a good synonym for himself. Where had he gone? He had become part of a landscape.

More important was *Dido and Aeneas* at the RA. This deals with the love of the hero and the Carthaginian Queen. Carthage is being built but in her love-obsession Dido halts the work. At this point the rivalry between Rome and Carthage has not yet begun, but the pause in construction is perhaps meant to suggest what will happen when the conflict matures. The passage from the *Aeneid*, in Dryden's translation, deals only with the happiness of the moment.

> When next the sun his rising light displays,
> And gilds the world below with purple rays,
> The Queen, Aeneas, and the Tyrian Court,
> Shall to the shady woods for sylvan games resort.

He had sent his *Apullia* to the British Institution in 1814, his first picture there since 1809, and entered into the competition for a premium of £100. *Apullia* had none of the elements that upset

the conventional in his other works, and one feels that he was challenging Beaumont, one of the directors, to find fault with it. However, the prize was given to Hofland with a far inferior work, and Turner could at least feel that he had proved the prejudice against him. Beaumont still refused to see any good in his work and declared that he painted 'in a false taste'. He insisted always that Turner's oils were a mere translation of his watercolour methods into the medium of oils. An anonymous academician replied in a pamphlet in 1815, attacking him and his fellow directors as seeking to dictate taste and deny any new developments in art by their praise of an archaistic kind of imitation.

Turner had an important group of pictures in the RA of 1815. *Crossing the Brook* depicts a scene in South Devon, but in Claudean style with a cool palette. The diffused clarity of light, the bridge in the middle-distance, the framing trees, are very Claudean in effect, though Ruskin suggests that the latter are based on some studies of pines. Turner seems to have got his idea from a painting (1803) by a minor artist, H. Thomson, of two girls crossing a brook on stepping-stones, but he transforms the image and its meaning. The girls here are his daughters. The elder, Evelina, has crossed the flowing waters and has become a woman; Georgianna is nearing puberty, but still lingers on the edge of childhood. Above Evelina, and ahead, looms the cleft that often plays a crucial role in Turner's pictures; here it provides the passage between foreground and distance, the vaginal passage from the familiar present into the still obscure future, the haze and lure of the unknown.

In *Dido Building Carthage; or the Rise of the Carthaginian Empire* he again drew on Claude in a joyous harbour piece. Here was the completion of the city interrupted by the arrival of Aeneas, suggesting in every way a triumphant expansion of empire and trade. Turner himself felt it to be his masterpiece; he left it to the nation on condition that it was hung between two Claudes. We see Dido, amid her generals and architects, standing before the heroic harbour of hope. Each figure, as in *Hannibal*, contributes to the total effect. Two girls in the foreground watch boys pushing out toy boats. (Here we have the important Jason motive that we earlier analysed in Turner's poetry.) There is a

Claudean motif in the great tree on the right, dark against the light, yet itself light-fused, with the golden rays of the rising sun spreading everywhere.

The Battle of Fort Rock was a very different work. He had in 1802 made a drawing of the scene. Here, looking back to Mont Blanc, he showed in strong clear forms the narrow space, the mountain road, the valley between wooded slopes. He used a restricted set of washes, with highlights scratched through the grey ground on to the white paper. Then in a large watercolour which is difficult to date – 1805–10 – he brought human figures in. Three girls lean and stare over the stone wall on the left into the ravine, surprised and awe-struck. Their reaction is stressed by a sheer vertical waterfall at their back, which comes down under a narrow bridge. What catches the eye is the strong central perspective (as in the early drawing). In 1815 the elements of the scene are the same, but dynamic interrelations have been added. The casual figures are supplanted by two armies furiously clashing. Instead of the waterfall we see the battle going on along a narrow bridge; the chasm below has become a black crevasse. The girls are gone, and instead a countrywoman with child helps a wounded soldier. Smoke surges round the rocky fort. Right at the back is Mont Blanc amid furious clouds, and the valley cuts right into the core of the design, so the right side is cut away, a savage precipice with waters falling down deep into the gorge. Turner has achieved a unity of rhythm embracing both wild nature and human beings in mad conflict. This point is stressed in the lines from *The Fallacies of Hope*. Now the descent into the plain is to be simply destructive.

> The snow-capt mountain, and huge towers of ice
> Thrust forth their dreary barriers in vain;
> Onward the van progressive forc'd its way,
> Propell'd, as the wild Reuss, by native Glaciers fed,
> Rolls on impetuous, with ev'ry check gains force
> By the constraint uprais'd; till, to its gathering powers
> All yielding, down the pass wide devastation pours
> Her own destructive course. Thus rapine stalk'd
> Triumphant; and plundering hordes, exulting, strew'd,
> Fair Italy, thy plains with woe.

[78]

The destructive forces of nature and mankind are seen as one. The work is best taken as a companion-piece to *Hannibal*, with clear precipitous mountain-structures instead of vortical storm turmoil. (The battle had occurred in 1798: Turner was painting shortly before Waterloo.)

The same exhibition had *The eruption of the Souffrier Mountains, in the island of St Vincent, at midnight, taken from a sketch made at the time by an eye-witness*. We may note that Mallet in his *Excursion*, in a passage describing earthquake and eruption, links them with disease and madness 'boiling o'er outrageous fancies, like the troubled sea, foaming out mud and filth', while in another passage he identifies such cataclysm with 'the tyrant's law' and 'the arm of Power extended fatal' to crush where it should protect. Must we 'homage hell' or bend the knee 'to earthquake or volcano when they rage'? (Turner knew this poem well and borrowed from it a phrase 'congregated clouds', which is repeated three times in a poem of his own.) We may well feel that there is a link between his fascination with scenes of natural violence and the furies he had seen his mother let loose: the Face of Nature (an eighteenth-century phrase) in convulsions.

In this context it is of interest to note how often the critics saw madness in his works. In 1806 the critic of the *Oracle* remarked before *Schaffhausen*, 'This is madness', and John Taylor, editor of *The Sun*, agreed: 'He is a madman.' Hoppner talked of his tendency to imbecility. In 1814 Hazlitt had seen 'a waste of morbid strength', and in 1823, 'visionary absurdities . . . affectation and refinement run mad'. *The Atlas* wrote of his *Boccaccio* of 1829, 'It would excite pity if painted by a maniac', and the *News* saw a daub of the most ridiculous kind: 'The whole group seems more like Bedlam broke loose than a family of ladies and gentlemen.' *The Times* in 1831 declared that Turner 'disgraced the high powers that dwell in him by caprices, more wild and ridiculous than any other man out of Bedlam would indulge in'. Richard Westmacott of the RA said of his exhibits in 1831, 'Only one was very mad – a Medea raving in the midst of her bedevilments and incantations. You can conceive how Turner would out-Herod Herod in such matters.' *The Athenaeum* in 1838 wrote, 'It is grievous to us to think of talent, so mighty and so poetical, running riot into such frenzies; the more grievous, as we fear, it is

[79]

now past recall.' Thackeray in 1839 wrote that Turner's exhibits 'are not a whit more natural, or less mad'. Thornbury, his biographer, carried on the tradition when he said of Turner's later work, 'the colour, that of fireworks, rising almost to insanity, and occasionally sinking into imbecility.' (A variant was to declare that he was afflicted with a diseased eye.)

Turner must have suffered greatly when he read or heard such abuse. It must have raised up the image of his mother in Bedlam, and if anything could have sapped his self-confidence, this would surely have done so. But it seems never to have deterred him in the least.

We saw how much he esteemed classical architecture. In 1799 Lord Elgin, appointed ambassador to Constantinople, invited him to join the party for the purpose of drawing Greek buildings and the sculptures which composed the Elgin marbles. But he offered a low salary and Turner refused the proposal. Later in 1806 Elgin let Turner see the drawings made by Tito Lusieri, and Turner wrote to thank him. 'Your Lordship's collection is perhaps the last that will be made of the most brilliant period of human nature.' He cited Horace in Latin and wanted very much to know Latin and Greek; for a while about that time he took lessons in them from Trimmer, to whom he gave art-lessons in return. We noted how he used the Roman phalanx as a model of united action in his speech reported by Frith. His most effective joke using classical ideas was his reference to McAdam, the developer of new road-surfacing, as the Colossus of Roads (Rhodes). We have seen many themes from ancient history or poetry coming up in his work, and more are to come up. In 1816 he exhibited *The Temple of Jupiter Panellenius restored* and *View of the Temple of Jupiter Panellenius, in the island of Aegina, with the Greek national dance of the Romaika: The Acropolis of Athens in the distance. Painted from a sketch taken by H. Gally Knight, Esq. in 1810.* The Greek war of independence did not start until 1822, but sympathy for the cause was already stirring. In 1814, for example, the Philiki Etairia of the Philomuse Society was formed; Britain's seizure of the Ionian Islands from Napoleon that year was a strong stimulus to the Greeks to revolt. Turner was probably first aroused to think about the Greeks, past and present, by Byron. He made a pen-and-ink design of a classical composition

with alternate titles: *Homer relating to the Greeks his Hymn to Apollo*, and *Attalus declaring the Greek States to be free*, perhaps about 1810.

Gally Knight had been a school-companion of Byron, and while travelling in Greece, 1810–11, he met him in Athens. He would have talked to Turner about him – though later Byron attacked him for his 'mountebank's mediocrity'. In July 1816 Turner in a letter speaks of a visit to Knight at his place in Yorkshire, Langold Hall. Knight supplied Turner also with a sketch of Parnassus used in preparation of an undated engraving by Cooke. The Temple in Aegina was of Aphaia, not of Zeus of All the Hellenes, but the mistaken attribution made it a good symbol of Greek unity. In his painting Turner added the modern national dance to underline the reference to the contemporary struggles for Greek independence, and the distant view (not possible in fact) of the Acropolis to strengthen these points. A watercolour of the Acropolis, dated 1822, which belonged to Fawkes, was inscribed with misquoted lines from Byron's *The Giaour*, "Tis living Greece no more.'

His continuing interest in the Greek cause is shown by his watercolour, *Fish-market, Hastings*, 1824, done when the struggle for independence was at its height. He added Greek figures at the edge of the crowd, as if they were trying to draw the attention of the English to their cause. In *Nottingham*, celebrating the passing of the 1832 Reform Bill, the flag of the new state of Greece (1831) flies from the mast of a canal boat.

He made a watercolour of the Aegina temple for C. R. Cockerell, who had excavated it with the Bavarian architect Baron Haller von Hallerstein; he showed the excavators at work with the disinterred sculptures lying round them. Gally Knight was offered a share of the sculptures for £2,000, so that he could give them to the British Museum, but refused. In 1812 all the finds were bought by the future Ludwig I of Bavaria, who outbid the Prince Regent. Ludwig built the Glyptothek of Munich in 1816 for the works, and the architect he employed later built the Walhalla in Doric style. (In 1842 Turner painted *The Opening of the Walhalla*.) In 1821 Cockerell ordered several drawings of the Aegina temple; his main loves were Turner's paintings, Beethoven's music, Walter Scott's writings. Around 1832

Turner did a view of Corinth (for a Bible illustration) after a drawing by Cockerell, and around that time he did his illustrations to Byron, which included views after drawings by younger artists who had been to Greece, mostly architects such as T. Allason and Sir C. Berry. Several of his Greek views in the Byron illustrations were bought by H. A. J. Munro, for whom he went to Venice in 1833. He himself, for all his love of ancient Greece, never went further east than Italy.

In 1817 he showed *The decline of the Carthaginian Empire*, in which he summed up his views on the inevitable result of expansion by war and trade: another Claudean harbour-piece with splendid buildings on either side of the water and with the litter in the foreground expressing this time disorder and breakdown. Disconsolate figures gather between the waters of sunset. The picture had a long explanatory notice: 'Rome being determined on the overthrow of her hated rival, demanded from her such terms as might either force her into war or ruin her by compliance; the enervated Carthaginians, in their anxiety for peace, consented to give up even their arms and their children.' His poem links the collapse of Hope with the ominous stormy sunset, the sun of blood, that pervades the scene.

> At Hope's delusive smile,
> The chieftain's safety and the mother's pride,
> Were to th'insidious conqu'ror's grasp resign'd;
> While o'er the western wave th'ensanguined sun,
> In gathering haze a stormy signal spread,
> And set portentous.

The various drafts suggest that he was thinking of the situation after Napoleon's defeat and of the falsities of any imposed peace. 'Held forth the peaceful olive but round the stem insidious twined the asp.' 'Revengeful twined the asp.' 'Urged her fresh demands to break the league to give but colour to her purposed hate.'

Much of 1817 was taken up with work for the engravers. He applied for permission to omit his lectures for that year. Refused, he applied again, speaking of the pressure of his 'present engagements'. He was let off. Visiting the Continent on a hasty

tour, he went to the site of Waterloo and explored the Rhine from Cologne to Mainz, sailing back from Rotterdam about the middle of September. A note in a sketchbook gives some idea of the things he carried on his travels.

Lost in the Walett. A Book with Leaves ditto. Campbell's Belgium. 3 Shirts. 1 Night ditto. A Razor. A Ferrel for Umbrella. A pair of Stockings. A waistcoat. ½ Doz. of Pencils. 6 Cravats. 1 Large ditto. 1 Box of Colors.

In England he went to Durham where he had commissions. From Raby he wrote to the watercolourist Holworthy that Lord Strathmore called and took him off further north. Then he went to Farnley. He had been moving about fast: 'my fugitive disposition from place to place'. Around Langold was only 'the brown mantle of deep strewed paths, and roads of mud to splash in and be splashed – as you have got me in the mud so I hope you will help me out again . . . The day of the Season is far spent the night of winter near at hand and Barry's words are always ringing in my ears – Get home and light your lamp.' Holworthy was about to marry a niece of Wright of Derby and Turner was helping him in some building operations. 'Every one seems happy why do you delay, for the world is said to be getting worthiless, and needs the regenerating power of the allworthy parts of the community.' Turner had probably been present when Barry in 1793, in his eulogy of Reynolds, spoke the quoted words. The context would have been close to Turner's heart. 'And exercise yourselves in the creative power of your art, with Homer, with Livy, and all the great characters, ancient and modern, for your companions and counsellors.' This year 1817 Turner's own daughter, Evelina, was married to Joseph Dupuis of the consular service.

He had sold to Fawkes the entire set of fifty-one views of the Rhine that he had made. Though in various stages of finish, none of these had reached the stage at which he would have exhibited them; and indeed when Fawkes held his own show in 1819 they were not mentioned in the catalogue. Turner would certainly not have sold any such drawings to anyone whom he did not consider a close friend. He used a few of the Rhine subjects as the

[83]

basis for finished watercolours a year or so later. The drawings, based on pencil sketches, have some affinities with the direct freshness of his work on the Thames, but they almost all developed as carefully considered compositions, with their grey ground used to give a dark richness. Round this time he was also drawing at Farnley, at times using chalk sketches, at times making very precise records. Some of the drawings, however, show a particular freedom of attack, which suggests the strong affection he felt, the personal closeness that made him feel inside the scene as well as observing it topographically from outside.

In 1818 he gave his lectures twice weekly so as to get them over quickly. Dupuis was appointed Consul for Ashantee in West Africa, and Evelina went off with him. Turner seems to have taken no interest in her after that. In his will be could not even remember how to spell her married name, giving it as Dupree. He seems more interested in buying some land at Twickenham, which he had perhaps already decided to leave for the use of decayed artists. On 4 June he went with the Fawkeses to see the Eton boat-race (Fawkes had two sons at the school). 'Little Turner came with us,' Mrs Fawkes noted. He was hard at work with the engravers, and in late October went to Scotland to get material for a work to which Scott was to write the text. He stayed about two weeks, returning to London by coach with a stop at Farnley. He does not seem to have been in good spirits. In Edinburgh, after he had breakfasted with one family, they found his manner so cold that they cancelled a party arranged in his honour. The sister of his host explained, 'finding him such a *stick*, we did not think the pleasure of showing him to our friends would be adequate to the trouble and expense'. Nicholson, a portraitist, did arrange such a party, but Turner did not turn up. He probably met Scott, who was not attracted to him. Next year Scott warned a close friend, 'Turner's palm is as itchy as his fingers are ingenious and he will, take my word for it, do nothing without cash, and any thing for it. He is almost the only man of genius I ever knew who is sordid in these matters.'

During his stop at Farnley in November he let young Hawkey, about fifteen years old, watch him at work. One morning at breakfast Fawkes remarked, 'I want you to make me a drawing

of the ordinary dimensions that will give some idea of the size of a man of war.' Turner chuckled and said, 'Come along, Hawkey, and we will see what we can do for Papa.' They sat together the whole morning as Turner produced *The First Rate taking in stores*. He 'began by pouring wet paint onto the paper till it was saturated, he tore, he scratched, he scrubbed at it in a kind of frenzy and the whole thing was chaos – but gradually and as if by magic the lovely ship, with all its exquisite minutiae came into being and by luncheon time the drawing was taken down in triumph.'

In the 1818 RA he showed *Dort, or Dordrecht; the Dort packet-boat from Rotterdam becalmed* and *The Field of Waterloo*. To the latter he attached lines by Byron comparing the lusty life of the day before the battle, and the horror after it, with 'rider and horse – friend, foe, in one red burial blent'. After the battle the government had set up a Committee of Taste to judge designs for commemorative monuments, and the British Institution offered a prize for a picture adequately dealing with Waterloo. Tourists were flocking to the site. The guidebook by C. Campbell that Turner lost in his wallet stated that 'Waterloo has become a kind of pilgrimage', and cited the poems by Scott, Byron, Southey. Turner made a watercolour of the scene as he saw it littered with dead, then an oil-painting. In the first he showed only the dead in a night-scape with garish moonlight and a rocket in the distance; in the second he adds the womenfolk of the soldiers who had come up to see if they could help. They hunt in a distracted way among the dead and beg for news from any of the wounded who can speak. The flares would have been fired in the hope of helping any men still alive. (The rocket thus suggests the up-flare or spire of Hope.)

The work seems to have struck home when exhibited. *The Morning Herald* first found it 'solemn and striking', then called it an abortive attempt, a failure. *The Annals of the Fine Arts* declared: 'Before we referred to the catalogue, we really thought this was the representation of a drunken hubbub on an illumination night, and that the host, as far gone as his scuffling and scrambling guests, was with his dame and kitchenwenches looking with torches for a lodger and wondering what was the matter.' *The Sun* saw that the picture was about 'the effects of battle'; the

[85]

Examiner said it depicted the way that wives, brothers, sons come 'to look at Ambition's charnel-house after the slaughtered victims of legitimate selfishness and wickedness'.

Turner had taken very seriously the question how best to depict the scene. He made sixteen sketches on the spot. The road from Brussels to Nivelles, with the farms of La Haye Sainte and La Belle Alliance at right angles to Hougaumont, was drawn several times from opposite directions, as was the ground with its various ups and downs. He even drew plans, illustrating his route from north to south to west, and what each scene meant to him. He scribbled: '4,000 killed here', '1,500 killed', 'Entrance Gate of Hugomont forced 4 times', 'Hollow where the great Carnage took place of the Cuirassiers by the Guards'. Nearly twenty years after his visit he returned to the theme with watercolours to be engraved for Scott's *Prose Works* and *Life of Napoleon*, and for Byron's *Works*; an engraving was also made of the 1818 painting. Stormlight or moonlight is important in the new works, and there is no glorification of the event. It has been well commented by A. G. H. Bachrach:

> As a total conception, *The Field of Waterloo* may be read as representing a new mood of post-Napoleonic cultural pessimism that had previously only been embodied in Turner's Carthaginian compositions. In its synthesis of actuality and imagination it is the embodiment, in contemporary terms, of classical decline-and-fall emblems: as such it is not an expression of nostalgic resignation but, instead, of fierce and embittered revulsion – indeed of a social criticism as personal and eloquent as that of the best Romantic poetry of the time.

It brings to a definite contemporary point of reference the political dissidence that we saw beginning in 1798 with the reading of Campbell and the linking of medieval ruins with tyranny and popular resistance.

In the same show he had *Dort*. Here is a very different work, with a clear sky, with mild yellow and gold in the ship and the water-reflections. The ship represents the constructive side of human beings. The master to whom Turner looks is Cuyp. As he

himself walked round Dort harbour-basins and canals he made his sketches. Here we find the material of the painting, especially in the sketch, 'Dead calm. Water lighter in the Nort' (the river). In Amsterdam he saw Rembrandt's *Nightwatch* – he used the French title, *Corps de Garde*. Though the imagery of this picture and of Turner's *Waterloo* are totally different, he may well have drawn inspiration from it for his picture of carnage. The Waterloo dead included men of the 3rd and 5th Guards, and he had filled nearly a whole sketchbook with Guards' uniforms. The *Nightwatch* must have stirred him with its elements of the Sublime, what Burke called 'the quick transition from light to darkness and darkness to light'.

In 1819 Turner had in the RA another Dutch sea-piece, *Entrance of the Meuse*, with subtitle: 'Orange-merchant on the Bar, going to pieces; Brill Church bearing S.E. by S. Masensluys E. by S.'. Here the shipwreck element is underplayed. The ship going to pieces is at the back, almost lost in spray and mist, while all interest is centred on the large array of varied clouds drifting or towering above. Warm punctuation-points in the waves are provided by floating oranges. *England: Richmond Hill, on the Prince Regent's Birthday* was a more ambitious project, over 70 by 131 inches in size, the largest picture that he ever painted. Here is a Claudean structure of a piece of the Thames that he much liked, a vivaciously naturalistic version of the paradise of *Mâcon*. The figures play an unusually important role, even the busy dog, and give the work an informal quality (whereas in *Thomson's Aeolian Harp* of 1809 the treatment is far more classical). Elements of Watteau infuse the figures, and though Turner has not yet moved far from the traditional handling of light and shade, there is much subtlety in the interrelations. (He perhaps did the work in rivalry with a large piece by Hofland at the British Institution; Hofland had beaten him for the premium when he sent in his *Apullia*.) To the picture he appended lines from Thomson: 'Which way, Amanda, shall we bend our course?' ending: 'Or ascend, while radiant summer opens all its pride,/Thy Hill, delightful Shene?' Summer richness is what suffuses the painting.

This year Sir John Leicester showed his collection to the public in Hall Street, London; it included eight oils by Turner. Soon

[87]

afterwards Fawkes also exhibited his collection of watercolours by British artists. There were 60 to 65 by Turner out of 85 or 90. Leicester had no Turners later than 1809, while Fawkes had works from the first Swiss tour on to that of the Rhine in 1817. Between those dates he had several English scenes, mainly of the region near Farnley. The pictures he owned revealed how Turner had moved from the formal elements of eighteenth-century approach to increasing delicacy and strength of light and colour, deepening control of aerial perspective. Fawkes had also bought *Dort*.

In the years between 1812 and 1819 Turner had extended his grasp of the various genres or methods he had been developing. Following *Hannibal* he had built up his epical works expressing what he felt most deeply about history, and had made a powerful contemporary application with his *Waterloo*. He was freeing his colour-sense, though he had yet to make the decisive steps to seeing colour as an aspect of structure, as indeed the structure of a scene, not something added to form or a mere atmospheric element however important in its unifying effects. He had thoroughly absorbed his main influences, Poussin in historic catastrophe, Claude with his great harbour-views as well as his tree-framed landscapes in fine recession, van de Velde or Cuyp in their treatment of ships and the sea in its endless moods. He had transformed the topographical approach in works like *Windsor*, *Petworth*, *Somerhill* and *Raby Castle*, with their impressive central structure transformed by swirls or drifts of mist, of diffused and penetrating light. To some extent his manipulations or recon-structions aimed at a unified composition (one unified in all its aspects, not merely in its design) at times obtrude themselves, but he was moving towards a position where the unifying system would more and more emerge dynamically from the scene itself. Hazlitt had recognized the direction in which he was moving when he declared that his pictures were 'too much abstractions of aerial perspective, and representations not properly of the objects of nature as of the medium through which they were seen'. The result was that Turner's pictures dealt with 'the elements of air, earth and water. The artist delights to go back to the first chaos of the world, or to that state of things, when the waters were separated from the dry land, and light from darkness, but as yet

[88]

no living thing nor tree bearing fruit was seen on the face of the earth.' Hazlitt thus puts the case in a negative way and describes the analytic method, but not its results. 'All is without form and void. Someone said of his landscapes that they were *pictures of nothing and very like.*' The new depth of unifying vision is seen only in terms of the way it breaks down conventional systems of representation, not in terms of the new vital totality that keeps on emerging.

We noted how Turner started his lectures as Professor of Perspective in 1811. Though he had much to say of his ostensible subject, he tried all along to link his ideas with his views of art-process, his elevation of History in its union with landscape. *The Sun* said of his first lecture that it was 'rather introductory than technical, and principally tended to show that the highest order of Historical painters, as well as Architects and Sculptors, availed themselves of the principles of Perspective in their most distinguished productions. He illustrated this with success by a reference to the print of Raphael's celebrated *Transfiguration* and a geometrical design of the subject.' The diagrams were generally held to be successful. Stothard, who was deaf, was asked why he attended the lectures; he replied, 'Sir, there is much to *see* at Turner's lectures – much that I delight in seeing, though I cannot hear him.' Not that any of the audience seem to have heard him very well. Redgrave wrote:

Half of each lecture was addressed to the attendant behind him, who was constantly busied, under his muttered directions, in selecting from a huge portfolio drawings and diagrams to illustrate his teaching; many of these were truly beautiful, speaking intelligibly enough to the eye, if his language did not to the ear. As illustrations of aerial perspective and the perspective of colour, many of his rarest drawings were at these lectures placed before the students in all the glory of their first unfaded freshness. A rare treat to the eyes they were.

Some 200 large drawings and diagrams that he thus used have survived; some of them deal with the construction of shadows, with (in Ruskin's words) 'measured gleams of moonlight on the

[89]

pillar of Trajan, and dispositions of chiaroscuro cast by the gaoler's lantern on the passages of Newgate'. There were coloured studies of reflection and refraction, displayed on glass balls empty and half-filled with water – the balls drawn by themselves and then in contact, showing reflections of each other.

As the years went by Turner lost his interest in the talks. He had himself excused in 1809, 1817, 1822 and 1823, and gave no lectures after 1828, but he carried on with the professorship till he resigned in late 1837. We can make out many of the ideas that he struggled to set out and clarify. He tried to define the relationship between poetry and art, and the points at which rules broke down and the artist's intuitive comprehension of natural process took over. We see how deeply he attempted to grasp all that optics could teach him. 'The eye must take in all objects upon a Parabolic curve for in looking into space the eye cannot but receive what is within the limits of extended sight, which must form a circle to the eye.' Such views must have helped him towards his systems of circling or vortical forms of organization. He makes clear that he does not abstract the problems of perspective, of form, from those of light and shade, of colour. 'Lineal pictures then is the parent of Light & Shade and Light and Shade is that of Color. Each reciprocal elevating.' He sees form by its very nature involving a complex unity of light and shade, and the resulting tonal systems by their very nature begetting colour. Reflections greatly interested him. (One reason why he loved fishing was that it enabled him to watch the movements and reflections in water.) The 'more minute investigation' of them, he held, 'may in the end discover positive axioms'. He thought that 'anyone must be sensible how much has been done by Reflexies in the British School and how much remains to be done', so that 'it becomes the peculiar study of our lives'. He goes on to muse and argue about the indefinite transmission and dispersal of light by an endless series of reflections from an infinite variety of surfaces and materials, each of which contributes its own colour mingling with every other, piercing finally to every lair and recess, everywhere reflected, 'plane to plane, so that darkness or total shade cannot take place while any angle of light reflected or refracted can reach an opposite plane'. He was expressing a point of view that went far beyond that of any artist

or thinker of his time, one that was to have powerful effects later in nineteenth-century art and that still has unrealized significances. 'We must consider every part as receiving and emitting rays to every surrounding surface.'

Further implications of his concept of a dynamic totality in nature are brought out in his comments on Opie's *Lectures on Painting*, 1809. He was irritated by Opie warning against 'a superficial study' of nature and art.

> He that has that ruling enthusiasm which accompanies abilities cannot look superficially. Every glance is a glance for study: contemplating and defining qualities and causes, effects and incidents, and develops by practice the possibility of attaining what appears mysterious upon principle. Every look at nature is a refinement upon art. Every tree and blade of grass or flower is not to him the individual tree, grass or flower, but what it is in relation to the whole, its tone, its contrast and its use, and how far practicable: admiring Nature by the power and practicability of his Art, and judging of his Art by the perceptions drawn from Nature.

He gives high praise to Wilson, and oddly identifies him with the Cicero in one of his pictures. Some of those pictures displayed 'contending elements' but did so in vain, unappreciated. In vain did 'Cicero at his Villa sigh for the hope, the pleasures of peaceful retirement, or the dignified simplicity of thought and grandeur, the more than solemn solitude that told his feelings. In acute anguish he retired, and as he lived he died neglected.' Turner's strong feelings entangle his constructions. The Cicero in the painting turns passionately into the Wilson who painted him. The man and his art are fused.

He pays a strong tribute to Gainsborough, who, he says, took over the positive qualities of the Dutch while avoiding their trivializations.

> His first efforts were in imitation of Hobbema, but English nature supplied him with better materials of study. The pure and artless innocence of the *Cottage Door* now in the

possession of Sir John Leicester may be esteemed as posses-
sing this class, as possessing truth of forms arising from his
close contact with nature, expression, full-toned depth of
colour and a freedom of touch characteristically varied
with the peculiarities of the vigorous foliage or of decaying
nature.

With sure judgement he selects one of the paintings of a cottage
on a slope with a woman at the door: the image in which
Gainsborough most powerfully expressed his desire to enter into
the life of the peasantry (go through that door).

The conflict he experienced as he tried to take over what he felt
to be valuable in Claude, yet resisted the temptation to see only
the Claudean elements of harmony in nature, is revealed in his
comments. He praises wholeheartedly 'the golden orient or the
amber-coloured ether, the midday ethereal vault and fleecy skies,
resplendent valleys . . . rich, harmonious, true and clear, replete
with all the aerial qualities of distance, aerial lights, aerial colour'.
Then in one draft he adds that 'all of the valuable freshness and
beauties' draw the spectator 'to deny that nature never did or
could appear so artificially deceitful'. But on second thought he
cut out the qualification, no doubt recalling how he himself was
accused of reconstructing nature to please himself. He analyses
Poussin's compositions and praises his 'antique and allegorical
allusion'. At one point he praises his 'purity of conception un-
charg'd with colour or of strained effects', yet finds his *Deluge*
deficient in line, though admirable in colour. *Pyramus and Thisbe*
he finds truly sublime:

> whether we look upon the dark, dark sky sparingly illu-
> mined at the right-hand corner by lightning there rushing
> behind the bending trees and at last awfully gleaming, her
> power reborn, its dying efforts upon some antique build-
> ings on the left, while all beneath amid gloom scatter'd
> foliage and broken ground lies the dying figure of Pyramus.
> And in the depth and doubt of darkness all is lost but
> returning Thisbe.

In Lecture IV he tries to define the powerful effects to be gained

by contrasts of ascent and descent. Discussing Titian's *St Peter Martyr* he refers to the sublimity of the 'arrangement of lines which by its unshackled obliquity and waved lines obtains the associated feelings of force'. Then some pencil and ink additions describe this effect as 'eruptive expanding', a 'continuity, that rushes with the ignited spark' or flame, 'struggling in the ascent from Earth to Heaven'. He then brings in the image of a rocket: 'and when no more propelled by the force, it scatters around its falling glories' (or 'ignited embers') 'seeking again its parents' (or 'Earthly Corner') and 'while diffusing around its living radiance in the descending cherub with the palm of Beatitude to the dying Martyr, sheds the mellow glow of gold th[r]o the dark embrowned foliage'. This passage brings out the importance to him of the rocket or flare image, noted above with regard to *Waterloo*, which is linked in turn with the spire, the column of smoke, and other such images, as an expression of Hope, of union between earth and sky.

6. REDEEMING LIGHT

Turner had been meaning to visit Italy for some years, now that peace had been declared. He had been delayed by the long sketching trip in Yorkshire and Lancashire in 1816, and by a large number of professional engagements in 1817–18. In July 1819 Farington had a letter from Sir Thomas Lawrence who was painting portraits of the Pope and a cardinal for the Prince Regent.

> Turner should come to Rome. His genius would be supplied with materials, and entirely congenial with it . . . He has an elegance, and often a greatness of invention, that wants a scene like this for its free expansion; while the subtle harmony of this atmosphere, that wraps everything in its own milky sweetness . . . can only be rendered, according to my belief, by the beauty of his tones.

He felt that Turner more than even Claude himself 'approaches, in the *highest* BEAUTIES of his noble works, nearer to the fine lines of composition, to the effects, and exquisite combinations of colour, in the country through which I have passed'. Claude, we may note, had been born in the French region of Lorraine in 1600; he went to Rome through his patron, a duke who played an important role in the Thirty Years War and who commissioned him to do works for his villa, as if to commemorate the Peace of Westphalia in 1648. He had just done the landscape with dancing figures often called *The Marriage of Isaac and Rebeka*, in which he used his Mill theme (his other theme was the Harbour). The Mill

peacefully carries on amid the bountiful beauties of nature, with earth and water providing food for all living creatures. He painted in a troop of soldiers to whom the Mill (of Peace) is pointed out. He then painted *The Embarkation of the Queen of Sheba*. The sun, just rising over the horizon in *Marriage*, is here well up in the sky, sending a warm blessing on the Queen's mission of peace and union. We see then that Claude's own work holds allegories close to those which Turner embodied in his Claudean landscapes.

At the start of August Turner nerved himself for his first visit to Italy, where he would at last meet the world on which Claude had based himself. The packet-boat left Dover at 10 a.m. but did not arrive in Calais for five hours, so the passage must have been rough. He took the diligence next morning for Paris. There was heavy rain throughout the journey, two days and nights. Then from Paris he seems to have taken the first coach to Lyons, using the *malle-poste* through Sens and Auxerre (as in 1802 on his way to Switzerland). He then passed through Grenoble, Chambéry, Modane and Lanslebourg, over Mont Cenis to Turin, where he stayed some days. Next, via Como, he made a tour of the Lakes, and went, via Milan and Verona, to Venice, where he seems to have spent a fortnight or more, if we may judge by the number of sketches made. Next he went to Bologna, Rimini, Ancona, and on by the usual post-route to Rome, arriving mid-October.

He carefully noted the colour of the hills and olive-groves: 'the ground reddish green-grey and apt to Purple, the Sea quite Blue, under the sun a warm vapour, from the Sun Blue relieving the shadow of the olive Trees dark, while the foliage light or the whole when in shadow a quiet grey'. At Venice in a canal the water was 'dull green', with 'very dark reflections of the Boats', the sky grey and fleecy, 'all the steeples blood red'. On one of the calves in a sketch of calves and wagon, 'Dun Brown, Claude'. Then, in a distant view of Loreto, 'The first bit of Claude'. Later, at Tivoli, 'Grey Castle, Claude'. At Frascati, 'Wilson–Brown Campagna'.

A letter in *The Literary Gazette* said that he had arrived to paint the most striking views of Rome for the Prince Regent; but that was an unfounded rumour. On 15 November the poet Tom Moore 'went at half-past five with Canova, Sir Thomas

Lawrence, Chantrey, Jackson, and Turner [four Royal Academicians] to the Venetian Academy of Painting [where Canova first studied when he came to Rome]. From thence we all went to the Academy of St Luke's ... All dined together except Canova, who has not dined from home these twelve years. Went in the evening to Lady Davy's, and had some music.' Moore also relates a tale told him by a Colonel Camac. Camac was standing one day in the tower of the Capitol when Turner and the Princess of Denmark were there. The wind was bothering the Princess, so Camac, who did not know her or Turner, snatched the latter's umbrella and held it over the Princess. Much to Turner's annoyance the wind blew the umbrella inside out and broke some of the ribs.

In late October Vesuvius began erupting and Turner hurried to watch it. His sketchbook shows that he went via the Pontine Marshes. Two other books have sketches of Pompeii, Amalfi, Sorrento, Salerno, Paestum, Herculaneum, and the first stages of his return from Naples to Rome. A fourth book, dated, shows that he was at or near Albano on 9–11 November. Soane's son wrote about him in November:

Turner is in the neighbourhood of Naples making rough pencil sketches to the astonishment of the Fashionables, who wonder of what use these rough draughts can be – simple souls! At Rome a sucking blade of the brush made the request of going out with pig Turner to colour – he grunted for answer that it would take up too much time to colour in the open air – he could make 15 or 16 pencil sketches to one coloured, and then grunted his way home.

Between the time of arriving in Rome and departing he made nearly 1,500 pencil sketches, besides going on trips to Tivoli, Naples, Paestum. After spending Christmas in Florence, he set off in January for home. Heavy snow had fallen, but he took the coach that was to cross Mont Cenis. At the top of the Mont the coach turned over and the travellers had to climb out of the window, while 'the guide and Cantoniers began to fight'. He and the others then had to walk, 'or rather flounder up to our knees, nothing less, in snow, all the way down to Lancesleyburgh', the

road being 'filled up by snow and only known by its precipitous zig-zag'. On his return he painted for Fawkes a picture of the scene just before the coach capsized.

The visit to Italy marked a crucial point of development in his work. In many ways all his previous search and achievement had been leading up to this moment, and all his work thereafter was marked by the experiences of 1819. We may thus call it a turning-point in his life and art. Not that there is a sudden or simple change. He had been moving steadily, if also along complex lines of experimentation and achievement, towards the discovery of Italian light and all it meant in validating so many aspects of his restless search; but the actual experience was nonetheless strong and inspiring. He had been moving away from the old systems of organizing a picture by tonal contrasts, towards a vision of nature based on colour contrasts and harmonies, colour as mass and structure. Now he felt himself confirmed in the truth of that vision. But with all his strong dependence on theory, on certain guiding ideas and methods, he was never doctrinaire; he always held that the artist must return to nature and test his systems in terms of natural process, actual phenomena. So he still for some time turned out works closely linked with those of his pre-1819 definitions.

Back in London, he felt the need to tackle oils. He seems to have worked on two big canvases. One, a view of the Grand Canal, Venice, was never finished. The other he managed to complete for the RA summer show: *Rome, from the Vatican; Raffaelle, accompanied by La Fornarina, preparing his pictures for the decoration of the Loggia.* We have here a panoramic view of the city taken from the gallery of the Loggia, into which Raphael, aided by his mistress, has taken a number of pictures to be hung up as decorations; they include not only the Madonna della Sedia, but also a landscape by Claude. The first point of the picture is then that it depicts a great artist in the midst of Rome, in a sense dominating the city. (Raphael had died just 300 years before: which may be one reason for thus commemorating him.) The picture was not well received. What is overwhelmingly success-ful in it is the powerful use of perspective. There is a mastery of the counterpoint of curves, especially in the arch of the loggia in opposition to the ellipse of the piazza. In the foreground the

connections are brought about by an optical illusion of opening a broad space under the loggia's arch through which a broad expanse of Rome can be viewed. As Andrew Wilton observes:

> The city lies in shimmering heat, with golden stucco and pink roofs, and with the snow-capped mountains beyond; and this is the theme of many of the watercolour studies in the Rome C[olour] Studies book. Here it is translated into the medium of oil, and on to a much larger scale, so that we are almost in the world of the great Panoramas which Robert Barker had made so popular in London. The cultural importance of the Vatican in the life of Rome as a whole is conveyed both by the parts of it that we see through the arch, especially Bernini's piazza – an anachronism, of course, if we think of the picture as an historical piece – and by the perspective of the arcade to the right, which suggests the great treasures of art that Rome possesses.

For the interior Turner used the careful pencil notes he had made on the spot. He was no doubt working at the same time as the oil on the two watercolours, *Rome from Monte Mario* and *Rome from the Pincian*.

But to understand just why Turner painted *Rome from the Vatican* we must consider his situation at home while he conceived and carried out the work. He had decided to do much rebuilding of premises at Queen Anne Street, which were connected with his Harley Street house. In a letter to Wells in November he recounts how his second gallery was disrupted during its building. 'Aladdin's palace soon fell to pieces, and a lad like me can't get in again unsheltered and like a lamb. I am turning up my eye to the sky through the chinks of the Old Room and mine . . . However, joking apart, if I can find a day or two I'll have a peep at the North Side of Mitcham Common.' He says that whenever he has been absent something has been done wrong, 'or my wayward feelings have made me think so, or that had I been present it wouldn't have occurred, that I am fidgetty whenever away'. At the time he painted his picture, he and his mistress (Sarah seems still with him for a few years more) were putting the pictures against walls or furniture for rehanging or

storage. He was then in the same position as Raphael, though his thoughts were with Rome not with London, so that in memory, imagination, and on the canvas his vision was of Italian light and Roman forms.

His thoughts were turned from the RA. He sent in nothing in 1821, and only one picture in 1822 and 1823, none in 1824, two in 1825. After that he went back to his number of four or five. His 1822 picture, *What you will*, depicted a garden with statues and women in fancy costumes. *The Literary Gazette* described it as 'a pretty piece of colouring, something in the style of Watteau'. In 1823 he exhibited *The Bay of Baiae, with Apollo and the Sibyl*, painted in blues and greens merging into warmer Mediterranean colours. Constable remarked of it, 'Turner is stark mad with ability. The picture seems painted with saffron and indigo.' The composition looked back to *Mâcon* and *Apullia*. He was picking up the theme of *Aeneas and the Sibyl*, his first full classical piece, of 1800. There was something of an identification of himself with Aeneas, the wandering hero devoted to his father, with a mother not of this earth, who linked the stories of both Carthage and Rome. In poems jotted down about 1811 he jokingly identifies the mating cave of Aeneas and Dido with Pope's Grotto at Twickenham: 'So Eneas retired/And Dido required/Both practice and practical care.' And 'Lecher lie still/To lie on and look at his ease/Ah Dido know howe.' (There is some punning joke about a man named Howe.) The Grotto is mentioned five times, and there are more jokes about peeping. 'Dogs neer look ere they leap' (copulate). Aeneas consulted the Sibyl before descending into the underworld. For Turner the meeting of Sibyl and Aeneas or Apollo (god of light, poetry, art, in his eyes) represented a crucial moment of choice, a new and difficult self-dedication to the earth, to fate. In 1800 he was about to make the full plunge into the sphere of History and all it entailed; now in 1823 he seeks to sum up his actual experience of the earth, the remains of the Roman world and of Claude's domain, which he had undergone on his Italian visit. The painting has a line of verse: 'Waft me to Baiae's sunny shore'.

At the end of 1821 he went on a hurried visit to Paris, and made sketches there as well as at Rouen, Dieppe, and on the Seine. On 10 December he was at a party given by Wilkie. 'Turner had

never been to see me before, but we found him a good humoured fellow, neither slack in wit himself, nor loth to be the cause of wit in others.' He spent Christmas at Farnley and made drawings of the historical objects of the Cromwellian period that Fawkes had collected. His notes show that Fawkes had owed him £750 at the start of 1821 and, as the money was not paid, interest was charged. At the year's end Fawkes owed £960 15s.

In February 1822 Cooke held a big show at his premises in Soho Square of drawings (which included works by Raphael, Claude, Reynolds, Gainsborough, Wilson and so on); his main aim was to show the watercolours Turner had made for his publications and to sell those already engraved. (The show was a success and Cooke repeated it in 1823 and 1824.) In June Turner was one of the twenty-three guests at the marriage of Fawkes's daughter Anne in London. Mrs Fawkes noted: 'Had a large party to dinner. All tipsey.' This year Turner's new gallery was opened.

In August he travelled by sea up to Scotland. One aim was to be present during George IV's state visit to Edinburgh. Wilkie was there in an official role and was surprised to see Turner, who managed to paint George at a banquet in a work never exhibited. He also made sketches to be engraved for *Rivers of England*, and was still sketching for Scott's *Provincial Antiquities of Scotland*, though he had not come to know Scott himself at all well. His main concern seems to have been to finish his sketches and hurry south to Farnley Hall.

He was busy with work to be engraved for publication. In the summer of 1825 he visited Holland, Belgium, North Germany; in 1825 he went to France and Germany to sketch the rivers Meuse and Moselle. Meanwhile in 1823 he did a very large painting of the Battle of Trafalgar. He had been commissioned to paint it for the royal collection as a companion piece to de Loutherbourg's *Battle of the First of June, 1794*. He decided to make it as acceptable as possible and asked the King's Marine Painter, Schetky, for studies of the *Victory*. In the first painting the view was down through a tangle of sails, masts, rigging; now he used a more conventional angle of approach, and tried it out in two oil sketches. But the kind of work he aimed at as a suitable companion to de Loutherbourg was not one into which he could

[101]

thoroughly throw himself; and the result pleased nobody. Sea-
men did not find it correct despite all the trouble he took. When it
was hung in the Palace, he was 'criticized and instructed daily by
the naval men about the Court, and during eleven days he altered
the rigging to suit the fancy of each seaman', wrote his friend, the
history-painter George Jones, 'and did it all with the greatest
good-humour'.

Some notes on the proof of an engraving, written in Novem-
ber 1824, show us the kind of advice that Turner gave to the
craftsmen:

> You ask me for my opinion. First I shall say in general *very
> good*, secondly the Figures and Barracks excellent; but I
> think you have cut up the Bank called Shorne Cliff too
> much with the graver by Lines [diagram] which are equal in
> strength and width and length, that give a coarseness to the
> ... quality, and do not look like my touches or give work-
> like look to the good part over which they are put – The
> Marsh is all a swamp. I want flickering lights upon it up to
> the sea, and altho' I have darkened the sea in part yet you
> must not consider it to want strength ... Get it into one
> tone, flat, by dots or some means, and let the sea and water
> only appear different by their present lines.

In 1825 he exhibited at the RA a big port-view, *Dieppe*, which
like *Dort* owes much to Cuyp and carries further *Dort's* radiance.
Turner was now back on his sea-themes. In August, before
leaving for Holland, he dined with Fawkes, who was not well.
This seems their last meeting. On 25 October Fawkes died. His
death was a great loss to Turner.

In 1826 Turner exhibited *Cologne, the arrival of a packet-boat,
evening*, which carries on the work of *Dieppe* with its golden
light. (This effect was in part due to the tempera ground, on
account of which he gave strict orders that the paintings should
not be allowed to get wet.) He also showed *Mortlake Terrace*. The
lawn, which overlooked the Thames not far from his own
Twickenham house, was depicted in the early morning, with the
sun casting long shadows on the still-wet grass. (In 1827 he
showed another view of the house, from a different angle, him-

self facing another way, into the glow of the summer evening.) This year the financial crisis, begun in 1825, worsened. Turner, who, with his peasant hoarding habits, would never have thought of putting money in a bank or in investments, joked about it. 'Look at the crash in the commercial world of mercantile speculation, and the check which must follow . . . Every one for himself, but at a more rapid trot notwithstanding steamboats, liability banks, and stoppages.' At worst he might lose some money by the bankruptcy of publishers. Scott was ruined by such a failure, and the Fawkeses were badly hit by a failure at Wakefield. Turner helped them generously. This year he sold Sandycombe Lodge. In January 1826 he wrote, in thanking his friend Holworthy for the gift of a turkey, 'Daddy now being released from farming thinks of feeding.' He added, 'Alas! my good Auld lang sine is gone . . . and I must follow; indeed, I feel as you say, near a million times the brink of eternity, with me daddy only steps in between as it were.' In a December letter to the same friend he says, 'I am fixt by Exhibition's log; in the summer I have to oil my wings for a flight, but generally flit too late for the trout, and so my round of time. I am a kind of slave who puts on his own fetters from habit, or more like what my Derbyshire friends would say an Old Bachelor who puts his coat on always one way.' He has heard that Callcott was getting married.

Late in 1826 he quarrelled with Cooke. The latter wrote him a long letter on the first day of the next year. He accused him of trying to get for past work the sum that had been offered for further work; and he said that a drawing which Turner gave him as a present and he himself gave to his wife, was later demanded back, with a charge of two guineas for the loan. 'You maintain a mistaken and most unaccountable idea of profit and advantage in the new work of the "Coast".' He ended, 'I have met in return such hostile treatment that I am positively disgusted at the mere thought of the trouble I have given myself on such a useless occasion.'

In 1827 Turner exhibited two contrasted works. *Port Ruysdael* depicted a squally bit of coast (with a name invented to pay tribute to the Dutch painter); a ship heaves on the outer line of water under masses of rearing clouds. Turner thought specially

[103]

of Ruysdael on three occasions: 1802, when he painted *Calais Pier*; this year; and 1844 when he again summoned up his invented port in a scene reminiscent of that of 1827. The latter attempts an improved version of the Ruysdael he had studied in the Louvre and made detailed notes about. His other work in the RA was *Rembrandt's Daughter*, an indication of the increasing interest he was paying to that painter. Near the end of July he went to the Isle of Wight to stay with the architect John Nash, who was in high favour with the King, turning from the Brighton Pavilion to reconstruct Buckingham Palace. Nash had a fine house on the brow of the hill opposite West Cowes, which had excellent views of the Roads, the starting-point and course of the races in the Regatta. Turner filled four sketchbooks with pencil drawings of yachts, ships, the Solent, as well as views of Nash's castle with its battlemented towers. He also made nearly fifty chalk sketches on blue paper of yachts. He even made oil paintings – an unusual thing for him on such tours. He had got his father to send him two unstretched canvases, each 3 by 4 feet, and on these painted nine direct sketches of the August Regatta, ships, and the interior of a man-of-war's mess-deck. At least some of these were probably painted aboard a boat anchored off-shore.

In 1826 he had shown at the RA *Forum Romanum*, but this was still rather a manifesto of the fact that he had seen and taken in the materials of Rome and Italy, not yet a full absorption of the new aesthetic elements. Not that those elements do not assert themselves in the high key of colour and the way in which the reflections under the arches are lighter than the sky. The high framing arch and the entrance curving in the shattered masonry give a powerful effect of the entry into a new world of sensibility, which is one with the discovery of the ancient world. The new elements, however, begin fully to assert themselves in the Cowes sketches, perhaps because he is no longer thinking in manifesto terms but is letting his sensibility have something like its full play. There are delicate colour-glazes and stronger notes in the skies, while near objects, boats or figures are given solidity by means of a thick impasto, where texture is provided by the use of thumb-nail or brush-handle. This latter method appears already in the painting of George IV in Edinburgh at the banquet, and it

is stressed in sketches that depict the regatta-boats beating to windward. In yet more developed form it appears in the two paintings of the Regatta that he sent to the RA in 1828. There is a special mastery in *The Regatta starting from their moorings*, with the view taken directly into the sun.

In the same show he had *Dido directing the equipment of the fleet, or the morning of the Carthaginian Empire*, which he may even have begun at Cowes. Here he seeks to revive once more the world of Dido, of an expanding society in its first stages before the Fallacies of Hope intervene to bring out the disastrous contradictions. He feels that his new grasp of the Italian splendour of inter-penetrating light will give his theme a new depth. At the same time he exhibited *Boccaccio relating the tale of the Bird-cage*, a rich picture with many figures in what we may call his Stothard–Titian style.

Two watercolours of the second half of the 1820s (for *England and Wales*) expressed his sense of the danger of war and the triumph of peace. *Great Yarmouth* showed the naval hospital and the stark vertical monument to Nelson (topped with Britannia) in the centre; behind lay the North Sea fleet at anchor under an ominous sky. *Dockyard, Devonport* showed 'ships being paid off', with the storm passing away.

It was some nine years since he had visited Italy. During those years we have seen him attempting a wide variety of themes, ideas, methods, without being able to come down clearly on a single comprehensive line of advance. Much of his time indeed had been taken up with work for the engravers, for series such as the *Rivers of England* or *Picturesque Views in England and Wales*; and he was beginning the illustration of books of poetry. Working on Rogers's *Italy*, he discovered the virtues of the vignette for his purposes; with its open edges all round, it enabled him to treat forms dynamically, cutting into them or giving them a free space for rhythmic balance. Perhaps it was Rogers's book that made him want to see Italy again, to test how much he had learned there and how effectively he had been developing those lessons ever since his work at Cowes. In August he left for Rome.

This time he was determined to get fully to grips with the Italian scene by painting pictures at Rome. For the first and only time he had a studio outside his own premises. He arranged for

the painter and scholar C. L. Eastlake, who was in Rome, to get the studio for him. 'Order me whatever may be necessary to have got ready, that you think right, and plenty of the useful, but nothing of the ornamental; never mind gimcracks of any kind.' He wanted, he says, to paint a companion piece for the Claude owned by Egremont. He was writing from Paris, and made a leisurely way to Rome, via Orleans, Lyons, Arles and Marseilles, then Nice, Genoa, Spezzia, Florence and Siena. It took him nearly two months, and he suffered from the heat, 'particularly at Nismes and Avignon, and until I got a plunge into the sea at Marseilles, I felt so weak that nothing but the change of scene kept me onwards to my distant point'. In mid-October he set up in the Piazza Mignanelli.

In Rome he could not help being much in the public view. Eastlake shared the same house and noted his frugal way of framing a canvas with painted rope, and the way he prepared his pictures with 'a kind of tempera'. He made sixteen strong oil-sketches, again on two rolls of canvas. He was above all concerned with clear concentrated colour. White impasto, with big splotches of brilliant blue, marks *Lake Nemi* and *Fishing Boat in a Mist*, while splashes of white vivify the waterfalls and foreground of *Tivoli, the Cascatelle*. The colour remains vivid whether he is defining a scene richly permeated with sunlight or heavily stormy as in *Archway with Trees by the Sea*. Three finished works he exhibited in his studio, despite the fact that they were the exact opposite of the style then exciting Rome, that of sharp outline and sober colour in the work of the Nazarenes. (These were a group of German artists, many of them converts to Catholicism, who wanted to regenerate religious art in the style of Dürer, Perugino, the young Raphael. They had settled in Rome, working in a deserted monastery. They influenced the Pre-Raphaelites.) The works that Turner showed were *Regulus*, *Orvieto*, *The Vision of Medea*. The last-named work was rather like the sketches in its bold direct handling, with the texture of the rough Italian canvas coming through. *Regulus* took up afresh the theme of Carthage against Rome. Regulus, a Roman hostage, is being tied up with the sun in his face while his eyelids are cut off so that he will soon be blinded. The intensity of the light is thus an aspect of the emotional theme and helps to express the

ferocious antagonism between the two empires. *Orvieto* used the Claudean framework, but with light bursting through into a great distance of undulating land.

Turner studied Titian's *Venus of Urbino* at Florence on his way to Rome and began a reclining Venus as his own version of the same sort of picture. He visited the Sistine Chapel and was interested in the work of a group of English sculptors headed by John Gibson, who had settled in Rome. In January 1829 he set off home. He meant to return soon, so he kept on his room. A fellow traveller has given an account of him on the journey back.

> I have fortunately met with a good-tempered, funny, little, elderly man, who will probably be my travelling companion throughout the journey. He is continually popping his head out of the window to sketch whatever strikes his fancy, and became quite angry because the conductor would not wait for him while he took a sunrise view of Macerata. 'Damn the fellow!' says he. 'He has no feeling.' He speaks but a few words of Italian, about as much of French, which two languages he jumbles together most amusingly. His good temper, however, carries him through all his trouble. I am sure you would love him for his indefatigability in his favourite pursuit. From his conversation he is evidently *near kin to*, if not *absolutely* an artist. Probably you may know something of him. The name on the trunk is, J. W. or J. M. W. Turner!

The diligence foundered on Mont Cenis as it had done on his first journey. He arrived in London in time to attend the meeting when Constable was elected an Academician by only one vote. Canvassing unsuccessfully the year before, Constable had written to Leslie, 'I am sorry that Turner should have gone growling to Chantrey, but I recollect that I did not quite like the whites of his eyes and the shake of his head.' But now Turner rushed round to inform Constable of the results.

The pictures he had done in Rome, despatched by sea, did not arrive in time for the 1829 show; but he had developed one of his Roman sketches into *Ulysses deriding Polyphemus*. (In a sketchbook dated about 1807 he had several studies for ancient themes:

Ascanius, Dido and Aeneas, Chryses, Ulysses and Nausicaa, Ulysses and Polyphemus.) The painting showed the triumphant departure of Ulysses and his men in their galleys, the baroque splendour of which is based on the boat in Etty's picture (1821) of Cleopatra arriving in Cilicia. Turner seems to have known Poussin's treatment of the scene, where also Polyphemus rages on top of a crag; but his composition looks back to the 1807 study. In its paint he let loose all the sense of luxurious colour that had been building up in him since 1819, a tumult of golds, reds, yellows, leading into the sun above the waters at the end of the passage of escape, salvation, between ships and rocks. In a way the composition is dominated by Polyphemus raging aloft, almost merged with the clouds, with the dangerous forces of nature; and this effect is stressed in a sketch of the composition, which is sombre in its hues. But the moment is one of escape, victory, with the sea-nymphs, the friendly forces of nature, rejoicing round the ships. Ulysses sailing off into the sunrise is Turner in his rich mastery of light and colour on a new level. He also showed *The Loretto necklace*. At Loretto, we noted, he recorded that he had first seen the Italian landscape as a clear bit of Claude. The bridal moment of his painting records his own happy union with the earth in terms of his new vision of light and colour.

He had meant to return to Rome for another year, but he wrote to Eastlake that he dreaded the journey in time of heat, and then his resolution failed him altogether. He made a short visit to Paris, Normandy, Guernsey. He was probably held back from a long stay abroad by his father's failing state. The latter died in September, aged eighty-five, a sad blow. The day after the funeral Turner signed and sealed his first will. The document survives only in a rough draft in his own hand. He left £50 a year to each of his two daughters, and to Hannah Danby, and £10 a year to Sarah herself. We may assume then that she had other means of support and that her close relations with him had been ended for some time. The girls are described as the daughters of Sarah Danby, widow of John. He left also the sum of £50 to each of his two paternal uncles and £25 to the eldest son of each of them; £500 to the Artists' General Benevolent Institution, funds to the RA for a Turner Gold Medal and a Professorship of

Landscape Painting. The rest of his property was to go to a charity or college for 'decayed English artists (Landscape Painters only) and single men', to be built on his Twickenham land, with a picture gallery and small houses each side for the Keeper and the artists.

In January of the new year Lawrence died and Turner went to his funeral, making a highly finished watercolour of it from memory afterwards. Elections for President were held. Turner was not even considered for the office. He no doubt expected to be treated like that, but would have been hurt none the less. After the funeral he had written to George Jones, who was wintering in Rome and who had been a pall-bearer: 'Who will do the like for me, or when, God only knows how soon; my poor father's death proved a heavy blow upon me, and has been followed by others of the same dark kind.' In March he wrote to Clara Wells, 'Dear Clara, I must not allow myself the pleasure of being with you on Saturday to dinner! Time Time Time So more haste the less Speed.' And he drew an overturned varnish-jar spilling on to the floor, with palette and brushes turned into a human head staring with a look of outraged horror.

Yet despite the dismay he now confessed, in general during recent years he must have felt an increasing confidence and happiness in his work. The *Dido* of 1828 and the two paintings of 1829 were all based on a rejection of the pessimism of *The Fallacies of Hope*.

The same sense of breakthrough appears in the pictures he did for Lord Egremont. They carry on the new freedom of the Cowes sketches. In *Ship Aground* the long swell of the sea is balanced by the delicate expanse of blue-grey sky with sunlight asserting itself in the fine orange passages integrated into that expanse and at the same time suggesting a steady recession. In *Petworth Park* and *Chichester Canal* we meet contrasted versions of rich sunsets, both of which however use compositions in which horizontal structures dominate. Hounds and deers, and their shadows, lead the eye into the distant point of fading light in the first; in the second the banks draw us across the shining water to the masted ship and the sun at its moment of dipping over the horizon of level hills. Turner achieved the precise effect of that moment by imposing the sun, a rough circle of disappearing

light, as a bit of yellow impasto stuck on over the faint purplish-blue of the hills. He has quite given up the method of defining shadows by dark browns and greys.

For some time he had been experimenting with compositions made up wholly of colour masses. They have generally been called Colour Beginnings (after A. J. Finberg, the first important scholar and biographer dealing with Turner), but that is a misleading term for it suggests that he was merely trying a general lay-out of the main colours in a painting before going ahead with the work. No doubt he at times did just that, but the main significance of these experimental works, which we can call Colour Structures, was to clarify his conviction of colour as an essential aspect of natural process, as light in its movement, refraction, reflection. He was going as far as possible to oppose the old conventional idea of light as a transparent medium that merely revealed the forms of objects and their inherent colour. Light-as-colour, colour-as-light, were vital elements in the total structure of nature: they existed as active aspects of process as well as components of a situation.

About 1830–1, in the watercolour *Dudley*, he made a comprehensive definition of what he felt industrialism was doing to England. The central factory-chimney is in a line with the church-spire above, and there is no structural system in the town, only an enveloping grey-mauve with slight tonal differentiations. The setting sun sends a faint farewell-glow on to ruined castle and priory. (The steam pumping engine on the left was not in fact put in until 1841.) Ruskin commented: 'One of Turner's first expressions of his full understanding of what England was to become.'

7. STORMY DAYS AND INNER MEANINGS

In 1830 at the RA Turner had a varied lot of pictures illustrating the range of interests that now obsessed him. There were two Italian views: *Orvieto*, 'painted in Rome', and *Palestrina*; two figure compositions, showing his deepening study of Rembrandt, *Pilate Washing his hands* and *Jessica*; two sea-scapes, *Calais sands, low water, Poissards collecting bait* and *Fishmarket on the sands — the sun rising through vapour*. He also sent along his watercolour of Lawrence's funeral. *Palestrina* had been meant as a companion for the Petworth Claude, but Egremont preferred to buy *Jessica*, a girl in contemporary clothes who leans out of a window. Three lines from *Fallacies* linked *Palestrina* with Hannibal on the heights:

Or from yon mural rock, high-crowned Praeneste,
Where, misdeeming of his strength, the Carthaginian stood,
And marked with eagle-eye, Rome as his victim.

There were Rembrandtian elements in *Jessica*, but also something of Gerard Dou (a pupil of Rembrandt in his early days who produced small scenes of everyday life). In *Pilate*, however, the composition has strong resemblances to the shadowy interiors of Rembrandt with people drawn close together; but there was a basic difference. Instead of the dark tones merging the figures, with strong contrasts of invading light, Turner sets the key high in a rich pervading light and uses colour for effects both lyrical and dramatic, as with the red of the Virgin's robe and the blues and greens of the surrounding clothes. As a result there is nothing

[111]

of the concentration of theme that Rembrandt could have achieved. The movement of light and colour over the surface begets instead an exciting tumult. The main event is blocked out by women who have their backs turned to it as they face the Virgin who has her back turned to us, her lumpish form grotesquely swathed in clothes. The light falls luxuriously on two of the women, making them the chief point of interest. In *Jessica*, Shylock's command provides the text: 'Shut the window, I say.' Come away from the temptations of the world.

But what was the impulse that led to the theme of *Pilate*? Turner cites St Matthew 27:24, with Pilate saying, 'I am innocent of the blood of this just person'. The theme is then the way in which people, society, seek to throw off responsibility for the crimes, the murders, perpetrated in their name. It has its links with the general message of *The Fallacies of Hope*, but does not seem to have been inspired by any particular event. If we may judge by the lines to *Palestrina*, his mood seems to have changed from the optimism of the 1828–9 pictures. However that may be, in *Orvieto* he continues to show how he could paint without using black in the conventional way to express the absence of light, though black could still be used for an emotional or symbolical reason. At the same time, by raising colour generally into a higher key of pure lustre, he gave it a new and stronger expressive power. *Orvieto*, like the *Sunset* with fighting bucks in Petworth Park, reveals a new unity of colour dynamically moving over the broken surface of paint. The two pieces of 1830 dealing with fishermen show his resolve to keep on applying each new lesson he learned to the depicting of the sea in its endless moods and the struggles of men to master it.

During the 1830s Turner deepened his connection with Petworth. Lord Egremont was an easy-going and tolerant man, with a genuine enthusiasm for art, which he more and more turned towards contemporary work. The diarist Creevey said, 'He has a fortune, I believe, of £100,000 a year, and never man could have used it with liberality and profusion as he has done.' Haydon observed, 'The very animals at Petworth seemed happier than in any other spot on earth.' Such a place was just what Turner needed to relax, now he had lost the refuge of Farnley Hall. He seems to have been there in late 1830 and early

1831; and perhaps it was then that the sculptor Chantrey was also there. Jones tells us:

> When Turner painted a series of landscapes at Petworth, for the dining-room, he worked with his door locked against everybody but the master of the house. Chantrey was there at the time, and determined to see what Turner was doing; he imitated Lord Egremont's peculiar step, and the two distinct raps on the door by which his lordship was accustomed to announce himself; and the key being immediately turned, he slipped into the room before the artist could shut him out, which joke was mutually enjoyed by the two attached friends.

During his stays Turner made a hundred or so colour-sketches on grey paper.

He had again a varied set of pictures at the RA in 1831. There were sea-pieces, one dealing with the Dutch wars in 1645, another with an action off the French coast in 1805; a third was called *Life-boat and Manby apparatus going off to a stranded vessel making signal (blue lights) of distress*, which was done for John Nash. The last-named showed how Turner kept up with developments connected with ships and the sea. George Manby had invented a life-saving apparatus after seeing a shipwreck when he was barrack-master at Yarmouth; this year he became a Fellow of the Royal Society. He used a mortar to throw a stone over the distressed ship, with a rope attached to it. A smoke-puff on the beach in Turner's picture marks the shooting of the stone; we can just make out the lifeline against the sombre sky. The trails of the signals of the endangered ship can also just be distinguished. Here we see the motive of the rocket or flare, but in a new form. The projectile, instead of representing disaster or destruction, shows men taking control and using the spurt or burst of force in a constructive way. (Around 1830 he tried his hand at an earlier theme, *The Vision of Jacob's Ladder*, perhaps painting over his first attempt. Here in mythological form was the image of heaven and earth securely linked in an active traffic up and down; but Turner could not develop it in a way that satisfied him.)

[113]

In 1831 he showed a picture of the ancient world with the moral of social collapse: *Caligula's palace and bridge*. The shimmering light almost absorbs and dissolves the building. His poem links the great ancient works with Baiae's bay, the place of the artist's initiation into the full meaning of art and life, the place of Aeneas or Apollo and the Sibyl:

> What now remains of all the mighty bridge
> Which made the Lacrine lake an inner pool,
> Caligula, but mighty fragments left,
> Monuments of doubt and ruined hopes
> Yet gleaming in the morning's ray, that tell
> How Baia's shore was loved in times gone by?

During the hanging of this picture there was a clash with Constable. David Roberts, RA, describes it in terms favourable to Turner, who, he says, 'was ever modest of his abilities, and I never remember him uttering a word of disparagement of others. Of a contrary disposition was Constable, ever talking of himself and his works, and unceasing in his abuse of others.' Roberts says that Constable's *Salisbury Cathedral* was put in the place where Constable, who was on the hanging committee, had first put Turner's *Caligula's Palace*. At an evening reception just before the opening of the exhibition, Turner 'was down upon him like a sledge-hammer; it was no use his endeavour to persuade Turner that the change was for his advantage, and not his own. Turner kept at it all the evening, to the great amusement of the party.'

Turner also showed a mythological piece, *The Vision of Medea*, done on coarse canvas which was often left more or less bare for textural effects. This was indeed a wild composition, with Medea whirled in the billowing wind and nymphs or handmaids heaped before a sort of dark cavern between leaning trees with *putti* and blown bubbles around. Indeed Medea seems wielding some sort of bubble-making instrument. The lines from *Fallacies* tells us:

> Or Medea, who in the full tide of her witchery
> Had lured the dragon, gained her Jason's love,

Had filled the spell-bound bowl with Aeson's life,
Yet dashed it to the ground and raised the poisonous snake
High in the jaundiced sky to writhe its murderous coil,
Infuriate in the wreck of hope, withdrew
And in the fired palace her twin offspring threw.

We are not surprised that *The Times* fell back on the insinuation
that Turner was mad; it spoke of the figure-paintings as 'caprices
more wild and ridiculous than any other man out of Bedlam
would indulge in'. Turner's poem suggests some love-disaster;
but his connection with Sarah must now have receded into the
past and we know of no new mistress. In June he made a second
will, close to the first but couched in more correctly legal terms.

There was yet another painting of importance in the 1831 RA,
Watteau Study by Fresnoy's rules. It shows the artist painting in
front of admirers; the style of the work is rather that of Stothard,
and the way that pictures and other objects such as a lute are
scattered about suggests Raphael in the Vatican. If so, we should
expect Watteau to be another self-image of Turner. Perhaps we
here have Turner as he felt when he painted in the luxurious
surroundings of Petworth, making studies of the ladies about the
house or gardens. In any event there is a reference to the use of
white which links with some of his recent experiments in
technique, though the accusation that he was a White Painter
goes back to the early days of Beaumont's depreciations. He
added in the RA catalogue: 'White, when it shines with unstained
lustre clear,/May bear an object back or bring it near. *Fresnoy's
Art of Painting*'. Charles de Fresnoy (1611–65) was a French
painter whose poem on art had for long a high reputation.

The publisher Cadell was seeking to draw Turner into
illustrating Scott's poems. Turner had known them at least from
1811, and in the early 1820s had done four watercolours illus-
trating them for Fawkes. In March he agreed to Cadell's pro-
posals. Scott agreed to receive him though, despite his genius,
he was hardly pleasant company. He finally himself wrote to
Turner, inviting him to Abbotsford. In April he suffered a
stroke. Turner, not knowing of this, wrote accepting the
invitation; and Scott, despite a speech impediment, had
recovered enough to be pleased at his letter and began planning

how best to use the visit. Cadell went to London to see Turner and was surprised to find him 'a little dissenting clergyman like person [with] no more appearance of art about him than a ganger'. Turner refused to go by sea; he wanted to take the land route so that he could sketch along the way. He went via Manchester, Penrith, Carlisle, and took two weeks. Then he went with Cadell to Scott and made several trips to sites linked with Scott and his works. At times, as when they went to Smailholm Tower, Scott accompanied Turner and Cadell; and at times there was much jollity, as when at Sandyknowe Farm they had a second lunch of 'whisky, gingerbread, cheese, nice bread and cool nice milk' provided by the farmer's comely wife. (Back at Abbotsford, Cadell was surprised to find Turner engaging in a long, involved discussion with a visitor about phrenology and physiognomy.) At another dinner Scott repeated many old ballads and poems, and the meal was punctuated by 'fun and jaw'. Scott had found much in Turner that surprised and charmed him. Turner was cheerful, co-operative, enraptured by the rolling countryside of the Vale of the Tweed, deeply aware of the relation of landscape to people, to history.

On 9 August Turner left with Cadell for a tour along the Tweed, to Berwick, and then by coach to Edinburgh. As they passed Norham Castle, Turner is said to have taken off his hat and made a bow, and to have done three sketches, saying, 'I made a drawing or painting of Norham several years since. It took; and from that day to this I have had as much to do as my hands could execute.' He left Edinburgh on 15 August 'in good glee' on the Dunfermline coach. From Stirling he travelled west, visiting sites like Loch Long and Inverary. He then went on, probably by sea, to Oban. There he took a steamer to the Isle of Skye and went in a small boat to Loch Coriskin, where, climbing up for a good view of the beach, he lost his footing on the smooth stony slopes, and 'but for *one* or *two* tufts of grass' he would have broken his neck. He called the Loch 'one of the wildest of Nature's landscapes'. In a watercolour he exaggerates the geologic formations to give an effect of cataclysmic sweeps and upheavals. He next went on to catch a steamer, *Maid of Morven*, that plied between Staffa and Iona. He wrote later how a strong wind and head-sea prevented them from reaching Staffa until it

[116]

was too late to go on to Iona. 'After scrambling over the rocks on the lee side of the island, some got into Fingal's Cave, others would not. It is not very pleasant or safe when the wave rolls right in. One hour was given to meet on the rock we landed on.' To make up for the failure to get to Iona the captain promised to sail thrice round the island. 'The sun getting towards the horizon, burst through the rain-cloud angry, and for wind.' They were driven for shelter into Loch Ulver, and did not get back to Tobermoray before midnight.

He was one of those who scrambled into the cave, for he sketched views from inside it, which he developed in illustrations to Scott's *Poetical Works*. But the most important expression of his experiences on the trip was the painting, *Staffa, Fingal's Cave*, shown in 1832. It was his first oil showing steam-power though he had used the motive in a few watercolours of the 1820s. Above the turbulent sea the ship sails round into the gathering dark, into the sullen orange-red of the setting sun, its smoke trailing back against the lividly white vapours that are blotting out the headland. (The same black and grey, the same opening burst of white light, the same deadly sun, appear in *Hannibal*.) The painting remained unsold for thirteen years until C. H. Leslie chose it for James Lenox, a book-collector and historian of New York. Lenox at first demurred, complaining of the work's indistinctness; and Turner commented, 'You should tell him that indistinctness is my fault.' (This remark was long reported as indistinctness being his 'forte'.) *Staffa* was the first work by Turner to reach the USA.

Returning to Oban, he went north-east to visit his patron H. A. J. Munro at Evanton; then via Aberdeen he reached Edinburgh about mid-September. He was annoyed on hearing that Scott meant to visit Naples, thinking the project of his *Poems* would be delayed or stopped. But Cadell pacified him, and he seems to have left by steamer on the 18th, exhausted and in uncertain health.

In the RA exhibition of 1832 he showed *Staffa* and four other works. One of them had an obvious reference to the struggles for the Reform Bill, which he knew would have delighted Fawkes: *The Prince of Orange, William III, embarked from Holland, landed at Torbay, November 4th, 1668, after a stormy passage*, with a vague

reference to a *History of England*. He was using the stormy passage of William that brought about the Glorious Revolution to symbolize the violent conflicts about the Bill, which included a semi-insurrection at Bristol. What he had in mind was not an authorless History, but Thomson's *Liberty*:

> Immortal Nassau came. I hushed the deep
> By demons roused, and bade the listed winds,
> Still shifting as behoved, with various breath,
> Waft the deliverer to the longing shore.

But while hailing the Reform Bill, Turner could not resist a touch of sarcasm in a note he added to the picture: 'The yacht in which his Majesty sailed was, after many changes and services, finally wrecked on Hamburg Sands, while employed in the Hull Trade.' The ship-of-state had been sold off to commercial interests, ending in shipwreck. He was afraid that the hopes aroused by the Bill would be betrayed, would prove fallacious. A note in his last sketchbook, written eighteen years later, remarks: 'Geese and Goslings hissing at Pigs – The Reform Question'. The issue is still alive in his mind and he hardly feels that Liberty has had the last word. The point of his picture was recognized at the time, but deprecated. *The Athenaeum* lamented: 'He has squandered the fairest hues and the finest perspective upon a subject which has lost somewhat of its feverish interest in the hearts of Englishmen.'

Childe Harold's Pilgrimage – Italy cited Byron on the way in which Italy though a wreck and a waste still had its ruins graced 'with an immaculate charm that cannot be defaced'. Here Turner returns to the Claudean paradise with one great elegant tree and a series of complex winding recessions. Ruskin observed, 'The eye can hardly follow the gradations of hue; it can feel but cannot trace them.' *Helvoetsluys; – the City of Utrecht, going to sea*, was a companion to *The Prince of Orange*, since it was from this port that William sailed in 1688. We have here an example of the way in which it would be easy to miss the impulse behind works by Turner. The peaceful port from which the leader of revolution sails into the storm is also the haven that he seeks, the resolution of the conflicts. *Then Nebuchadnezzer came near the mouth of the*

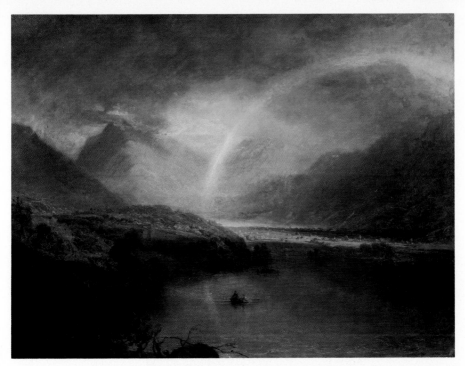

Buttermere Lake with part of Cromackwater, Cumberland, a shower, 1798. Oil on canvas. Based directly on a watercolour study in a sketch-book, it shows the breadth and atmospheric subtlety developed in Turner's tour of the Lake Country.

Frosty Morning, 1813. Oil on canvas. The sun is just coming up. The composition is carefully constructed with the road going directly into the distance of light; but it gives an effect of simple immediacy.

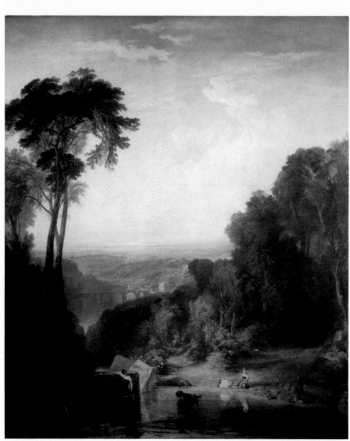

Crossing the Brook, 1815. Oil c
canvas. The classical structure
frames the view of the river
Tamar which divides Devon
from Cornwall, with the
symbolism of division echoed
in the girls (Turner's
daughters), one of whom has
just crossed the waters of
puberty.

*The Bay of Baiae, with the
Apollo and the Sibyl*, 1823. Oil
on canvas. Again a Claudean
structural basis. Painted with
delicate touches, the work
shows a subtle merging of
classical and romantic
elements.

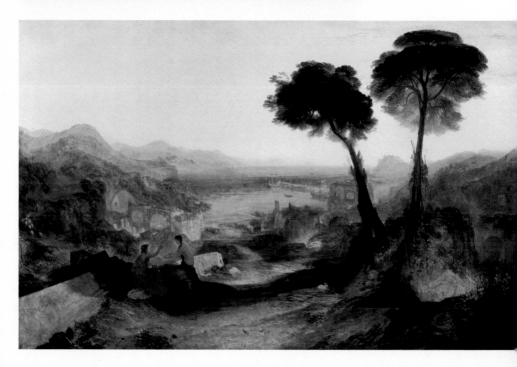

Colour Beginning, Sunrise over the waters, paper watermarked 1825. Such works bring out the way in which the structure and movement of colour underlie Turner's definition of a landscape, unifying and giving a dynamic force.

Ulysses deriding Polyphemus – Homer's Odyssey, 1819. Oil on canvas. Turner uses a drawing made some twenty years earlier. The mythological effect is achieved by the rich tumult of colour, with the escape out through the setting sun.

Petworth Park: Tillington Church in the Distance, about 1830. Oil. The finely balanced oval composition returns in on itself in the tunnelling recession of the almost vanished sun.

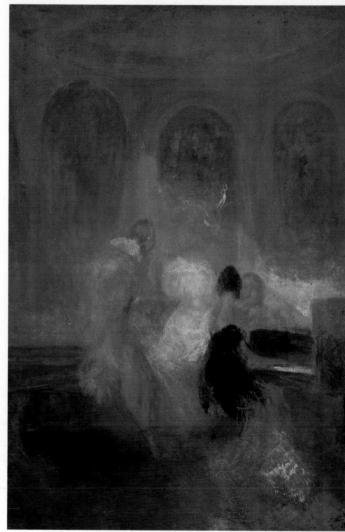

Music party, Petworth, about 1825. Oil. The rich concentration of colour, with its broken elements, evokes the effect of music on the scene.

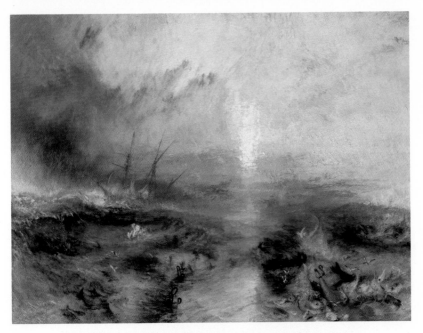

Slavers throwing overboard the dead and dying – Typhon coming on,
1840. Oil. One of Turner's allegories of a commercial society.
A rich dramatic effect is achieved by a wide range of colours
applied in a variety of handling, from glazes to thick impasto.

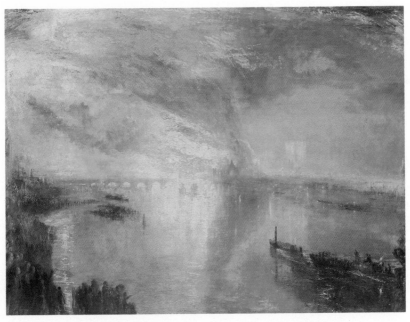

The Burning of the Houses of Lords and Commons, October 16,
1834. Oil. Exhibited 1835. Turner hurried to the scene and
made several quick watercolour sketches. Here fire instead of
sunset provides the drama of wild enveloping colour.

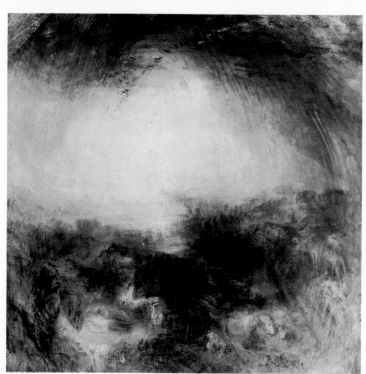

Shade and darkness – the eve *of the Deluge*, 1843. Oil. A cosmic image. A spiral of darkness leads the way int brilliant distance, with ani filing into the shadowy ar.

Rain, Steam and Speed – Th *Great Western Railway*, 184 Oil. A classical structure is merged with a strong reali to express the impact of th industrialized world on na on the older England.

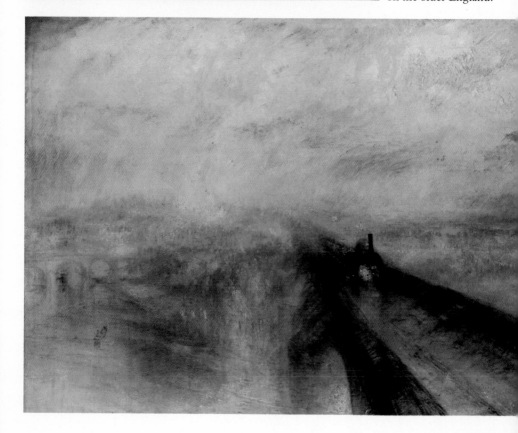

burning fiery furnace was done in friendly rivalry with Jones, who had mentioned he was at work on this theme. Turner bade him order two canvases of the same size, 'and desire one to be sent to me; and mind, I will never come into your room without inquiring what is on the easel, that I may not see it'. The odd thing about the picture he produced is that, as in *Pilate*, there is no concentration on the main event. At the back a great burst of fire occurs with a giant figure of power merged in the flames; but the composition is mainly made up of the lounging women at the front, who are quite unconcerned about the miraculous ordeal going on. In *Pilate* the fate of the Redeemer is being decided, but interest is centred on the lamenting women at the front. Why then in these works, and in these alone, does Turner thus relegate the great and terrible event which is his theme to the background, to a minor place? Perhaps he is saying that great events are more or less ignored by people at the time, ignored and misunderstood by people of later ages as well. Perhaps by the stress on obstructing women, he is blaming them in particular. Perhaps he is saying that the meaning of his art is missed, twisted, ignored. Or merely that, whatever shattering ordeals or sacrifices occur, life goes on and people are aware only of what directly impacts upon them.

In another work with a biblical theme, *Christ driving the Traders from the Temple*, about 1832, again the action occurs far back, but is not so disconnected with the foreground. The foreground figures are again women, and there is far more emphasis on them than on Christ. The theme of the picture links with the stress in *Fallacies* on the disasters resulting from commercial expansion.

Nearly all the critical work on Turner has been concerned with analysing his artistic achievement; and that is right enough. But it is wrong to ignore, as has generally been done, his emotions and ideas, personal, poetic, social, historical, which come together under the heading of his symbolism. In the last resort we need to bring these together with the aesthetic struggle if we are fully to understand the driving force of his life and art. Now and then he made a remark illuminating the symbolic process in his work, which is inseparable from his aesthetic development. Thus, when revising a drawing by someone else of Elgin Cathedral, he opened the windows of the nave. Later he was asked why he had

opened them and he replied, 'They ought to have been open; how much better it is to see the light of day in God's house than darkness.' The open windows were an allegory of anti-medievalism. When John Pye engraved the drawing of Wycliffe's birthplace for Whittaker's *Yorkshire*, Turner introduced a burst of light. Pye asked why. Turner told him, 'That is the place where Wycliffe was born, and there is the light of the glorious Reformation.' Pye then asked him the meaning of the big geese fluttering in the foreground. 'Oh, those – those are the old superstitions which the genius of the Reformation is driving away.' He was recalling Thomson's lines:

> The returning light
> That first through Wickliff streaked the priestly gloom
> Now burst in open day. Bared to the blaze,
> Forth from the haunts of superstition crawled
> Her motley sons, fantastic figures all.

And it is strongly in the key of *The Fallacies of Hope*, that just before this passage we are told that the Papacy was a power, 'wild at last, to plunge into a sea of blood and horror', and that immediately after it we learn that the dispersal of monastic wealth begot Trade with 'guilty, glittering stores', which destroyed the Indians.

He was so much a supporter of the national liberation movements that when the leader Görgei betrayed the Hungarians he said to his friend Jones, 'I shall not call you Georgey any more!' The name had become hateful to him, observes Thornbury. A good example of the way his fancy played about with forms appears in a poem he wrote on the architectural orders. Tuscan is defined as a Labourer, Ionic as a Courtesan, Corinthian as a full-blown Matron. Ionic is further linked with the Pawnshop. 'The little dentals in suffite/Show grinding power here complete/And placed as the teeth of Shark', they represent the Usurer who swallows up the Poor. Turner wanted his complex meanings to be understood and he gave clues in the passages from *The Fallacies of Hope*, but he wanted the points to emerge from the spectator's comprehension of each work in its totality.

Ruskin tells us, 'The want of appreciation touched him sorely, chiefly the not understanding his meaning'.

Watercolours of the early 1830s (as Eric Shanes has shown) reveal how strong was Turner's interest in, and support of, the Reform Bill and the radical struggle in general. *Northampton* is the most direct expression of his zeal. It depicts the triumphal re-election of Lord Althorp, who was to be the new Chancellor under Grey, on 6 December 1830. The tumultuous scene is set on a gusty day, with tossing flags. Althorp is shown, chaired with garlands over his head, acknowledging the plaudits. All round are banners for Reform and Independence; and one slogan is 'Speed the Plough'.

Blenheim, as suits its battle-name, shows the aggressive landed gentry. *Stoneyhurst College*, Lancashire, April–May 1829, is a complex allegory of the movement for Catholic Emancipation, then in its last phase. The College was a Catholic foundation of 1794. Truculently demonstrating children on the left are answered by the man on a watering horse (King, State); a boat with two boys has at last reached the shore on the right. Above, Jesuits and academics move in procession to the gatehouse where the twin piers are surmounted with shining crosses (not on the original building or in an earlier sketch, but inserted to express the new equality of the two branches of the Christian Church). Washerwomen on the far side of the Infirmary Pond represent the cleansing of Christianity, while, above, a rainbow replaces a dark retreating storm-sky. *Ely Cathedral*, with stone-throwing boys, looks back to the collapse of the building in 1322 and forwards to the coming Fall of the Church.

At the Varnishing Days of 1832 Constable was putting vermilion and lake into the decorations or flags of his *Opening of Waterloo Bridge*, so Turner put a round daub of red lead on the grey sea of his *Helvoetsluys*, and went off. The daub, made more vivid by the cool colours of his work, killed off Constable's reds. 'He has been here,' the latter said, 'and fired a gun.' Cooper said, 'A coal has bounced across the room from Jones's picture and set fire to Turner's sea.' Then at the last moment Turner came in, a day and a half later, and glazed his scarlet seal, shaping it into a buoy. Before the show closed, the government announced it would provide funds for a National Gallery. In August Turner

again reformulated his will, trying to tighten up the legal aspects. He may have paid another visit to Venice this year, but the matter is uncertain.

In the RA of 1833 he had four sea-pieces, including *Rotterdam ferry-boat*, and two views of Venice, one of which is now lost. In *Bridge of Sighs* we see his rich Italian colours, but he has not yet achieved the qualities of his later Venetian works with their fine translucent atmosphere. Of the sea-pieces the important one was *Mouth of the Seine*, with a note saying that the estuary was dangerous with its quicksands. The composition is dominated by the tension between the towering clouds and the spray of the curving waves, the swing of bird-flight. Turner is concentrating on pure elemental forms of violence and interlocked tension, which men must somehow grasp and control by their understanding of natural process in all its harmonies and sharp conflicts. The first of his *Annual Tours* had appeared in June, as also did Part XVI of *England and Wales*, with a show of drawings at 6 Pall Mall. Perhaps in August he went to Paris. (Some time in these years he called on Delacroix, who recorded that 'he had the look of an English farmer, black clothes, gross enough, big shoes and hard cold demeanour'.) In December came the second issue of *Tours* (Seine) and the illustrated *Poems* of Rogers. Turner was re-elected RA Auditor and elected Visitor of the Life Academy.

For some years he seems to have been lodging with a family, the Booths, when he was at Margate. John Booth died in 1833, but Turner still used the Booth house and soon Mrs Booth became his mistress. They kept up the relationship for the rest of his life. She seems to have been a comfortable easy-going person, a good thrifty housekeeper, who suited Turner. The engraver Charles Turner, who met her some eighteen years later in 1852, described her as 'exactly like a fat cook and not a well educated woman. *Muster* Turner instead of Mr Turner when speaking to me.' (About this time, in a sketchbook with the same red leather binding and brass clasps as those used on his Rhine tour, there are drawings of wild embraces.)

In the RA show of 1834 he had a sea-piece, *Wreckers on the coast of Northumberland*, 'with a steam-boat assisting a ship off shore', and a view of St Michael's Mount, Cornwall; a Venetian view; and two fanciful themes, *The Fountain of Indolence* and *The Golden*

Bough. The catalogue adds to the latter *Fallacies of Hope* but drops out the verses. Here we meet again the scene of Baiae and the Sibyl; Aeneas–Apollo–Turner is again at a crucial moment, and as at Baiae a snake lurks in the foreground to remind us of the Fall. Turner must be expressing what he feels as he enters into close relations with a woman again. The Sibyl-Mother who is the guide in hell-harrowing is also the bearer of the bough of salvation, of hope. In July Turner went to Oxford to discuss some Oxford subjects. Then he went to Brussels and further on to make sketches along the Meuse, Moselle, Rhine, covering much the same ground as he had in 1826. But the series of engravings of drawings of the visited rivers never materialized. On his return to England he went to Petworth. In December he was elected one of the Visitors to the School of Painting in the RA for the next year and his *Annual Tour* for the 1835 was published, the third and last of the *Rivers of France* series.

On 16 October the Houses of Parliament had been burned down. Turner saw the event and made watercolour sketches so hurriedly that he blotted one page of the book on another. He was deeply impressed by the sight of the great burst of fire in the night, especially as it occurred on a reach of the Thames familiar to him in childhood and youth. He made two paintings of the scene. The first, shown at the British Institution in 1835, took a viewpoint from the south end of Westminster Bridge; the second, shown at the RA, took a long-range view down the river. In the first the bridge thrust out white-greyish from the right, with the fire swinging up at it and bursting high over the Houses which are enveloped in the great misty glow; the further bank, furnace-red, and the near bank with the spectators balance the storm of fire. In the second, with bridge and banks providing a strong horizontal line, the flames sweep up and leftwards at the centre, while their reflections in the water lead us down river to the spectators in boats or crowded on the near bank.

The moment of this great uprush of flames seems to have occurred when the roof of the House of Lords crashed in and was 'accompanied with an immense volume of flame and smoke', emitting 'in every direction billions of sparks and flakes of fire'. It gave out a roar, said the *Annual Register*, like the report of a piece of heavy ordnance, like an explosion. The effect on the

watching masses was to make them clap their hands 'as though they had been present at the closing scene of some dramatic spectacle'. Turner, with his capacity to see visual images as symbols, and symbols as visual images, may well have felt that this fiery explosion of the seat of political power expressed the defeat of the oligarchic corruption that had opposed the Reform Bill: the end of an old world that betokened the birth of a new.

The picture arrived at the RA in a form described as a mere dab of colours without form and void 'like chaos before the Creation', but Turner worked at it on the wall. E. V. Rippingville wrote, 'For the three hours I was there – and I understood it had been the same since he began in the morning – he never ceased to work, or even once looked or turned from the wall on which his picture hung.' At his feet were a few very small brushes, a small box of colours, a vial or two, 'very inconveniently placed; but his short figure, stooping, enabled him to reach what he wanted very readily'. He worked almost wholly with his palette knife, and at one time he rolled and spread a lump of half-transparent stuff over his picture. Rippingville remarked to Callcott, who was also watching, 'What is that he is plastering his picture with?' Callcott replied, 'I should be sorry to be the man to ask him.'

Another night-scene at the RA was of a very different character: *Keelmen heaving in coals by night*, a view of the industrial Tyne, where torchlight and moonlight were contrasted. A Venetian scene was of bright clear sunlight, as was *The bright stone of honour (Ehrenbrietstein [sic] and the tomb of Marceau)*. There is a citation from *Childe Harold* describing the small pyramid on rising ground near Coblenz, under which are the ashes of a hero, Marceau: 'He was freedom's champion.'

In the summer Turner left for Venice. But he went on a roundabout route, by the Baltic to Berlin and Dresden, Prague and Vienna. At Venice he made many pencil drawings of buildings and stored his mind with architectural and topographical information, doing only three or four coloured drawings. He was largely concerned with light-effects, and much of his work was done in body-colour on grey or brown paper. He made drawings of a festival night, buildings at night with strong

lighting, the Piazetta under a storm with lightning, fireworks and Bengal lights, an open-air theatre, figures on a bridge, strange events in dim wineshops, a bedroom.

At the RA in 1836 he showed a mythological piece, *Mercury and Argus*, with composition based on the systems of retreating curves that he now often used in place of the more normal symmetries and planes parallel to the picture's surface; *Rome from the Aventine*, with clear pellucid light and a great Claudean tree on the right over the curving expanses of water; and *Juliet and her Nurse*. In the last-named he transported Juliet to Venice; she looks down over a high parapet on to the carnival enacted below in the Piazza di San Marco. The jutting-out building on the right represents a structural element that Turner was often using in his compositions: for instance, in the second *Burning of the Houses of Parliament* it appears in the boats emerging from the right-hand corner. Indeed, the high viewpoint and the jutting buildings are characteristic of the kind of composition he was employing in the vignettes for the poems of Campbell and Rogers. Here the night is broken with fireworks, which serve as points of punctuation in the general shimmering glow.

H. A. J. Munro, a large landowner in Ross-shire, had known Turner for several years. Turner liked him; and when Munro bought two of the RA pictures, he asked him to go on a tour with him. (Munro mentions that the scene of *Mercury and Argus* was based on the coast of Ross-shire: an enlargement of the harbour of Cromarty.) The tour was to take them across France to the Val d'Aosta, and Turner wanted if possible to visit towns he had not yet seen. At Bonneville 'we were amused in seeing so little that reminded us of his pictures of that place': the two oils shown in 1803, the third in 1812, and a design engraved in *Liber Studiorum*. The two men made sketches generally at the same time, but from different viewpoints. At one site Munro had trouble over a coloured sketch. Turner watched a while then said, 'I haven't got any paper I like; let me try yours.' He took Munro's book and went off for an hour and a half. Coming back, he threw the book down with a growl, 'I can't make anything of your paper.' In fact he had made three sketches in different stages, showing, says Ruskin, 'the process of colouring from beginning to end, and clearing up every difficulty which his friend had got into'. This

was an example, Ruskin adds, of the way he disliked 'to *appear* kind'. Finally the pair went down the Val d'Aosta to Ivrea and Turin, where they parted. Munro says that Turner went back by the Rhine, though the sketchbook only shows him going as far as Chambéry. By this time Turner was very tired. Most of the sketches he had made in the Val involved a climb on foot up steep and narrow mountain-paths.

Soon after his return to London there was a violent attack in *Blackwood's Magazine* on the modern English School, who, unlike the Old Masters with their love of shade and depth, delighted in glare and glitter, with Turner as the worst offender. In *Juliet and her Nurse*, various parts of Venice had been 'thrown higgledy-piggledy together, streaked blue and pink, and thrown into a flour tub. Poor Juliet has been steeped in treacle to make her look sweet.' The author was the Rev. John Eagles who, trying to be a Poussinesque landscapist, failed to get into the Watercolour Society, so took orders and wrote art-criticism for *Blackwood's* from 1831. He attacked Constable and, later, Millais. John Ruskin, now aged seventeen, was deeply angered by the attack on Turner, whose illustrations to Rogers's *Italy* had delighted him. He wrote a reply, but his father advised him to send it to Turner, not the periodical. Turner, who had long ago decided to ignore all depreciations, dismissed Eagles's essay as 'of no import' and refused to sanction the publication of Ruskin's defence. Later, in 1840, Turner and Ruskin met.

On 10 November Turner's old friend, Wells, died at Mitcham. Clara, Wells's daughter, says that Turner came at once to the house in an agony of grief. 'Sobbing like a child, he said, "Oh, Clara, Clara! these are iron tears. I have lost the best friend I ever had in my life." Oh! what a different man would Turner have been if all the good and kindly feelings of his great mind had been called into action; but they lay dormant, and were known to so very few.' Indeed he felt deeply and feared to show his emotion. Earlier that year the son of Charles Turner (who engraved many of the best plates in the *Liber*) was very ill. Turner went constantly to the house to make inquiries, but would not give his name. Only when the boy died and Charles Turner was told that a little short gentleman of odd manners had been calling every evening did he realize what had been going on. He asked Turner

to the funeral, but Turner refused, recalling how his attendance at Lawrence's funeral had resulted in a long illness.

In 1837 he sent in to the RA four very varied works. In *The Grand Canal, Venice,* he again used Shakespearean characters, setting by the canal the encounter of Shylock and Antonio, and adding an episode involving the Friar. Once again the foreground structure juts out into the scene, but the time of day is now noon. *Snowstorm, avalanche, and inundation – a scene in the upper part of Val d'Aosta* combined as many kinds of catastrophe as possible, using a vortex of curves to express the violent involvement of objects and forces. *Apollo and Daphne,* on the contrary, has Claudean tranquillity and clarity, with the elements securely interlocked. Ruskin took the picture to celebrate the union of earth and water, Daphne being child of the Earth and a river god; but that is to ignore Apollo, who for Turner represented light and the sun as well as poetry and art. God and nymph are shown amiably chatting, but the break, the flight of Daphne, is forecast in the motif of greyhound coursing hare. (Compare rabbit and snake in *Baiae.*) All is not going to be well soon with the artist and his girl; the elements are going to flow and clash. This point is stressed in the accompanying passage from Ovid.

The most powerful work was *The parting of Hero and Leander,* with a citation 'from the Greek of Musaeus', which tells of morning coming too soon. 'On the raised spray appeared Leander's fall.' In fact the verses were Turner's own. Here is a great orchestral piece of colour and moonlight with the sun just setting in the centre behind a headland. (The idea goes back to the sketchbook of 1802 in a study of black and white chalk, though the immediate stimulus was a painting by Etty shown in 1827, which in 1836 was on loan in York. This was a circular composition, bringing the figures forward, but also having a moon sea-reflected.) There is a Poussin element in the architecture rising on a slope to the left, though in general Turner is thinking of artists like Howard and Francis Danby with their fantastic subjects, their mythological personifications. But the total effect is all his own, with warm colours on the left to express the lovers' meeting, cold on the right for tragedy. Sea-nymphs appear as in *Ulysses,* but on the side of the devouring elements.

[127]

At the British Institution Turner showed *Regulus* and a sea-piece in which we see fishing-boats with men-of-war ominous in the distance.

Constable died this year just before the RA show. Queen Victoria succeeded to the throne. Her first honours included Newton the miniaturist, Westmacott the sculptor, and Callcott. C. R. Leslie remarked of Turner, 'I think it possible he was hurt.' In November Lord Egremont died. Turner was himself not well. He resigned his Professorship of Perspective; in thirty-one years he had lectured only in twelve sessions. From the way he clung to the office we can see that it meant a great deal to him. When formal thanks to him were voted and his successor elected, a resolution was passed to ensure that there would be no more neglect of duty.

Since 1819, then, we see that Turner had developed two main lines: what we may call epical versions of myth or ancient history, which expressed his deep feeling of human life, in its individual or collective aspects, as involving great surges of energy leading to defeats through inner corruption; and versions of Italian landscape in which the Claudean vision and system of constructions were transformed by a new depth and richness of colour, of permeating light. But he also produced his sea-pieces, at times keeping to a style that carried on his earlier and darker focus, at times embodying more elements of his new dynamic sense of colour. Direct topography was maintained only in his watercolours, often done for reproduction by engravers as in the *Tours* of Rivers. However, in his Venetian works elements of the topographical attitude persisted because of his interest in the buildings and layout of the town, even when he was adding figures in a dramatic situation.

8. PETWORTH AND MUSIC

Lord Egremont had died on 11 November 1837, aged eighty-six. Turner went to the funeral at Petworth on the 21st. More than a thousand mourners walked behind the hearse, which was drawn by sixteen men; there were no vehicles. Four hundred labourers in white smocks with crêpe armbands and black gloves joined in. Before the hearse was a group of artists headed by Turner. He caught a cold and was still laid up in early December, though he attended a Council meeting on the 28th. He had first visited Petworth in 1809, and became a regular visitor only from about 1827. But from this time the place exerted a strong influence on him, now that he had lost Fawkes and Farnley Hall. A set of drawings (in gouache on blue paper) made about 1830 show how assiduously he noted, drew, painted the place and its frequenters. The set includes drawings of the park, the lake, the church, the picture gallery, the white and gold room with Van Dyck portraits, bed with crimson silk curtains, library with spinet, twilight on the lake, the red room, flowers, morning room with figures, lady in pink, a solo on the harp, toilet, waiting for dinner, the ladies' drawing-room, the red lady on a couch, musicians, in church, at dinner, spinet-players, ladies seated round a table, firelight and lamplight, lady in black silk sitting on couch with picture at her side, a little music at evening, amateur theatricals, figures at table, the pond with people watching a swan, steeple under repair, bedroom, the hall with people in it, blue pot, bed with green silk curtains, room with fire burning and man on couch in black, woman in blue seated reading, two women seated, lady in black at toilet, various interiors, men

chatting round fireplace, lady in black with green-curtained bed, after dinner, a ladies' party, teasing the donkey, staircase, billiard table, bedroom scene.

One drawing, which shows a painter in the library seated before a picture on an easel, brings out the close relation of Turner's experiences at Petworth and his painting *Watteau*. Out of the gouache studies developed a series of paintings of a remarkably fresh and lyrically direct kind. *Music Party* and *Two Women with a Letter* show his bold handling of paint at its best. The paint is thick, put on and worked over with a palette knife; Martin Butlin has described it as 'scratched and gouged, partly to suggest the texture of wall hangings and leather or the effects of figures in a capriciously lit room, but partly to add to the frisson of the scene depicted'. In *Music Party* the rich vivid reds with the contrasts of the white textures and the dark clothes of the woman at the keyboard create an immediacy, a total impact of aesthetic sensation, which draws us in to the musical experience with an unparalleled lyrical intensity. In *Interior at Petworth* we certainly see Turner's feelings about the place after Egremont's death: a catafalque surrounded by forms in colour-dissolution, with green bursting in from the right and dogs jumping about. A world is breaking down.

These works are linked in turn with a work like *Pilate* (1830) in which Turner uses colour in the same way as a pervading force that powerfully holds people together and merges them with their setting. The use of colour as a dynamic unifying element, creating the very space in which people and things exist, has a musical quality about it.

The early sketchbooks show Turner's interest in songs and glees, and his connection with Sarah Danby – presumably also with her husband before his sudden death – seems to indicate that he early had connections with musicians. His friend and disciple Callcott, we noted, had a brother who ranked with Danby as a leading glee-composer. During his years in close association with Sarah he must have had many contacts with the musical world. One sketchbook has a song written down for alto, soprano, bass. He himself no doubt sang in a bass key, as he had a deep speaking voice. C. R. Leslie says, 'His voice was deep and musical.' Among his effects were six books of music and 'sundry

ditto' as well as a volume of Scots Airs. The Swiss notebook of 1802 has a pencilled version of 'I am a Friar of Orders Grey'; the words, 'And down the valley I take my way' would have suited the tour and no doubt he sang them as he strode along. A little earlier, probably about 1801, he was trying to train himself in song and an elementary grasp of musical form. Wanting to take in more than the mere tune, he set out the clefs for soprano, mezzo-soprano, alto, tenor, bass; the names of the space-notes of the treble staff; the subdivisions of time as well as the ascending scale from E and the signs of sharp, flat, natural. He learned to play the flute; 'Gamut for the Flute' occurs. His interest in part-singing was no doubt stimulated by musical parties connected with Sarah, whether at their own place or at the houses of friends. As a joke he told the Rev. Judkins that his *Ulysses* was inspired, not by Homer, but by Tom Dibdin's song: 'He ate his mutton, drank his wine, and then he poked his eyes out.' But the joke had a serious side. About 1816 inside a cover of a Yorkshire sketchbook is a song that begins, 'Here's a health to Honest John Bull'.

It is likely then that the songs he himself made up and jotted down were not just attempts at verse-writing but were written to some tune so that he could sing them at the right sort of gathering. One begins:

> The sweets of the bee and the bloom of the Rose
> Did dear Josephine in her May-day disclose
> Content she had known as the day rolld its round
> But Josephine's Cottage Love at last found.

He could have sung that in a drawing-room; but 'Be still my dear Molly', which was cited earlier, could only have been given in a tavern with suitable cronies.

We have one lucky piece of evidence that shows his interest was not only in glees and simple songs. His Exeter nephew had some musical talent; and after attempts at painting he became a choral singer. In 1834 he visited London to sing at a Royal Musical Festival connected with Handel. He stayed some three weeks and called on his uncle who 'told me', he says, 'of my engagement in London having seen my name in the printed

programme'. We see then that Turner attended concerts and kept his eye on what was happening in the musical world.

We have noted how he did much touching and repainting on Varnishing Days at the RA. It was from the 1830s that he gave bravura performances, often with dramatic effects. It has been suggested (by John Gage) that 'the decisive catalytic factor in directing Turner's attention to the value and legitimacy of demonstration painting' was the series of concerts given by Paganini in the summers from 1831 to 1834, which had a shattering effect on audiences. Many artists were greatly affected: Haydon, Maclise, Edwin Landseer, and 'in Turner's Roman circle of 1828, the address of William Havell, the landscape painter, was itself compared to that of the violinist'. Delacroix painted Paganini in an evocative work and told his assistant: 'We must render our visions with ease: the hand must acquire a similar facility, and this can only be achieved by similar studies. Paganini owed his astonishing execution on the violin solely to the daily practice of scales for one hour. It is the same exercise for us.' Thus a new awareness was generated of the expressive virtues that could be attained by brushwork and painterly handling, through a comparison of artistic and musical methods. Turner would certainly have been aware of the impact of Paganini on the art world and would have been stimulated. We may link the Petworth gouache, the Watteau painting, and the *Bridge of Sighs* of 1833, which has 'Canaletto Painting', with the Paganini impact and the new consciousness generated of the artist at work as subject matter, 'not as mere *genre* in the Dutch manner', says Gage, 'but as a demonstration of principle'.

No doubt from early years Turner felt an intuitive link between art and music, as he did between art and poetry. But it was in the Petworth series, dated at the same time as the Paganini concerts, that a more definite sense of the relation between musical and artistic form emerges, above all in *Music Party*. Here he dissolves contours in the light-burst without losing structure; the aesthetic definition seems strongly influenced by the actual mood of the music being played, by a feeling for the flow of rich semitones, fine modulations of liberated colour.

The poetic image, expressed through sound, was for Turner a mediating form between art and music, in which the definition

through harmony and rhythm took completely over. He must have known well Danby's most famous glee, 'Awake, Aeolian Lyre', with the image of music as a flowing river. In 1809 in his own gallery he showed a river-scene with young people carrying out an act of homage to the poet, *Thomson's Aeolian Harp*. In the catalogue he printed a poem of eight quatrains, headed, 'To a gentleman at Putney, requesting him to place one [an Aeolian Harp] in his grounds'. Here the Harp is seen as mediator between poet and nature. Two of the stanzas run thus:

> In silence go, fair Thames, for all is laid;
> His pastoral reed untied, and harp unstrung,
> Sunk is their harmony in Twickenham's glade,
> While flows the stream, unheeded and unsung . . .
>
> Then kindly place amid thy upland groves
> Th' Aeolian harp, attun'd to nature's strains,
> Melliferous [*sic*] greeting every air that roves
> From Thames' broad bosom or her verdant plains.

The Aeolian Harp is felt to bring together Poetry, Music, the sounds and essences of Nature, the living scene in its fullness. Turner wants somehow to transpose this synthesis into his art. The importance of the concept for him is brought out by the fact that he repeated with variants that last stanza on the Harp in his poem 'On Thomson's Tomb', and he wrote a third poem, 'Thomson's Aeolian Harp', which ends, 'Till Nature's melting touch bids rapturous music flow'.

That he kept on brooding about the relation of art and music is shown by his Lectures. In Lecture IV of 1812 he sets about explaining Historic or Poetic Colour and turns for help to Music and the Associative Theory.

> Historical colour, were we to follow the musical dis-
> tinctions offered to designate styles or tones of colour, of
> grave, soft, magnificent, as have been ascribed to Poussin,
> with qualifications of colour innate, as those of Fury and
> Anger for Phyrrus [*sic*]; gracious and delicate in the picture
> of Rebecca; langour and misery in the gathering of the

[133]

Manna. Every tone must be Dorian, Lesbian, Ionic, Bacchanal. [But in this case] all would be historical theory and practically imprisoning, depriving those tones of explicable commixture, that appears by gloom, and drags the mind into contemplation of the past, [as] in his picture of the Deluge, distracting theory by the uniformity. He has buried the whole picture under the deep-toned lurid interval of approaching horror, gloom, defying definition, yet looking alluvial [?]; calling up those mysterious ties [memories] which appear wholly to depend upon the association of ideas.

In his difficult idiom he is invoking two powers to explain the full release of colour potentialities. One is Music, which represents the emotional outburst and expression; the other is the Association of Ideas, deep-buried in the whole past life of the artist and producing 'mysterious ties' or interrelations based in memory. The two combine to beget the dynamic unification of the pictorial image.

In the same lecture he discusses how 'the qualities of the mind may combine its perceptions to avoid error or failure, in labour-ing to unite contending elementary or natural incongruities, to produce the feeling excited by poetic pictorial members . . .' That is, how to resolve any conflicts in the various elements making up a work in terms of a 'poetic pictorial' unity. He argues that there are no rules for such a solution. The artist can go astray through 'the active powers of the mind' that may 'lead the imitative powers of the hand into a labyrinth through false choice', or through feeling that 'whatever sounds harmonious' is 'capable of receiving pictorial effects'. He thus counterpoints intellectual activity or analysis with a musical or 'poetic feeling of harmonious numbers'. Neither element is to be allowed to take charge and dominate, but each is needed for the successful work, which comes about through the resolution of the tension or conflict between them.

His Background Lecture shows how he uses musical terminology and analogy in considering tone, light, colour. Of Veronese's *Mercury and Herse* he says that it is wrought 'upon the same high pitch in the same high key (as the Cana) which keynote

is likewise blue . . .' Note his use of the terms *key* and *pitch*. The *Oxford English Dictionary* cites a passage of 1851 for the first use of key for tone or relative intensity of colour; and a passage of Ruskin (written 1876, published 1880) is cited as first using the term: 'Their harmonies of amber-colour and purple are full of exquisite beauty in the chosen key.' Pitch as 'a particular standard of pitch for voice or instruments' is dated 1797, but its application to light as analogous to sound is dated 1871, some fifty years after Turner thus used it. He may not have been the first to speak of key or pitch of tone and light, but he was certainly one of the very earliest to do so, long before the usage grew common.

In such matters he was in accord with certain trends found both in Newtonian theory and romantic sensibility. Newton had suggested that the effects of both light and sound could be related in terms of the proportions of the vibrations. So *striking* emerges as a critical term, especially in connection with Thomson's imagery. L. de Pouilly, a French psychologist, tried to explain emotional responses by the theory that 'there is a chain of chords in unison, which convey from one brain to the other the vibrations of the fibres of another'. P. Murdoch, who edited Thomson's *Works* in 1762, suggested that a reader failed to respond to a poet when his 'faculties are not tuned in to a certain consonance'. Reynolds used the term *striking*: distinct colours 'strike the mind more forcibly, from there not being any great union between them; as martial music, which is intended to rouse the nobler passions, has its effect from the sudden and strongly marked transitions from one note to another', while in works meant 'to move the softer passions, the notes imperceptibly melt into one another'.

Turner's acquaintance, G. Field, set out analogical theories at great length. In his *Chromatics* of 1817 he observed of 'gradations of hues and shades' that they may be termed 'the *melodies of colour*'. And he went on to identify analogically the 'accordance of two colours' and the musical term Concord. In all his thinking he has a sort of dialectical triad in mind. Here he ends: 'As the relation of harmony in colours is consonant, or co-expansive, and an evident trinity governing the Chromatic system, the most proper figure in which to illustrate the correlation of colours is the equilateral triangle.' Turner knew his work well and later he

[135]

read Goethe on Genuine Tone: 'If the word tone, or rather tune, is to be still borrowed in the future from music, and applied to colouring, it might be used in a better sense than heretofore.' He added, 'Very likely because even Music hath bounds which can only be transgressed by talent.' Perhaps he was thinking of his earlier insistence on the fusion of intellectual and musical elements for the unity of the image. Goethe went on, 'For it would not be unreasonable to compare a painting of powerful effect with a piece of music in a flat key, while the equivalent may be found for the modification of the two leading notes.' Turner commented, 'Too general to make much of'.

At times his work in its subtlety of tone and colour was compared with music. Already in 1812 the *Monthly Messenger* stated, 'His paintings in their variety and effect have been aptly enough compared to Brahma singing'.

About 1808 he struggled hard to write a poem: *The Origin of Vermilion or the Loves of Painting and Music*, but it is unfortunately only a mass of suggestive fragments.

> In days that's past beyond our ken
> When painters saw like other men
> Then Music sang the voice of truth
> Yet sigh'd for Paintings homely proof.

He seems to say that once art merely reflected the actual world while music uttered deeper things (truth) but lacked a direct relation to life. The Marriage of Painting and Music would then unite imagination and reality. But Turner never quite comes to the point, linking Vermilion (warmth, vitality) with the Embrace.

> Her modest blush first gave him taste
> And chance to Vermilion gave first place
> As snails trace oer the morning dew
> He first the lines of Beauty drew
>
> These far faint lines Vermilion dyed
> With wonder view'd – enchanted cried
> Vermilions honors mine and hence to stand
> The Alpha and Omega in a Painter's hand.

Music and Painting embrace; Painting comes on Music lying down.

> It chanced one day the dame was tired
> Recumbent Beauty Genius fired.

Music thus appears as both Beauty and Truth in the Keatsian sense. Painting copulates with her and her blush is Vermilion, the warm pervading flush which begets the beauty of colour and regenerates the art.

> No matter, ready Love supplied
> What niggardly Nature here deny'd . . .
> Nimbly the princely course of color trace
> As snails trail oer the morning dew
> He thus the line of Beauty drew.

The discovery of living colour is also the discovery of the Hogarthian Line of Beauty, of sinuous involving movement. The snail seems to come in because of its spiral shell: there is a Cornish maze-dance called the Snail. At the same time the serpentine or spiralling line of beauty is a luminous trail of morning dew.

Other phrases in the draft are: 'Invoked the graphic Muse'; 'Dutch Vermilion close at hand' attacks the problem but fails, being as coarse as sand; Love, supplying what Nature lacks, begets the quest for a higher aesthetic, 'in quest of taste'. That quest is checked if only the direct forms of nature are superficially noted. Success comes from tracing the princely course of colour and discovering the Line of Beauty: which needs the union of Art and Music. There seems to be a prayer for a colour-system to the heart, and an appeal to grasp the whole range of art. 'He wondring view'd with conscious pride/And soft conceit alas too near allied.'

The many variants show how much Turner wanted to work out the formulations of this poem and how difficult he found it to do so. Vermilion is the flush that gives form its vitality, its organic life. In his colour-analyses he stresses that Red 'possesses the utmost power of attracting vision, it being the first ray of

light and the first which admits the diminishing of light'. The prominence of the Line of Beauty suggests strongly that he had recently been reading Hogarth's *Analysis of Beauty*. In the 1818 Lecture V we find him going behind Hogarth to C. P. Lomazzo, a writer on art in the late sixteenth century, for a discussion of waved lines, serpent-like. In 1812 he used the Hogarthian idea of the search for the concrete image as a hunt or chase. There comes a point, he says, where the term Vermilion, apart from being used to describe cinnabar or red crystalline mercurial sulphide (or any red earth resembling it and used as pigment or cosmetic), came into general use to describe a blush: J. Hall, *Poems* (1656), 'A Rose can more Vermilion speake,/Than any cheeke.' (Hogarth himself was much interested in the relations of art and music; but Turner could hardly have known this, as the passages he wrote on the subject were not used in the printed text of the *Analysis*.)

Finally, we may note that Turner's work has an abundance of musical and festival moments; he liked fairs, theatres, dances, processions, popular musicians. Looking at a proof of the engraving of *Plymouth Dock*, he asked Cooke, 'Can you make the fiddle more distinct?' and drew it on the margin. His annotation of a drawing made in Italy, 1819, reminds us of Hogarth's vivid account of dances in the *Analysis*: 'Girl dancing to the Tabor or Tambourine. One plays, two dance face to face. If two women – a lewd dance and great gesticulation: when the men dance with the women a great coyness on his part till she can catch him idle and toss him up or out of time by hip: then the laugh is against him by the crowd.'

We see then that music played an important part in his life and art. It stirred and deepened his sense of nature as process, a ceaseless flow of elements in rhythmic harmony and conflict. With his analogies of sound and light, the concept (in Field's words) of gradations of tone and colour as 'the melodies of colour', he was helped to free himself from naturalistic limitations and to achieve his conviction that art-process did not merely reproduce natural forms, but itself acted by a method analogous to that of nature. These attitudes appear one way or another early in his work, but they come to a head with his Colour Structures, the first sketches of which go back into the 1820s. They enabled him to dispense more and more with the

accepted methods of tonal relationship and to think dynamically in terms of colour as a force and a constructive system. We cannot understand Turner's creative drive unless we realize how Art, Poetry, Music were for him all expressions, in different forms of sensory and intellectual organization, of the one transformative faculty. Later, we will consider how he fused an opera and a ballet in his *Masaniello*.

9. THE ANGEL IN THE SUN

In the RA show for 1838 Turner continued his contrasts of Ancient and Modern Italy in two canvases. In the ancient scene he showed Ovid banished from Rome; the setting is one of brilliant sunlight. In the modern scene we see simple Abruzzi peasants. Perhaps the moral is that a society which does not appreciate its art and poetry is doomed to decline. At first glance the theme of *Phryne going to the public bath as Venus – Demosthenes taunted by Aeschines* seems as puzzling. The processional part may have been suggested by H. Tresham's *Phryne at the Possidonian Feasts*, which he had seen as a young man. Here he is defining the Greece of beauty, where humanity could aspire to a sort of godhead. But he adds the conflict between the orators to express the other side, the discords in the city which brought the system down. Demosthenes represents the hopes of keeping the democratic city–state intact; Aeschines looks to the Macedonian power which will take over. We happen to know why he had grown interested in Demosthenes. Munro's bastard son went to Shrewsbury School where the headmaster, Dr Kennedy, who took over in 1836, was passionately devoted to that orator. Turner may have met the son after the 1836 trip or Munro may have told him about Kennedy. No doubt Munro would have explained to Turner the place of Demosthenes in Greek history. Turner clearly wanted to make his picture represent Greek culture as fully as possible. He put as much architectural design and landscape gardening into the middle distance, Ruskin observed, 'as would be worth to any student of Renaissance composition, at least twenty separate journeys to Genoa and Venice'.

In 1839 he showed versions of 'Ancient' and 'Modern Rome'. The first depicted 'Agrippina landing with the ashes of Germanicus. The Triumphal Bridge and Palace of the Caesars restored'. The attached verses declared, 'The clear stream, Aye, – the yellow Tiber glitters in the beam,/Even when the sun is setting.' The second, 'Campo Vaccino', has its different light-effect: 'The moon is up, and yet it is not night,/The sun as yet divides the day with her – Lord Byron.' There was a mythological picture, *Pluto carrying off Proserpine*, in which the figures are almost lost in the mountainous scene; and *The Fighting 'Temeraire' tugged to her last berth to be broken up, 1838*. Thornbury says that Turner saw the ship being towed from Sheerness to Deptford as he came back from a trip with other artists to the Greenwich marshes; Woolner, however, tells how a sculptor friend was on a steamboat returning from Margate when he saw the ship. 'But he was not the only person on board who took professional notice of the splendid sight, for he saw Turner himself there, also noticing and busy making little sketches on cards.' In Turner's picture there is a subtle set of contrasts: warm colour on the right, cool on the left; the pallid moon and pearly-white ship against the orange-reds of the sinking sun; tall white glowing ship and squat black-brown business-like tug; old and new, death and life, death and rebirth. The ships with their forward-cast reflections and the sunray on the waters converge on the artist, the spectator. As well we see the contrasts of the tug's smoke-line and the ray bursting out in the same sweep, while other rays wheel inside the tunnel of recession centred on the setting sun, which sinks between the closing lines of the two shores. The verticals are held on the left by the moon and its reflection. Chiaroscuro is gone, even in the form to be seen in *Ulysses*; depth, structure, all relationships are expressed through colour.

Turner links and opposes two different worlds, two phases of history. The attached verses declare: 'The flag which braved the battle and the breeze,/No longer owns her.'

He had been approaching the theme of sail against steam for some time in lesser works. Thus in his *Tour* of 1834 (Seine) the title page has an engraving of a headland with a steamer leading the sailing-boats round it into the moon-glow; the picture of

Havre harbour is dominated by a steamboat that seems to be pushing a sailing-boat out of its way; in *Between Quilleboeuf and Villequier* a steamboat dominates the sailing-boats behind it as if it is drawing them along with much the same effect as the tug in the painting.

In *Cicero at his Villa* we look down into a wide expanse. Cicero, back-turned, also looks down. Turner is thinking of a *Cicero* by Wilson, which he described as 'sighing for the hope, the pleasures of peaceful retirement, or the dignified simplicity of thought and grandeur, the more than solemn solitude that told his feelings. In acute anguish he retired, and as he lived he died neglected.' The confused construction makes first Cicero, then Wilson do the sighing, till Cicero fades out and Wilson becomes the theme himself. We may then surmise that the Cicero here is Turner.

Thackeray in *Fraser's Magazine* praised the *Temeraire* for patriotic reasons, but condemned the other works with the common surmise that Turner was mad. They were 'not a whit more natural, or less mad, than [his work] used to be in former years, since he has forsaken nature'.

This year the whole stock of engraved plates for the *Picturesque Views in England and Wales* was sold by auction. Publication had stopped the previous year, when only 96 of the proposed 120 plates had been issued. Steel had displaced copper for plates, enabling larger and cheaper editions of prints to be published. Turner managed to keep his plates for the *Picturesque Views*.

In 1840 he had seven works at the RA, as well as *Mercury and Argus* at the British Institution. It had been at the RA in 1836. Another mythological work, *Bacchus and Ariadne*, was among the RA exhibits; it seems to have been meant originally to be framed as an irregular octagon. We see how his use of vignettes in his illustrations of poetry has affected him, breaking up Claudean constructions. Here the tree rises in the centre with water swirling in all round. There were two of his richly atmospheric Venetian views; and two very different sea-pieces. *The new moon; or 'I've lost my boat, you shan't have your hoop'* shows children and dogs at play on the flat sands, with steamer-smoke afar on the horizon. *Rockets and blue lights (close at hand) to warn steam-boats of shoal water* returned to the rocket-theme in a vortex composition

of tossing wind, with the burst of light over the ship carried across the wet sands in a broad beam, while foam of the breakers seethes away on the right. We have two versions of *Neapolitan fisher-girls suprised bathing by moonlight* (one darker than the other), and are not sure which he exhibited. Here we find a Claudean composition though with a powerful burst of suffused light; the girls bathe in the shade under the tree.

But *Slavers throwing overboard the dead and the dying – Typhon coming on* was the outstanding work. He was no doubt thinking of the slave-ship *Song* of 1783 when sick Negroes were thrown overboard so that insurance could be claimed for them as lost at sea. The story had been retold in the edition of Clarkson's *History of the Abolition of the Slave Trade* (1839). Turner would have been reminded of lines from Thomson's *Summer* on 'the circling typhon, whirled from point to point', which go on to describe 'the direful shark', and to tell of the wreck of a slave-ship, in which 'one death involves the tyrants and the slaves', and the shark dyes the purple seas with gore, and 'riots in the vengeful meal'. He himself added to his painting a passage from *The Fallacies of Hope*:

> Aloft all hands, strike the top-masts and belay;
> Yon angry setting sun and fierce-edged clouds
> Declare the Typhon's coming.
> Before it sweep your decks, throw overboard
> The dead and dying – ne'er heed their chains.
> Hope, Hope, fallacious Hope!
> Where is thy market now?

Britain's commercial prosperity in the eighteenth century had been based on the slave-trade. That trade was now abolished, but Turner sees the market-system as still carrying on the same inhumanities in different guises. His picture is one of a violently stormy sunset, with the light coming down across the waves to reveal the sharks and the torn pieces of human beings. Here is one of his works in which deep red means blood.

In the summer of 1840 he met Ruskin for the first time. In the evening of that day Ruskin recorded his impressions. 'Everybody had described him to me as coarse, boorish,

unintellectual, vulgar. This I knew to be impossible. I found in him a somewhat eccentric, keen-mannered, matter-of-fact, English-minded-gentleman: good-natured evidently, bad-tempered evidently, hating humbug of all sorts, shrewd, perhaps a little selfish, highly intellectual, the powers of his mind not brought out with any delight in their manifestation, or intention of display, but flashing out occasionally in a word or a look.'

Turner was now sixty-five, but he was still far from giving up his strenuous way of life. He visited Venice again this year, and went to Switzerland in the four following years. On his way back from Venice he made a detour to Rosenau, Prince Albert's birthplace. (The Queen's marriage had recently taken place.) His painting of Rosenau, a quiet view of close trees and water, was shown in 1841 and seen as 'eggs and spinach' by one critic. The Prince did not buy it or anything else by Turner for his collection; Turner's work did not fit into the German taste that the Prince was favouring. On his way home Turner had also sketched the Walhalla, a temple in ancient Greek style, intended by Ludwig I as a shrine of the arts.

In 1841 he had six works at the RA: *Rosenau*; three Venetian works; a mythological piece, *Glaucus and Scylla*, another love-chase (with the figures playing a minor part in the light-diffused landscape); and *The Dawn of Christianity*, a circular work with a palm on one side of a river flowing straight into the distance of light. The Venetian works were the most liked, and he sold them this year.

He felt the need to appeal to a wider audience than that of the connoisseurs with his paintings; and he took up an idea he had long nursed, of issuing five big plates of his compositions, at his own risk. His choice is of interest: *Mercury and Herse*, 1811; *Dido and Aeneas*, 1814; *Crossing the Brook*, 1815; *Caligula's Palace and bridge*, 1831; *Juliet and her Nurse*, 1836. All the works, apart from *Crossing the Brook*, are linked with the Mediterranean, and even *Crossing the Brook* has strong Claudean elements.

In the RA, 1842, he had two Venetian views (which he sold, as the three the previous year), *Snow storm*, *Peace* and *War*. *Snow storm* has the information: 'steam-boat off a harbour's mouth making signals in shallow water and going by the lead. The author was in this storm on the night the *Ariel* left Harwich.' It

[145]

shows a steamboat tossing in the waves in a wild swinging pattern of terrific storm-forces. The details that he gives of the event have usually been misread. He says that the scene is 'off a harbour's mouth', which he does not name, and that the night was that in which the *Ariel* left Harwich, not that he was in the *Ariel*. A label stated that the work was painted 'during the great storm that raged on the day that the Princess Royal was born', 21 November 1840; a second label stated that it was given by Turner to the Pound family (Mrs Booth had been Mrs Pound by an earlier marriage). We may then assume that the scene was off Margate and that Turner had been caught in it while travelling to visit Mrs Booth. There had been bad storms during November, and the most notable victim was the *Fairy*, a surveying ship, which left Harwich in good weather, then was caught in a storm and sunk. Turner has recalled the ship's name incorrectly. (There was an *Ariel* paddle-steamer at Dover, which would have been known at Margate, but in November 1840 it was at Woolwich for a refit. No *Ariel*s seem to have been sunk in the storms, and the loss of the *Fairy* caused quite a stir.)

Turner told a friend that he had only painted the picture because he 'wished to show what such a scene was like; I got the sailors to lash me to the mast, to observe it; I was lashed for four hours, and I did not expect to escape, but I felt bound to record it if I did'. (The painter J. C. Vernet used to go to sea in bad weather to observe sky and water; once he is said to have had himself bound to the mast; and while the others cried or prayed, he watched the mountainous waves, exclaiming how fine they were.) The critics jeered at Turner's picture as a 'frantic puzzle' or a 'mass of soapsuds and whitewash'. Ruskin tells how Turner dined at his father's house on the day the latter criticism was published. 'After dinner, sitting in his arm-chair by the fire, I heard him muttering low to himself at intervals, "Soapsuds and whitewash!" again and again, and again. At last I went to him, asking "why he minded what they said?" Then he burst out – "Soapsuds and whitewash! What would they have? I wonder what they think the sea's like? I wish they'd been in it."'

On 1 June 1841 Wilkie had died on board a ship on his way home from Egypt, and Chantrey, a genial friend of Turner, had died suddenly in his drawing-room on 25 November. (When

Jones called on Turner next morning, 'he wrung my hands, tears streaming from his eyes', and rushed out of the house without uttering a word.) In *Peace – burial at sea*, he paid his tribute to Wilkie. Jones meant to draw the committal of the body to the sea, with the ship's deck as viewpoint; Turner told him, 'I will do it as it must have appeared off the coast.' He depicted the scene on a calm evening, with the ship silhouetted in black, with black smoke, except for a strong passage of white light that cuts across the black and is reflected on the water up to the spectator. Thus Turner expressed his feeling that the artist who has been a truthful revealer of nature, of which he feels a harmonious part, returns to the elements in peace. *War, The exile and the rock limpet*, showed the other face of things. Napoleon in exile stands meditating on a shore of blood-red sunset. *The Fallacies of Hope* tells us:

> Ah! thy tent-formed shell is like
> A soldier's nightly bivouac, alone
> Amidst a sea of blood –
> – but you can join your comrades.

The man of war has totally alienated himself from humanity and from nature; but the innocent limpet can rejoin its fellows at will. Red sky, red sea, as in *Slavers*, are equated with blood, with murder. The two lines to *Peace* declared that the artist, whose world was one of peace, becomes a part of nature in death as in life:

> The midnight torch gleamed o'er the steamer's side,
> And Merit's corse was yielded to the tide.

How strongly Turner felt about his symbolism is shown by his answer to Clarkson Stanfield, RA, who remonstrated that the effect of the black sails was untrue: 'I only wish I had any colour to make them blacker.' (There was also the point that Wilkie had changed his earlier style, imitating the blackness of the later Spanish masters.)

At the RA in 1843 Turner had six pictures: three Venetian views, the *Walhalla*, and two circular pictures inspired by reading

Eastlake's translation of Goethe's *Theory of Colours*. Goethe based his position not on the spectrum, but on a chromatic circle divided into plus and minus colours: the reds, yellows and greens associated with happiness, gaiety, warmth, and the blues, blue-greens, and purples, which produce 'restless, suspicious, and anxious impressions'. Turner was always doubtful about dogmatic and schematic analyses, deeply interested as he was in any discussions of the nature and function of colour. He questioned or disagreed with many of Goethe's propositions; but when he found him relaxing the rigidity in his rules, he was more favourable. 'Goethe leaves Genius almost to herself here', or 'Goethe allows an ample room for practice even with all his Theory'. At times he agreed. When Goethe said, 'opposite colours tend towards each other and become united in a third; then, certainly, an especially mysterious interpretation will suggest itself, since a spiritual meaning may be connected with these facts', Turner commented on the 'simbolizing power of color to designate qualities of things'. In any event he was deeply stimulated by Goethe's work.

So he painted the two pictures, which were shown in 1843: *Shade and Darkness – the evening of the Deluge*, and *Light and colour (Goethe's Theory) – the morning after the Deluge – Moses writing the book of Genesis*. He painted the first in the colours that 'produce a restless, susceptible, anxious impression'; blue suggests 'cold, and hence reminds us of shade', as well as owning 'an affinity with black'. The second was done with dominant reds, yellows, greens; orange-red, says Goethe, expresses 'warmth and gladness', yellow and green juxtaposed is cheerful, and yellow has a 'gay, softly exciting character'.

In *Evening* the vortex appears in the sky curving and sweeping down heavily over the earth, in the line of dark birds wheeling above. The lines from *Fallacies* describe the moment of disaster come on an earth of people who have been wholly corrupted:

The moon put forth her sign of woe unheeded;
But disobedience slept; the dark'ning Deluge closed around,
And the last token came: the giant framework floated,
The roused birds forsook their nightly shelters screaming,
And the beasts waded to the ark.

In *Light and Colour* we see the revival of life. The vortex has
become the seething womb of renewal. In the centre rises a green
mass, with uplifted serpent; and aloft sits Moses amid the misty
white, with pen in hand, recording the scene. (He is the artist at
the heart of the light-bubble, the life-circle, realizing the nature
of things, the event, and setting down its laws. Turner makes
him the author of Genesis.) Inside the enclosing iris-edged
bubble we see heads in transparent rainbow-bubbles. Each
bubble, by enclosing the prism of colour, encloses the sun, the
whole of light, and is a macrocosm. The lines from *Fallacies* run:

> The ark stood firm on Ararat; th' returning Sun
> Exhaled earth's humid bubbles, and emulous of light,
> Reflected her lost forms, each in prismatic guise
> Hope's harbinger, ephemeral as the summer fly
> Which rises, flits, expands, and dies.

The Sun of Venice going to sea brings out how important Venice
had grown to Turner, combining as it did a rich exuberance of
light, omnipresent water, fine buildings. Here he shows a ship,
full-sailed, emerging out of the luminous space of the city. The
lines from *Fallacies*, with echoes from Gray, make the usual
moral that prosperity can lead to disaster:

> Fair shines the morn, and soft the zephyrs blow,
> Venezia's fisher spreads his painted sail so gay,
> Nor heeds the demon that in grim repose
> Expects his evening prey.

This year the first volume of Ruskin's *Modern Painters* appeared.
From Turner's viewpoint it depreciated painters like Claude and
elevated Truth to Nature in an over-simplified way, but it began
soon to affect critics and public with its defence of his work. A
second edition appeared in March 1844.

In 1844 at the RA Turner had three Venetian scenes, but also
three sea-pieces in which he returned to the Dutch scene and
outlook. His important work, however, was *Rain, Steam, and
Speed – The Great Western Railway*, which showed a train
crossing the recently built bridge between Maidenhead and

[149]

Taplow. The Great Western, built by Brunel, was the great pioneering long-distance railway; by early 1845 it covered over 230 miles. Turner took as his setting one of Brunel's most impressive bridges, with two 130-foot flat elliptical arches, which he contrasted with the old bridge on the left, more graceful but not an engineering triumph. The countryside was one he had known and loved for some thirty years, and the train was heading for Devon. An old friend of Ruskin said she had been on the Exeter express, making for London, when an old gentleman in her carriage asked if he might open the window; he put his head out into the rainstorm for nine minutes; next year she saw the picture of the scene outside at the RA. (Her story has some contradictions, but may well record the moment when Turner felt the urge to show a train travelling through the countryside.) The composition has the jutting diagonal of the bridge on the right, this time counterbalanced by the old bridge. Turner wants above all to catch and define Speed, which means also expressing Time as a crucial aspect of a violently changing world. The impetus of the engine is brought out by making the engine darker in tone, sharper in edge, than anything else, so that it rushes out in aerial perspective ahead of its place in linear perspective. He uses the mingling or superimposition of different moments to define a direction in time as well as a pattern of tensional movements in space. In his most powerful works the sunset darkens as we look at it; the dawnlight whitens and deepens. As Ruskin said of the *Temeraire*, 'As you look, you will fancy some new film and faintness of the night has risen over the vastness of the departing form.'

To the aesthetic definition he adds an allegorical element: the hare racing the train. The mechanical movement is linked and contrasted with speed in nature. (He had used hound and hare as emblems of speed since his *Battle Abbey*, 'the spot where Harold fell', 1819, *Colchester*, 1825–6, and *Apollo and Daphne*, 1837.) G. D. Leslie, nine years old at the time, watched him at work on the picture on Varnishing Day.

> He used rather short brushes, a very messy palette, and, standing very close to the canvas, appeared to paint with his eyes and nose as well as his hand. Of course he repeatedly

walked back to study the effect. Turner must, I think, have been fond of boys, for he did not seem to mind my looking on at him; on the contrary, he talked to me every now and then, and painted out the little hare running for its life in front of the locomotive on the viaduct. This hare, and the train, I have no doubt he intended to represent the 'Speed' of his title; the word must have been in his mind when he was painting the hare, for close to it, on the plain below the viaduct, he introduced the figure of a man ploughing, 'Speed the plough' (the name of an old country dance) no doubt passing through his brain.

Men have taken over the speed of the hare: what are they going to do with it? Advance or hinder the movement of true humanity?

In November a young man who hoped to be taken on as a pupil called at Queen Anne Street. The place was very untidy. 'Most of the pictures, indeed all those resting against the wall, being covered with uncleanly sheets or cloths.' Turner was very quiet, clutching a letter. 'At last he stood abruptly, and turning to me, said, "Mr Hammersley, you *must* excuse me; I cannot stay another moment; the letter I hold in my hand has just been given to me, and it announces the death of my friend Callcott." He said no more; I saw his fine grey eyes fill as he vanished.'

He had drawn up a deed relating to three pieces of freehold land at Twickenham, to be used for the Almshouse for Decayed Artists. He must by now have been living for some time with Mrs Booth in Chelsea, at 6 Davis Place, Cremorne New Road (now part of Cheyne Walk). The place was held in her name, so that the local folk did not know his name and, taking him for an old sea-captain, called him Admiral or Puggy Booth. The house faced south on a bend of the river. On the roof he built a sort of gallery, and from there, and from his bedroom, he could gaze out at the waters or watch the Vauxhall fireworks. In his back garden he caught a starling, which he made much of and kept in a cage in the porch. He had lost his teeth and his powers were weakening. A surgeon dentist, who was called in, never knew his real name. 'He was very fond of smoking and yet had a great objection to anyone knowing of it. His diet was principally at that time rum and milk. He would take sometimes two quarts of milk per day,

and rum in proportion, very frequently to excess.' In his toothless state his uncouth way of eating made it hard for him to dine out.

In 1845 he showed four Venetian scenes, morning, noon, sunset, evening. The catalogue mentions *Fallacies of Hope* for each, but cites nothing. There were two *Whalers*, mentioning Beale's *Voyage*. Beale's book, *The Natural History of the Sperm Whale*, had stirred his imagination. Whales seemed the right sort of large powerful creatures to symbolize the energies of ocean, of unwieldy surges and curving waves. Turner was now selling more pictures. When Shee tried to resign as President of the RA, the Council persuaded him to keep on lending his name to the office, while the actual duties were delegated to Turner as the oldest Academician. When in September he went to France, at Eu he stayed at the house of a fisherman. An officer arrived to invite him to dine with the king, Louis Philippe, at the Château. (They had known one another in Turner's Twickenham days.) Turner pleaded his lack of the correct clothes, but was told that everything would be right as long as he had a white neckcloth. The fisherman's wife cut up some of her linen, and Turner went to dinner.

This year he sent his *Walhalla* to a show in Munich, but it was ignored. Elizabeth Rigby (later Lady Eastlake) tells of a visit to Queen Anne Street about this time. 'The old gentleman was great fun: his splendid picture of Walhalla had been sent to Munich, there ridiculed as might be expected, and returned to him with £7 to pay, and sundry spots upon it: on these Turner laid his odd misshapen thumb in a pathetic way. Mr Munro (of Novar) suggested they would rub out, and I offered my cambric handkerchief; but the old man edged us away, and stood before his picture like a hen in a fury.'

In 1846 he showed at the RA two more whaling pictures, one of them entitled *Whalers (boiling blubber) entangled in flaw ice, endeavouring to extricate themselves*. His whaling canvases were indistinct in atmosphere, conveying the sharp cold of Arctic regions, but in the one of boiling blubber there were contrasting fires. Two more Venetian paintings again depicted evening and morning, going to the Ball and returning. *Queen Mab's Cave* was a fanciful work, linked with Danby's *The Enchanted Island* (issued

as a mezzotint, 1841), with water and birds. A supposed citation from Shakespeare ran, 'Frisk it, frisk it, by the Moonlight beam'; *Fallacies* told us, 'Thy Orgies, Mab, are manifold'. More important was *Undine giving the ring to Masaniello, fisherman of Naples*. Here he conflated memories of Auber's opera on Masaniello and Perrot's ballet *L'Ondine* (performed at Her Majesty's Theatre, 1843). Masaniello was a fisherman who, in 1648, leader of a festival, became by revolution the head of Naples, but was betrayed and killed. The Undine is shown giving him a ring, which must have the same meaning as the ring that wedded Venice to the sea. (About 1835 Turner painted *La Piazetta with the ceremony of the Doge wedding the sea*.) The Undine is the treacherous water-spirit; her gift of power destroys. (In these years there was the strong Chartist agitation; on the Continent the unrest that led to the revolutions of 1848. Turner is asking whether the gaining of power by the common folk will not in its turn lead to corruption and disaster.)

It is of interest to note that the Rev. John Eagles in his attack on *Ulysses* had called the sea-nymphs of that work Undines. (An Undine had to trick a mortal into marriage if she was to gain a soul and immortality; the mortal would be doomed.) Ruskin in the essay which Turner read in manuscript asked what sort of critic it was to whom *Blackwood's* 'has presented the magic ring of her authority'. Turner may well have recalled this phrase and seen the Undine as also the malignant force in society that attacked and ridiculed him. To read fully the complex riddle of Undine giving the ring we must further note that Auber's opera played an important part in the revolutionary year of 1830, being the direct stimulus for the uprising that brought about Belgian independence. It is of much interest that Turner fused his feelings about two works of music, to produce his image of the deep struggles in the world of the later 1840s. (That he had been moved by the French revolution of 1830 is shown by his watercolour *Northampton* of 1830–1, in which a French Marianne reminds an old Tory of the event. Turner thus linked it with the radical struggle in England.)

Again, to get inside *Masaniello*, we must set it by *The Angel in the Sun*, also shown in 1846, a circular work like *The Deluge* and *The Morning After*, with its text from Revelation 19:17–18, in

which the Angel calls the birds to feast on the flesh of kings, captains, mighty men, horses and their riders. There was also a couplet from Rogers: 'The morning march that flashes in the sun;/The feast of vultures when the day is done.' Once more we meet the moral of collapse through corruption that was first set out fully with *Hannibal*. Michael with sword in hand and the enchained serpent below provide the vertical line of the composition, separating the figures to left and right, dividing good from evil. On one side Adam, Eve and Cain show the genesis of deceit and murder; on the other are contrasted pairs, Samson and Delilah expressing the betrayal of love, Judith and Holofernes bringing out the point that beguilement can be done in a good cause – Judith kills the general and saves her city and the lives of its people.

Ruskin in the first volume of *Modern Painters* compared Turner with the Angel in the Sun of Revelation. The passage so scandalized many persons that he later omitted it. Turner could not but have had the passage in mind, but he would not be depicting the Angel as himself. Rather, he would have seen him as the revelatory force in true art, of which he was trying to make himself an exponent.

In 1847 Turner sent to the RA only *The hero of a hundred fights*, which has been taken to depict the casting of Wellington's statue by Wyatt in September 1846. But once set up at Hyde Park Corner, that statue met strong disapproval; Turner was not likely to want to remind a colleague of such a misfortune – it seems that what he had in mind was Chantrey's statue of the Duke, completed by an assistant after his death. The casting took place at Chantrey's own foundry in Eccleston Place, and Turner would most likely have been invited to witness the event. His picture is thus mainly a tribute to his old friend Chantrey. Artist and statue may well have been meant to share in the apotheosis of light bursting from the foundry. For the scene Turner had recourse to a study of a foundry made in the late 1790s.

In 1848 he had nothing in the RA. He made two more codicils to his will, insisting that his pictures were to go to the National Gallery only on condition that a room or rooms were added for them, to be called Turner's Gallery. Ruskin was now married and had his own house in Grosvenor Square. A note from Turner

in November, sent from the Athenaeum, suggests that he knew all was not well with the marriage: 'My dear Ruskin!!! Do let *us* be happy.' His mental alertness, his wish to keep abreast with all matters concerning light is shown in his interest in the new science of photography. He knew the daguerrotypist Mayall and had many discussions with him. 'He took great interest in all effects of light, and repeatedly sat for his portrait in all sorts of Rembrandtic positions.'

In 1849 he sent to the RA a sea-piece, *The Wreck buoy*, and the mythological *Venus and Adonis*. The first had two great curves of light coming down on a ship to the left of the buoy, and was a transformed version of a work done some forty years before. The second was his Titianesque work of 1803, with its sensuous richness untouched. Perhaps he added it to the sea-piece to bring out the wide range of his work. In any event he seems to be looking back far into his own past achievement. In 1850 he again looked back for themes, but painted quite new pictures, all four of them. He returned to his love of Carthaginian views, to the story of Dido and Aeneas. In three of the works he kept to the Virgilian basis: *Aeneas relating his story to Dido, Mercury sent to admonish Aeneas*, and *The departure of the fleet*. But he added an invention of his own: *The visit to the tomb*, in which Dido goes, with Aeneas and Cupid, to the tomb of her husband, Sychaeus. Each picture has its tag from *Fallacies*. First, 'Fallacious Hope beneath the moon's pale crescent shone, Dido listened to Troy being lost and won.' Then, 'Beneath the morning mist, Mercury waited to tell him of his neglected fleet.' Then 'The orient moon shone on the departing fleet, Nemesis invoked, the priest held the poisoned cup.' For the visit to the tomb he wrote, 'The sun went down in wrath at such deceit.' Dido's Carthage had been for him a world of early hopeful expansion, with Claudean vistas in a golden glow. Now the stress is on the failure of Aeneas as a lover. He, we saw, seems to have been a self-projection of Turner. The point of the present set of works could then be that the artist by his self-dedication tears himself from the relationship in which he could have been happy, to carry on with his destined task. The result is fallacious hope, deceit, Nemesis, a poisoned cup. In each of the four paintings light breaks the barrier of sea and sky and pours down into the foreground with its human actors.

[155]

Turner certainly felt he was near his end and made a strenuous effort to paint these works so that they could be shown together as a farewell gesture. Despite the emphasis on defeat in the passages from *The Fallacies of Hope*, here as elsewhere we would be mistaken if we saw only pessimism in Turner's outlook. Rather, there is a stress on the indomitable spirit of life, the restless energies in human beings and nature, which reasserts itself despite distortion and defeat. In the *Angel* the tale of betrayals and murder culminates in the character of Judith who becomes liberator. In the poem that Turner struggled hard to write on Willoughby, who sought to find the North-West Passage and died in the attempt, he opens with a declaration that Money is the driving force. 'O Gold thou parent of Ambition's ardent blush/Thou urge the brave to utmost dangers rush/The rugged terrors of the northern main . . .' And so on at length. But then, turning to depict the 'chaotic strife, elementary uproar wide', he forgets the curse of Gold and concentrates on the courage and endurance of the seamen. 'The daring Willoughby died . . . thy unfading honor neer can sleep.' In another poem, watching the waves of the tide surge in to the shore, he feels that here is the lesson that humans must learn: union in worthwhile action:

> Repulsed not humbled miriadlike they join
> United portions roll but onward to the shore
> Giving a daily lesson to combine
> To Man himself, so niggard of his store.

The multiple meanings that his pictures had, meanings at different levels which combined in the last resort with the aesthetic definition for the total effect, were of the utmost importance to him. Yet he felt that to explain them in a moralizing way was to kill the vitality, to destroy the very unity of emotion, sensory definition, intellectual analysis, which created the work and provided its deepest impact. At times, caught off his guard, as with the comments on Wyckliffe, he gave others a glimpse of the way his mind, his artistic faculty, worked. Otherwise he said nothing. But he wanted people to make the effort to see deep into his intentions and achievements.

Ruskin says that he kept on asking him what he saw in *War*, but was not satisfied with his comments. Yet he would not prompt Ruskin or explain his own intentions.

He died on 19 December 1851 at Chelsea. The doctor who was present says that 'just before 9 a.m. the sun burst forth and shone directly on him with that brilliancy which he loved to gaze on. He died without a groan.' One likes to think that he really said, 'The Sun is God.' The phrase seems too much in character to have been invented. He had hidden his Chelsea house as well as he could; he is said to have walked back deviously to it from any meeting at the Academy or the like, making sure that he was not being followed. However, Hannah Danby knew of it, whether or not she discovered it only a brief time before his death. When news of what had happened reached his executors, his body was discreetly moved to Queen Anne Street, and lay in state in the picture gallery there till the funeral on 30 December.

There were the full trappings: mutes carrying wands and feathers, four horses to the hearse, a long line of eleven coaches and at least eight private carriages. One executor told his son that a large number of persons had been told they could not attend. The united body of Landscape-Engravers came as a group, paying for their own carriage. Many artists such as Eastlake and George Jones were present. (Ruskin was in Venice.) The chief mourners gathered at 8 a.m. Two hours later the procession left, taking nearly three hours at a walking pace to reach St Paul's. 'The streets near the Cathedral were crowded with spectators and but for the admirable tact of the Police, the procession must frequently come to a halt.' The Dean conducted the service, which ended in the Crypt. Later that afternoon, back at his house, his will was read to the executors.

How may we best sum up his work? We can confidently claim that no artist of high standing did anything like the amount of work he did, or drew in so many influences, mastered so many methods and styles without losing his strong individuality. The volume of work is not an incidental quality; it is an aspect of his restless and resolute quest to produce an art as fully and richly based in reality as possible, an art which at the same time drew on relevant elements of previous art, transforming them in terms of

his personal struggle. Thus he sought both for continuity in tradition and for an intense individual freedom. No previous artist had expressed and sustained such an effort in comparable terms.

When we come to his personal vision, we may best define it by saying that he was the first artist who realized light as colour and colour as light. Previously light had been considered a transparent medium that rendered objects visible and revealed their colours. Now it was seen as a dynamic force impacting on objects and penetrating them, breaking into colour. So nature itself was seen in a different way: not as a static pattern at any given moment, but as an active process in continual change, with endless interactions. The attitudes expressed in *The Fallacies of Hope*, in other poems, in his Lectures and comments, were not something that could be considered in abstraction from the art. They were vitally embodied in the art, in his whole approach and methods. *The Fallacies* did not merely express personal moods or views, though he himself, his life and activities, were part of the total process, human and natural, which he was struggling to understand and express. Unless we see his ideas, the meanings of his pictures, as inseparable in the last resort from the aesthetic process, we cannot fully understand the latter. All great artists had embodied a general view of life, a judgement on it, but with Turner the struggle for a fuller consciousness of everything involved in the creative process was lifted on to a new level. He thus had his roots in the same struggle to deepen consciousness as the great romantic poets, such as Coleridge, Keats, Shelley, though he did not know these contemporaries; and he looked forward to positions worked out by the French painters from Delacroix to Cézanne, as well as anticipating those developed by the *symbolistes* in poetry. With all his zeal for keeping contact with the great integrative expressions of the past, he faced decisively forward into the modern world.

What then were the effects of his work in England? The answer is very disappointing. He had no deep-going effect at all. In the first decade of the nineteenth century he was still close enough to the more perceptive artists to learn from the latter and to have an effect on them. Thus emerged the group nicknamed the White Artists, who were all deeply concerned with light and

atmosphere. A. W. Callcott is the best example of the young artists of this phase with whom he was in vital touch. But after works like *Hannibal*, and then the deep changes in his art stimulated by his visit to Italy, he found himself increasingly isolated. (Callcott followed him to Italy, but merely turned out works of classic nostalgia; then in the 1830s he broke wholly away, declining into pastoral pastiche, and came to look on Turner as a dangerous obstruction to the development of landscape painting.) Almost from the start Turner had attracted a mixture of praise and abuse from the critics, with the accusation of derangement or madness, then of diseased eyesight, becoming ever more common. He did not find patrons coming forward as he had in the first decades of the century, though at the same time he was gaining a wide popular audience through the engravings of his works. Even as late as 1939 a sympathetic biographer like Finberg headed the last chapters of his book, dealing with the years 1834 on to the end: 'Imagination and Reality strive for Mastery', 'Talent Running Riot', 'The Absurd and the Sublime', 'Only Visions of Enchantment', 'Sudden Failure of Powers'. Most of these phrases are quotations, but the fact that Finberg felt impelled to use them is significant.

The full Victorian distrust of Turner is revealed in the summing-up by P. G. Hamerton in his *Life of Turner*, 1879:

> He was technically a wonderful but imperfect and irregular painter in oil, unsafe and unsound in his processes, though at the same time both strong and delicate in handling...
>
> The qualities of Turner's art are so various and so great, that there is some danger, especially with the influence of Mr Ruskin's eloquence and frequent use of hyperbole, of a national idolatry of Turner, like the Roman idolatry of Raphael, or the French idolatry of Claude. Such a result would be a great evil to landscape-painting in England, and to the aesthetic culture of Englishmen who are not practical artists. Even as it is, the fame of Turner is injurious to English landscape-painters of merit, who, if inferior to him in range of study or strength of imagination, are often in some respects his superiors, and able to render what they love best in nature with a degree of affectionate fidelity

[159]

which he certainly could not have equalled. With all my admiration for Turner I should be sorry to contribute to such a result as this . . .

An uncritical adoration of Turner might narrow and falsify English landscape-painting if the natural vigour and independence of the English race did not continually re-assert itself. Let us enjoy what is delightful in his art, and admire what is admirable, but let us remember that he belongs already to the past, that he is a dead master, that he will soon be an old master, and that an art which would preserve its freshness must work on towards its own future.

It is true that there was one critical exception to this wish to see Turner as an interesting eccentric. John Ruskin had powerfully championed him in his *Modern Painters*, published in 1843. But though Ruskin sympathized deeply with one aspect of Turner's art, his delicate and complex rendering of aspects of nature, he lacked a comprehensive view of his achievement in its full integrative, exploratory, and imaginative bearings. Also, when his book appeared there had already been a decisive turn in the tastes of the English art world. He submitted his book first to John Murray, who rejected it because the public 'cared little about Turner' and were calling for works on the contemporary German school of Pre-Raphaelite painters. Smith, Elder and Co. published the book, but though it helped to keep various aspects of Turner's work alive it could not have the effect of bringing his work as a whole into an active relation with the art-trends of the day.

Things were very different in France. Delacroix in his old age, in 1858, wrote that 'He [Constable] and Turner were real reformers. They broke out of the rut of traditional landscape painting. Our school, which today abounds with men of talent in this field, profited greatly by their example.' Paul Signac, a close friend of Claude Monet and Camille Pissarro, in his book, *From Eugène Delacroix to Neo-Impressionism* (1898), described the early struggle of those two artists.

But in 1871 during their lengthy stay in London they discovered Turner. His marvellous and enchanting use of colour

astounded them; they studied his work and analysed his working method. From the start they were struck by his effects of snow and ice. They were amazed how he managed to convey the effect of whiteness of snow, they, who at that point were unable to obtain such effects when they laid on big blobs of silvery white with wide brushstrokes. They noted that this marvellous effect was obtained not by a uniform white colour, but by a mass of different colours placed side by side and giving the desired effect when viewed from a distance. Through the undeniable influence which Turner and Jongkind had on the Impressionists they returned to the technique of Delacroix from which they had strayed in trying to obtain effects through juxtaposition of light and dark blobs of colour.

Thus Turner had an important effect on the development of Impressionism with all its rich consequences in opening up the ways of modern art – not so much by stimulating some particular kind of technique of handling paint, as by exerting a general liberating and stimulating influence through his fresh and varied ways of defining light and colour. He had a direct impact on Sisley and Renoir among others.

In England there was one attempt to build directly on him, which brings out clearly how adverse the situation was. He had had some influence on the growth of the school of Protestant mystical world-end themes, of which F. Danby and John Martin were the most effective exponents. A painter linked with this school, John Linnell, made some efforts to learn directly from him. In the 1840s and 1850s he painted works with a Turnerian drama of storm or sunset, with strongly centralized light, and appealed to the examples of Claude, Poussin, Turner. He drew with his brush in transparent glaze and built up form with multiple strokes. But his vision flagged and weakened. It did not lead to any new direction in art, but merely worked out as producing a pleasant variation of the conventional systems.

10. THE BEQUEST

Turner was dead but the fate of the pictures he left was still to be decided. He had been very concerned about them, as is shown by his having drawn up a will and added codicils in 1831, 1832, 1846, 1848 (twice) and 1849. The main matters that had obsessed him were the founding of the charity for decayed or indigent artists and the bequeathing of the works he left to the nation. He first asked that a separate gallery for all 'my pictures' should be built as part of Turner's Gift; in the late 1840s he directed that all his 'finished Pictures' should go to the National Gallery on condition that 'a room or rooms', to be called Turner's Gallery, were added to the existing Gallery. (*The Sun rising through Vapour* and *Dido building Carthage* had been left to the Gallery on the condition that they were hung next to two Claudes.)

He left in fact 370 unsold oil paintings. In all there were some 95,800 watercolours, sketches, oils, engravings and plates. There were just over 52,500 engravings bound into 547 volumes. Of the other 43,000 items some 16,000 were drawings from his 260 bound sketchbooks, plus 1,500 sketches on single sheets of paper. There were many sets of *Liber Studiorum* mezzoprints, book illustrations to poems of Scott, Byron, Milton, Campbell, Rogers, and a large number of his topographical engravings. He had long planned the Turner Gallery. He refused to sell certain pictures and sketchbooks despite good offers; he bought back certain works at prices higher than those at which he had sold them. Late in life he refused two offers of £100,000 for the contents of his own gallery. He had always held that the works must be seen together to be properly understood and appreciated. (In a sense his collection had become his family.)

[163]

The various changes of detail in his codicils did not affect the essential nature of his Bequest. He wanted his pictures to be kept together as a national possession in a building accessible to the public. The National Gallery had been founded in May 1824 and housed at 100 Pall Mall. But in the early 1830s much of the area where it stood was being demolished. The collection was put temporarily in 105 Pall Mall; then a new building was raised on the north side of Trafalgar Square, and was opened as the National Gallery in April 1838. The collection had been early increased by gifts from connoisseurs like Sir George Beaumont and J. J. Angerstein; the Gallery itself began buying works in 1825, starting with a small Correggio, and the next year acquiring important paintings by Poussin and Titian. But in 1851 it was still in its infancy despite a large number of visitors; there were less than a dozen employees, all with mere custodial or housekeeping duties except for the Keeper, a part-time official in charge of the collection who was required 'to be present occasionally in the Gallery'. There had been hardly any effort to get work by living artists.

On Turner's death, his relations on his father's side, with whom he had very little contact, decided to fight for the valuable works he had left to the nation. First, they argued that he had been of unsound mind and incapable of making a will. This implied that for twenty years and more he had been witless. The claim was dismissed and the claimants had to pay costs. Probate was ordered. They then started proceedings in the Court of Chancery, arguing that the will was unclear and that it was in any event void as Turner had failed to comply with the requirements of the Charitable Uses Act of 1736 in seeking to set up his Charity. (That Act had been aimed at preventing clergymen from persuading people on their deathbeds to forget their rightful heirs and leave money to charities.) Turner had complied with the main rules that the Act laid down: he had registered his charity seven years before his death, but he had failed to deliver the deeds of his Twickenham land to the designated Trustees twelve months before that event. Only an acre of freehold land was involved, valued at about £400. But his omission was interpreted as annulling his will with its gift of some £140,000 to poor artists and of his artworks to the nation.

[164]

His executors had no course but to undertake a complicated action in the Court of Chancery against the Attorney-General, the relatives challenging the will, and the two beneficiaries named in that will: Mrs Booth and Hannah Danby. Turner had not imagined that his will could be challenged, so he had allotted no funds for his executors to meet such a situation. Two of the eight executors (one of them being Ruskin) promptly resigned; the other six did their best to carry on. The best tactics they could devise were to fight a rearguard action in the hope of salvaging something of Turner's wishes. After three and a half years, on 19 March 1856, a decree was issued by the Vice-Chancellor, setting out the compromise finally reached by the parties. Turner's estate was to pay the very heavy legal costs of everyone involved. A large portion of what money remained was divided among the relatives, who also were awarded Turner's properties such as the gallery in Queen Anne Street; the poor artists got nothing; the Royal Academy got £20,000, though such a gift was not at all suggested in the will.

On 18 March 1857 Lord St Leonards (who had been Lord Chancellor and was looked on as one of the finest legal experts of the time) raised the matter in the House of Lords. He strongly disapproved of the terms of the compromise and said that Turner's intentions were clearly stated in the will; he opposed the position of the newly appointed (first) Director of the National Gallery, that the Gallery now need not feel bound by Turner's conditions for their acceptance of his Bequest.

But his protest had no effect; no steps were taken to build a Turner Gallery. A selection of oils and watercolours was shown in 1857 at Marlborough House (then an annexe of the National Gallery); in 1859 some 100 oils and 200 watercolours were taken to the South Kensington Museum (now the Victoria and Albert) where a section of the National Gallery, the British School, was being installed. Lord St Leonards spoke again in the House of Lords in 1861 to point out that what had been done was in no way a substitute for a Turner Gallery. He declared that to the legal obligations were added 'higher obligations – moral obligation and national honour'. The limit of ten years which Turner had laid down for the creation of his Gallery was coming near. Copies of the will and the Chancery decree were handed out; the

Lord President moved that a Select Committee of Enquiry be set up; and he himself then chaired the meetings. The National Gallery was instructed to recall Turner's works from South Kensington and to lose no time in exhibiting them in a gallery of its own. In late October 1861, just as the time-limit came close, the National Gallery merely piled ninety-four oils and a few watercolours into an emptied room. They were huddled so close that the Keeper took the frames off the third tier so that they could be crammed in between the second tier and the ceiling.

The relatives wanted to make sure of their legal ownership of engravings and gallery. In 1872 Chancery settled the matter. Only one executor of the will was still alive and the relatives were safe in destroying all the plates so as to ensure that no more printings could be made. In nineteen days of sale between March 1873 and July 1874 some 76,000 prints were sold at Christie's. The relatives got £40,000 and a priceless collection was dispersed. (Many of the copper plates had been engraved by Turner himself, so that his methods and skills could be seen on them.) No one in the art world made any protest whatever. The pretence of a Turner Gallery was quietly dropped. In 1883 the National Gallery gained the right to lend pictures to the provinces and, after that, making selections on the basis of Ruskin's ridiculous division of the Bequest into Fine, Middling, Bad, Rubbish, it dispersed much of its collection. A great deal of the Bequest remained in the Gallery's vaults; and for fifty years no one could look at any of it without a special permit. At times even scholars were shut out.

In 1897 the Tate Gallery was opened, for the encouragement of British art, as the result of a donation by Sir Henry Tate, who had made a fortune largely out of sugar. It had a Keeper and was administered as part of the National Gallery. Only by 1905 was the Bequest slowly taken out of storage and handed over to the Tate; the first show was held in 1906. (As late as 1939 about fifty ignored works were found in the National Gallery basement; they had been thought to be old tarpaulins.) But now things began to stir. In 1906 the Director of the National Portrait Gallery in a letter to *The Times* drew attention to the disgraceful situation. Turner had left the Bequest 'for the honour and glory of British art and for the enjoyment and instruction of posterity

. . . Like so many other episodes in the history of art in England, lack of money, lack of official sympathy, and, above all, and worst of all, lack of national interest nullified the effect of Turner's specific intentions.' The Tate, short of space, was keeping most of the Bequest in its cellars.

In 1905 the National Gallery had commissioned the art critic A. J. Finberg, to catalogue the 19,500 sketches and watercolours, and in 1909 his Inventory was published. In 1908 Sir Joseph Duveen, art-dealer, stepped in to rescue the Bequest. His donation made possible the building of a new wing to the Tate, which included five galleries for Turner's oils and watercolours; an existing gallery was used for *Liber Studiorum* prints and their watercolour designs. A big advance was thus made, though more space was needed for anything like a complete showing of the Bequest.

In 1916 an attempt was made to sell off many of the works. A trustee of the National Gallery, Lord d'Abernon, moved a bill in the House of Lords, permitting the sale of surplus pictures. Another trustee admitted that it was the Bequest that was mainly in mind. Eighteen RAs and Associates wrote in protest to *The Times*. The RA President and the heads of twenty leading art-societies issued a manifesto against the Bill, which was dropped. But the neglect of the Bequest continued. In 1928 a flood destroyed some of the watercolours in the Tate basement and damaged many others. So the sketches and watercolours were removed to the Print Room of the British Museum. (In August 1980 an article in *The Times* dealt with the danger of fires there and the inadequacy of the cataloguing.) In 1975 there was held at Burlington House the biggest show of Turner's work so far organized, which had a powerful effect. In the same year, in April, the Turner Society was formed and at once began pressing for implementation of the Bequest, for the creation of a Turner Gallery and Study Centre. It was suggested that Somerset House (the first home of the RA) should be used. In December 1975 a Petition to the Prime Minister was drawn up, urging the taking-over of Somerset House. The Tate objected that if fires broke out there it would be very difficult to get the paintings out. In December 1977 the Tate, joined by the National Gallery, argued against the whole project of a separate Gallery; but the Society

[167]

continued to agitate. In February 1978, replying to a Petition to the Queen, the Secretary of State, Shirley Williams, ruled that things should stay as they were, with an increased display of Turner's works. The Society issued two pamphlets in June 1979, dealing with the case for the Turner Gallery and the value of Somerset House for the purpose.

Then in January 1980 the situation totally changed, mainly through the offer of five million pounds from the estate of Sir Charles Clore. The Tate director, Alan Bowness, proposed the construction of a Turner Gallery on the site of the disused military hospital across the street from the Tate.

The new Gallery, to be called the Clore, has been designed by the architect James Stirling. As far as possible the Clore Gallery is integrated with the Tate, though it has its separate identity and is clearly seen from Millbank across the gardens of the Tate; the plane-trees have been kept and new lawns have been laid across Bulinga Street to the Lodge. The Gallery is designed as a garden building, with pergola and lily pool, a paved terrace with sheltered seating. It is L-shaped with a gallery wing that connects with the existing building behind its pavilioned corner, and with the shorter wing returning towards Millbank. By setting the new building back and by matching its parapet with the Tate's, the pavilioned corner, with its greater height and mass, keeps its own particular qualities without upsetting the symmetry of the Tate frontage. The galleries in the upper section are at the same level as those of the Tate, thus allowing uninterrupted access from the main building. The series of rooms, smaller and larger, are related to the scale and grouping of Turner's works. On the lower level is a lecture theatre with 196 seats.

Nothing can now affect the disgraceful Chancery decree of 1856 that allowed the dispersal of the prints and the destruction of the plates; but at last, after more than 130 years, the major requirement of Turner's will, the creation of a separate Gallery for his Bequest, is to be more than adequately met.

SELECT BIBLIOGRAPHY

All items, unless otherwise stated, were published in London

Note the following abbreviations:

BM – Burlington Magazine; CL – Country Life; JWCI – Journal of the Warburg and Courtauld Institutes; TS – Turner Studies; TSN – Turner Society News.

Armstrong, Sir W., *Turner* (2 vols), 1902.

Arnoult, L., *Turner, Wagner, Corot*, Paris, 1930.

Ashby, T., (1) Turner in Rome, *BM*, xxiv, January 1914, 218–24, and xxv, May 1914, 98–104. (2) Turner in Tivoli, *BM*, xxv, July 1914, 241–7. (3) *Turner's Vision of Rome*, 1925.

Bachrach, A. G. H. (1) *Turner and Rotterdam*, 1974. (2) *Light and Sight*, 1974, 41–58. (3) *TS*, I, 1980 (Turner, Ruysdael and the Dutch). (4) *TS*, II, 1981 (The Field of Waterloo).

Baldry, A. L., *British Marine Painting*, 1919.

Bayes, W., *Turner, a Speculative Portrait*, 1931.

Bazalgette, L., *L'Art et les Artistes*, XII, 1910, 124 (Turner and Crome, Painters of Paris).

Bega, *The Turner Spell: Its Influence and Significance*, 1931.

Binyon, R. L. (1) *English Watercolours*, 1931, 2nd edn 1934 (2) *English Watercolours from the Work of Turner, Girtin, Cotman, Constable and Bonington*, 1949.

Blunt, A., *National Trust Studies*, 1980, 119–32 (Petworth).

Boase, T. S. R., (1) *JWCI*, XIX, July 1956, 283–93 (English Artists and the Val d'Aosta). (2) *JWCI*, XXII, July–December 1959, 332–46 (Shipwrecks in English Romantic Painting). (3) *English Art, 1800–70*, 1959.

SELECT BIBLIOGRAPHY

Brill, F., *Turner's 'Peace-Burial at Sea'*, 1969.

Brooke, S., *Notes on the Liber Studiorum of J. M. W. Turner*, 1885.

Brown, D. B., (1) *BM*, CXVII, 1975, 719–22. (2) *TS*, I, 47–8 (Callcott). (3) *A. W. Callcott*, 1981, Tate Gallery.

Bunt, C. G. E., *J. M. W. Turner: Poet of Light and Colour*, Leigh-on-Sea, 1948.

Burnet, J., *Turner and his Works*, 1852, 2nd edn 1859.

Butlin, M., (1) *Turner Watercolours*, 1962. (2) *The Later Works of J. M. W. Turner* (Tate) 1965. (3) *Watercolours from the Turner Bequest*, 1968. (4) *Turner* (Tate) 1974. (5) and Joll, E., *The Paintings of J. M. W. Turner*, 2 vols, 1977. (6) *Turner at the Tate*, 1980.

Chamot, M., *The Early Works of J. M. W. Turner*, 1965.

Chubb, W., *TS*, II, 26–35 (Minerva Medica and the Tall Tree).

Clare, C., *J. M. W. Turner, His Life and Work*, 1951.

Clark, Sir K., (1) *Ambassador*, 8, 1949, 75–90 (Turner at Petworth). (2) *Looking at Art*, 1960 (Snowstorm).

Cornwell-Clyne, A., *CL*, 14 April 1955, 974–6.

Cundall, E. G., *BM*, XIX, April 1916, 16–21 (Fonthill Abbey).

Cunningham, C. C., *Art Quarterly*, XV, Winter 1952, 322–30 (Van Tromp).

Dafforne, J., *The Works of J. M. W. Turner*, 1877.

Davies, R., *Turner and Girtin's Watercolours*, 1926.

Dearden, J. S., *Turner's Isle of Wight Studies*, 1979.

Dick, J., *The Vaughan Bequest of Turner Watercolours*, National Gallery of Scotland, 1980.

Eastlake, Lady, *Journals and Correspondence*, ed. C. E. Smith, 1895.

Eitner, L., *Art Bulletin*, XXXVII, December 1955, 281–90.

Falk, B., *Turner the Painter: His Hidden Life*, 1938.

Finberg, A. J., (1) *Life of J. M. W. Turner*, 1939. (2) 2nd edn, rev. by H. F. Finberg, 1961. (2) *Complete Inventory of the Drawings of the Turner Bequest*, 2 vols, 1909.

Finberg, H. F., (1) *BM*, XCIII, 1951, 383–6 (his Gallery). (2) *BM*, XCIX, February 1957 (Turner in 1797).

Finley, G. E., (1) *JWCI*, XXX, 1967, 157–66 (Colour Theory). (2) *JWCI*, XXXVI, 1973, 385–90. (3) *Landscape of Memory* (Turner and Scott) 1980. (4) *JWCI*, XXX, 1967, 379–85. (5) *Turner and George IV at Edinburgh*, 1981.

Gage, J., (1) *BM*, cvii, January 1865, 16–26, and February 1865, 75–81 (Picturesque). (2) *Colour in Turner, Poetry and Truth*, 1969. (3) *Turner – 'Rain, steam and speed'*, 1972. (4) *Art Quarterly*, xxxvii, 1974, 55–87 (Stourhead). (5) *Journal of the Royal Society of Arts*, cxxiii, July 1975, 448–58 (Distinctness of Turner). (6) *TS*, ii, 14–25 (Turner and Greek Spirit). (7) *Collected Correspondence of J. M. W. Turner*, 1980.

Gaunt, W., (1) *Turner*, 1971. (2) *L'Univers de Turner*, Paris, 1974.

George, H., *Art Bulletin*, liii, 1971, 84–7 (Venice).

Gowing, L., (1) *Turner: Imagination and Reality*, New York, 1966. (2) *Art News*, 62, October 1963, 30–3 (Pictures of Nothing).

Gray, R. D., *German Studies Presented to W. H. Burford*, 1962 (Goethe's Colour Theory).

Hamerton, P. G., *The Life of J. M. W. Turner, R.A.*, 1879.

Hardie, M., *Water-colour Painting in Britain*, ii. *The Romantic Period*, 1967, 2nd edn 1970.

Hawes, L., (1) *Art Quarterly*, xxxv, 1972, 23–48 (Temeraire). (2) *Presences of Nature: British Art 1780–1830*, Yale University Press, 1982.

Hermann, L., (1) *J. M. W. Turner*, 1963. (2) *Turner: Paintings, Watercolours, Prints and Drawings*, 1975.

Hill, D., *CL*, 25 December 1980 (Frosty Light).

Hirsh, D., *The World of Turner*, New York, 1969.

Joll, E., (1) *Apollo*, cv, May 1977, New York (Egremont). (2) see Butlin (5).

Kitson, M., (1) *J. M. W. Turner*, 1964. (2) *Listener*, 12 August 1965, 240–1 (Hannibal).

Lindsay, J., (1) *J. M. W. Turner, His Life and Work*, 1966. (2) *The Sunset Ship, The Poems of J. M. W. Turner*, 1966. (3) *TSN*, i–ii, Turner and Music.

Livermore, A., (1) *CL*, 6 July 1951 (Sandycombe Lodge). (2) *Music and Letters*, xxxviii, 1957, 170–9 (Turner and Music).

MacColl, D. S., *BM*, xii, March 1908, 343–6 (Turner's Lectures).

Matteson, L. R., *Art Bulletin*, lxii, 3, September 1980, 335–98 (Hannibal).

Mauclair, C., *Turner*, 1938; English trans. 1939.

Nekrasova, E. A., *Turner*, Moscow, 1970.

Nicholson, K. D., *BM*, LXXII, October 1980, 679–86 (Apullia).

Ninnis, C., *TSN*, 20, January 1981, 6–8 (Ariel).

Paulson, R., (1) in *Images of Romanticism*, ed. K. Kroeber and W. Walling, New Haven, 1978 (Turner's Graffiti: the Sun and its Glosses). (2) *Literary Landscape: Turner and Constable*, Yale University Press, 1982.

Rawlinson, W. G., (1) *The Engraved Work of J. M. W. Turner*, 2 vols, 1908, 1913. (2) and Finberg, A. J., *The Watercolour Drawings of J. M. W. Turner*, 1909.

Reynolds, G., (1) *Turner*, 1969. (2) *Geographical Magazine*, XXI, 2, 1948 (Wilson and Turner in Italy). (3) *Victoria and Albert Museum Yearbook*, 1969, 67–9 (Cowes).

Selz, J., *Turner*, Paris, 1975, English trans. by E. B. Hennessey, 1975.

Shanes, E., (1) *Turner's Picturesque Views of England and Wales*, 1979. (2) *Turner's Rivers, Harbours and Coasts*, 1891. (3) *Artscribe*, 20, November 1979 (Turner's human landscape). (4) *Artscribe*, 23 (The Golden Bough). (5) *TS*, 11, 36–42 (Turner's unknown London series).

Shipp, H., *Apollo Miscellany*, 1951 (aesthetic theory).

Stader, K. H., *W. Turner und der Rhein*, Bonn, 1981.

Stokes, A., *Painting and the Inner World*, 1963.

Stuckey, C. F., (1) *Jahrbuch der Berliner Museen*, XVIII, 1976, 155–75. (2) *TSN*, 21, 1981 (Turner's birthdays).

Swinburne, C. A., *Life and Works of J. M. W. Turner*, 1902.

Thornbury, W., *The Life of J. M. W. Turner*, 2 vols, 1862; rev. 1876; reprint, 1970.

Tinker, C. B., *Painter and Poet, Studies in the Literary Relations of English Painting*, Cambridge, Mass., 1938.

Turner in Yorkshire (York City Art Galleries), 1980.

Turner at the Bankside (Bankside Gallery, London SE1 9JH), 1980.

Tyrrell-Gill, F., *Turner*, 1904.

Walker, J., *Joseph Mallord William Turner*, New York, 1976.

Warburton, S., *TSN*, 18, 1980 (Turner and Yorkshire).

Weil, E., (1) *The Case for a Turner Gallery*, 1979. (2) *TSN*, 16, 1980, 4–6 (Turner and Claude). (3) *TSN*, 13, 1979 (Turner and Impressionism). (4) *TSN*, 23, 1980–1 (Turner's Covent Garden).

Whitley, W. T., *BM*, xxii, January 1913, 202–8, and February 1913, 255–9 (Turner as Lecturer).

Whittingham, S., *Constable and Turner at Salisbury*, 1980.

Wilton, A., (1) *The Life and Work of J. M. W. Turner*, 1979. (2) *Turner and the Sublime*, 1980. (3) *Turner in the BM*, 1975. (4) *BM Bull.*, March 1975 (Turner watercolourist). (5) and Russell, J., ed. W. Amstutz, *Turner in Switzerland*, Zürich, 1976. (6) *Turner Abroad*, 1982.

Ziff, J., (1) *BM*, cv, July 1963, 315–21 (Turner and Poussin). (2) *JWCI*, xxvi, 1963, 124–47 (Turner's Lecture, 'Backgrounds, Introduction of Architecture and Landscape'). (3) *Studies in Romanticism*, iii, 4, Summer 1964, 328–33 (Turner on Poetry and Painting). (4) *JWCI*, xxviii, 1964, 340–2 (John Langhorne and Turner's Fallacies of Hope). (5) *Gazette des Beaux-Arts*, lxv, 1, January 1965, 51–64 (Copies of Claude in Turner sketchbooks).

INDEX